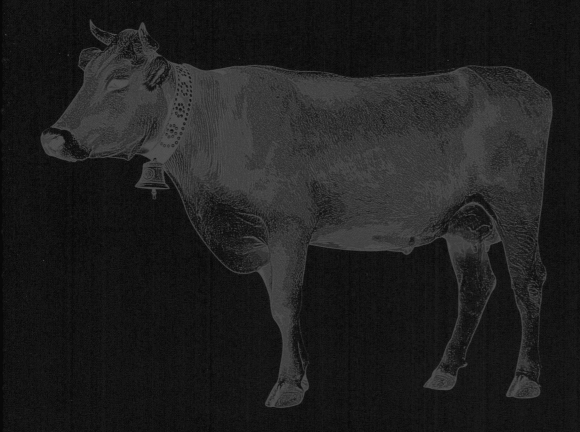

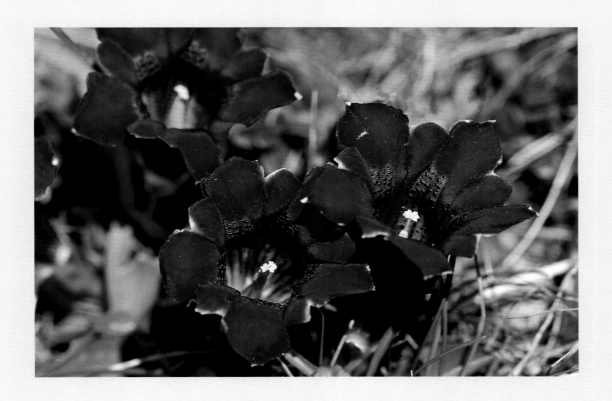

Journey through the

ALLGÄU

Photos by
Martin Siepmann

Text by
Katrin Lindner

Stürtz

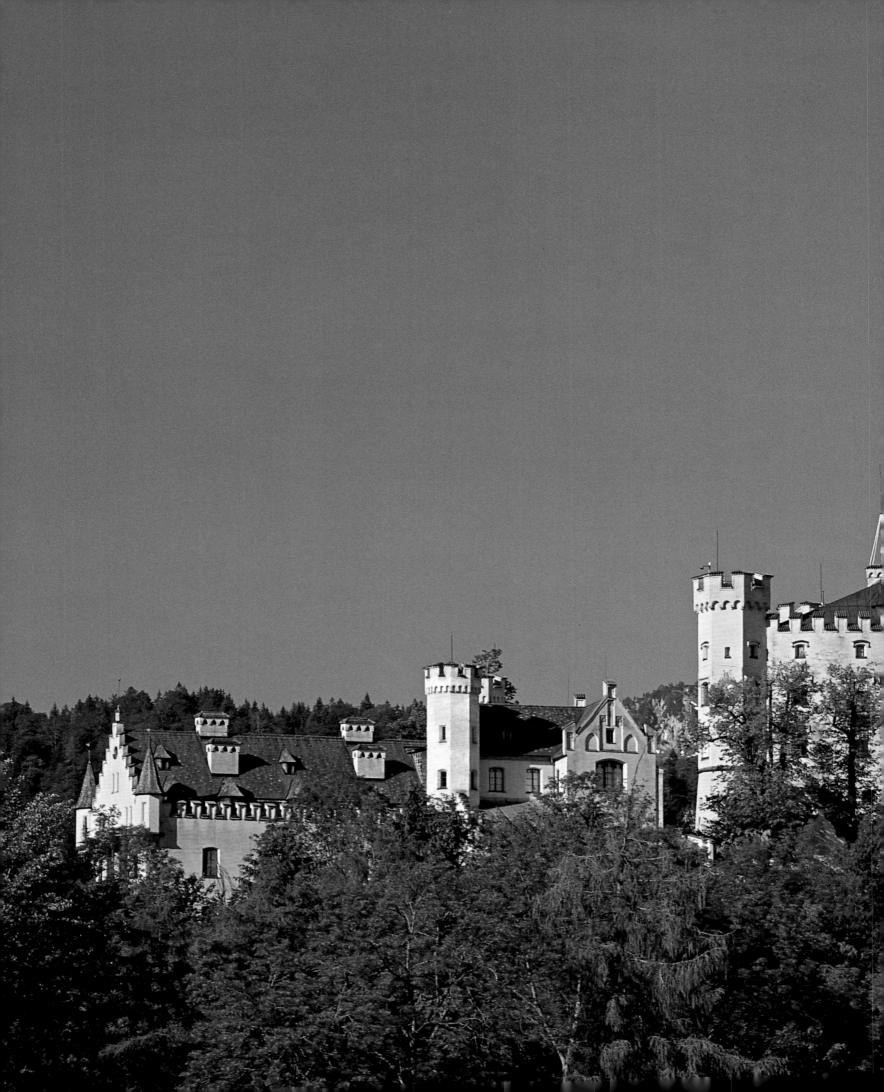

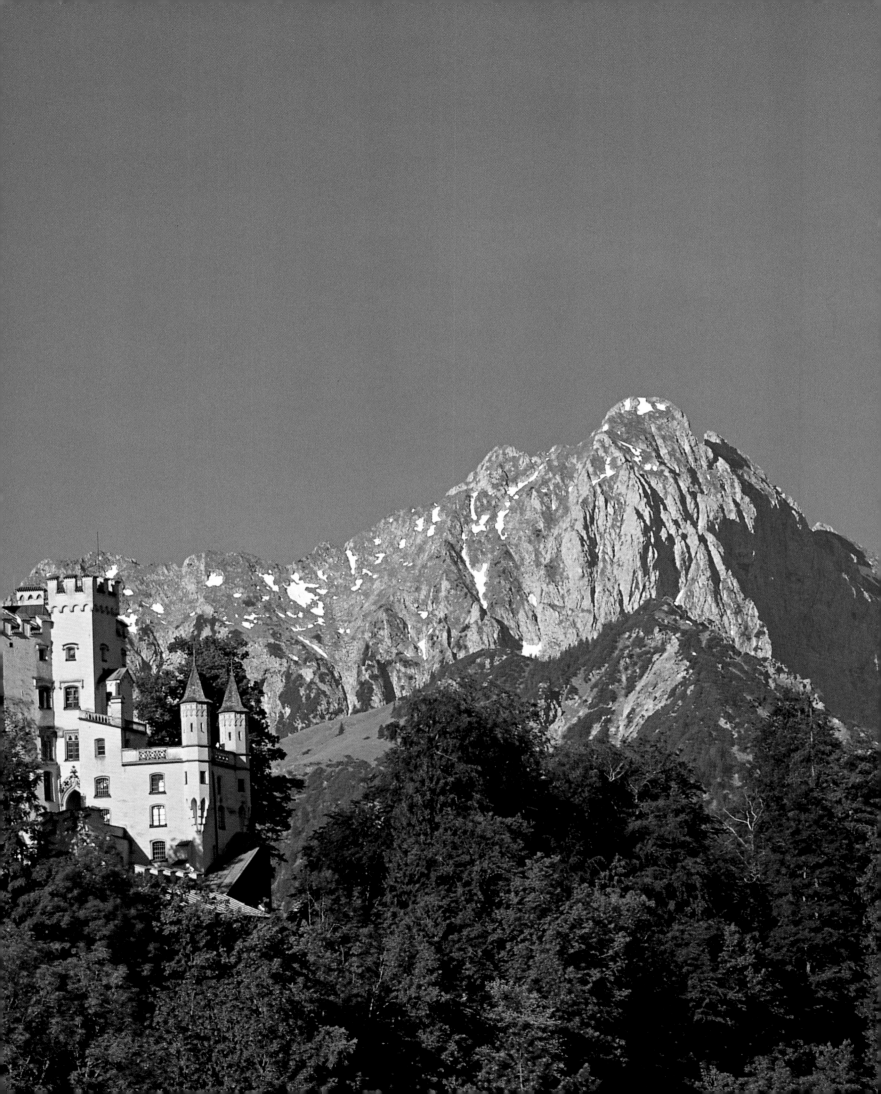

First page:
Stemless gentian (Gentiana clusii) with its purply blue, bell-like flowers which seem to grow straight out of the ground is a classic

Alpine plant which loves alkaline soils. The popular schnapps of the same name is distilled from the roots of the yellow gentian Gentiana lutea.

Previous page:
Schloss Hohenschwangau, scenically perched atop one of the foothills of Schwarzenberg Mountain, owes its present grandeur to extensive restoration work.

Below:
There are two types of regional costume in the Allgäu. One is a variation on the original Allgäu red waistcoat with silver

buttons, a traditional outfit which had become practically obsolete by the beginning of the 19th century. The other, also known as "mountain dress" or

"Gebirgstracht", originated in Upper Bavaria. The pilgrimage in Nesselwang is one occasion when both are put on proud display.

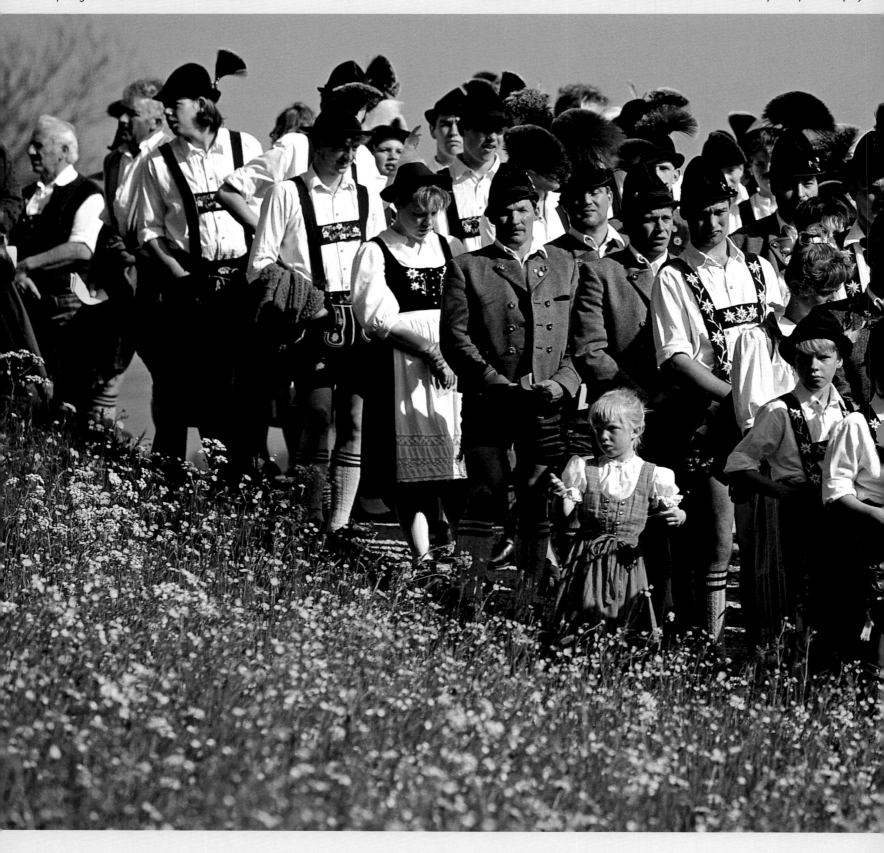

Contents

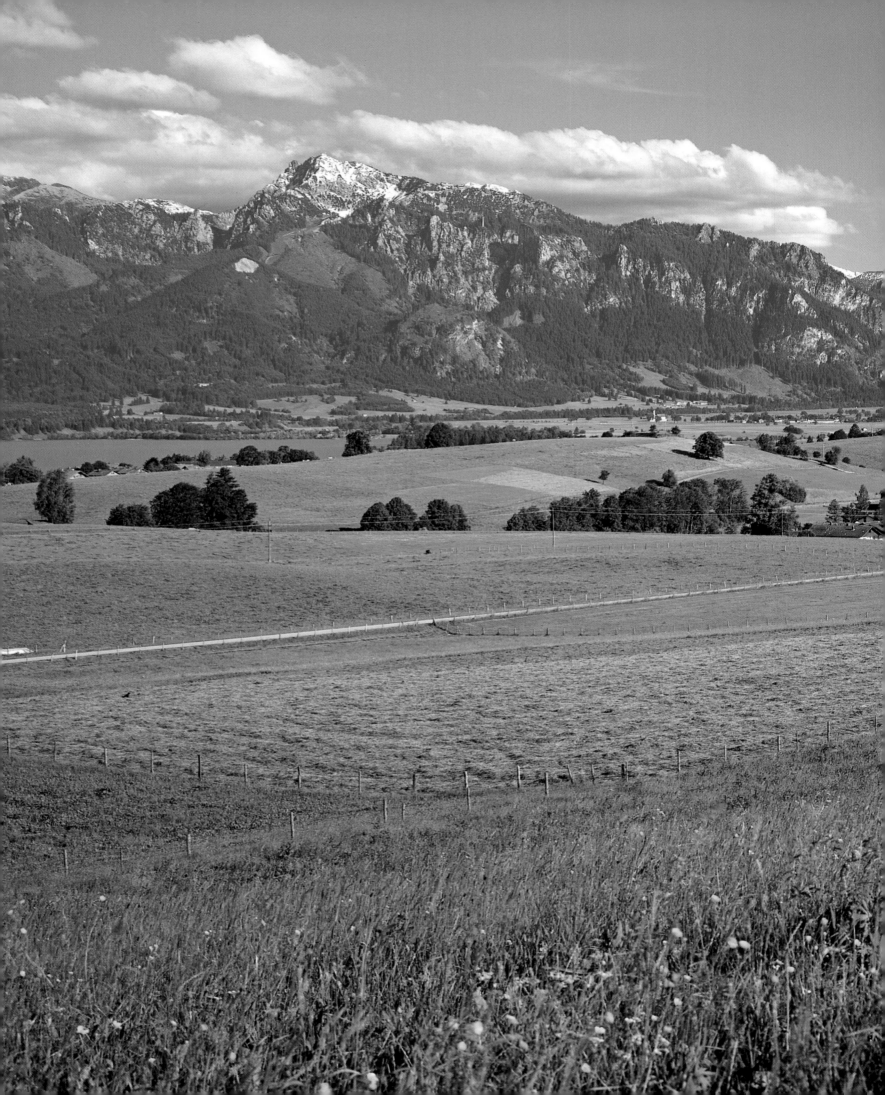

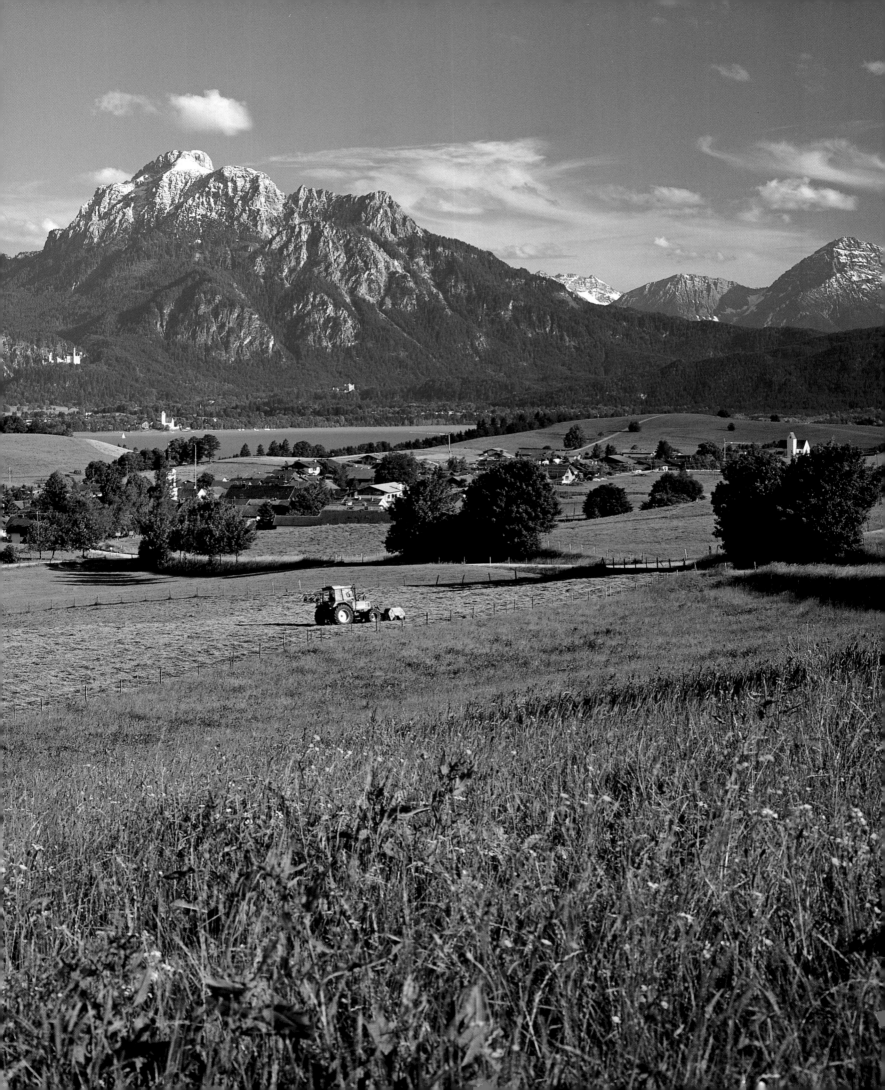

The Allgäu – Panoramic Magnificence

The cable car servicing the Fellhorn covers 1,000 metres (3,281 feet) in altitude on its journey up the mountain from the Stillach Valley. During the winter months skiers can also master the ascent using one of the many lifts in operation.

If you were to hear the word "Allgäu" in reference to Germany (or Baden-Württemberg or Bavaria), you might well ask where (or what) it is. The Germans themselves are also a little foggy on the exact geography of the region, for nowhere else in the country causes so much confusion when it comes to discerning local boundaries. Traditionalists will explain to you with great enthusiasm that the 'real' Allgäu is the area surrounding the towns of Immenstadt, Hindelang and Oberstdorf – and nowhere else. If in his or her presence the people of nearby Ravensburg, Lindau or even Augsburg have the audacity to refer to themselves as "Allgäuer", be prepared for a slinging match. You may be bemused by this display of provincial patriotism; to the people of the Allgäu this is a matter of the utmost severity. Historically speaking, the 'hardliner' definition pertaining to an area sometimes called "Urallgäu" is correct, as the first documents to mention the Allgäu in 817 refer to precisely this pocket of land on the northern edge of the Alps. In the course of time, however, the name has come to be applied to a larger swathe of country; most people today understand "Allgäu" to describe a part of Germany which has Memmingen and Mindelheim at its northern corners, Kaufbeuren and Marktoberdorf to the east, the area around Füssen and the Allgäu Alps to the south – including the Säuling, Hochvogel and Mädelegabel mountains – and Wangen and Bad Wurzach to the west.

Germany's southernmost region owes its name to its panoramic location at the foot of the magnificent Alps and to its great abundance of water. "Allgäu" is derived from "Albigaue", a compound of the words "Alp" or "Alb" ("mountain") and "Gau" or "Gäu" (pastureland rich in water). The Alemanni, who are presumed to have first used the term, chose the name well, for where else in Germany can you find lush green fields, rolling hills, sparkling lakes, roaring rivers and giddy slopes in such glorious harmony and profusion?

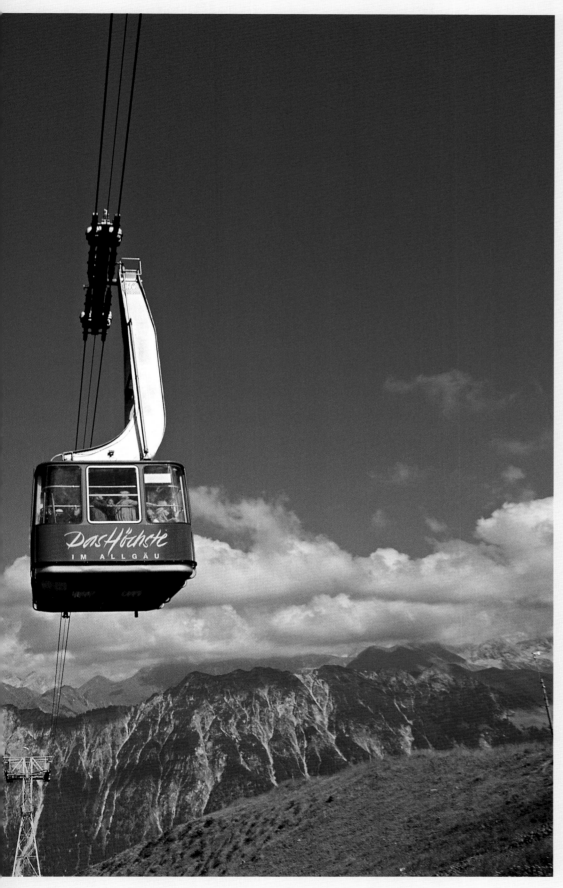

The ups and downs of the Allgäu

Endless chains of mighty mountains, tier upon tier of ancient stone deposits, craggy, precipitous walls of rock dotted with turquoise lakes which glitter like jewels in the sunlight: this is a landscape which has been moulded by millions of years of history. Time and again enormous massifs were created and destroyed, diverse layers of rock shunted together and torn apart, leaving wastelands of Alpine scree in their wake. Even today the Allgäu is still on the move, its geological evolution far from over.

The oldest witnesses to this turbulent past date back 280 million years when the first gneiss and granite mountains in what is now the Allgäu arose. In time these mammoth elevations were reduced to a flat desert of sand which was swallowed by an enormous ocean around 250 to 200 million years ago. Microorganisms, molluscs and snails were deposited on the seabed in layers several hundred metres high. These were later weathered away by relentless wind, rain and snow after sections of the seabed were exposed to the air c. 100 million years ago, creating jagged pinnacles of rock and gaping, vertiginous ravines. In some places, such as around Oberstdorf, ancient mud and silt made up the body of the land, in time forming smooth, keenly defined ridges and crests as opposed to the ragged, sawtooth massifs of the limestone Alps. Millions of years of geological unrest have resulted in bizarre combinations of rock, the different strata still clearly visible along many of the rock faces here.

The activities of the world underground weren't the only force behind the creation of the mountains; the glaciers, too, have played their part. About 20,000 years ago great swathes of ice, some up to 700 metres (2,290 feet) thick, surged across the peaks, flattening giant obstacles in their path or carving cavernous channels and basins out of the ground. Scree was deposited at the foot of the Alps far into the north, creating the gentle undulations which are so characteristic of the Allgäu. It was then that most of the valleys were formed, some cutting deep into the earth's crust, where today in some places the only reminder of the huge mass of water which once forced its way along the valley floor is a babbling brook.

A journey through time

These geological workings went on long before man appeared on the scene. The earliest human artefacts found in the Allgäu date back to the Stone Age (c. 5000 BC), but it is the Celts, who settled here in c. 500 BC, who were the first to make their mark on the region, 'founding' among other places the Allgäu metropolis of Kempten.

The tiny 14ᵗʰ-century chapel dedicated to St Bartholomew in Zell near Oberstaufen is rather unassuming viewed from outside. Once inside, however, you are treated to a splendidly carved high altar and richly ornamental frescos fashioned by Memmingen artist Hans Strigel.

The Celts were driven out of the area in 15 BC by the Romans seizing control of the foothills of the Alps and the area south of the River Danube. By establishing several important trade routes, such as the Via Claudia which ran from Rome via Füssen to Augsburg, the Romans built up an important infrastructure which was to connect the Allgäu to the outside world. Yet the Romans also didn't survive here for long. In the middle of the 3ʳᵈ century AD the Alemanni, a conglomerate of Germanic tribes (Alemanni = "all men"), forced their way through the Roman Limes or line of defence from the north, seizing land and territories right down to the edge of the Alps.

300 years later the Alemanni were in turn defeated by the Franks and subjugated to their rule. It was then that the Allgäu began its long conversion to Christianity, with the abbey of St Gallen at the helm. At this time the peasants were still their own lords and masters on their own turf; in times of war, however, they were obliged to serve their ruling superiors. The long periods of absence on these occasions (which were many) meant that countless farms and holdings went to rack and ruin. Many were forced on their return to cede their land and estates to the local nobility, bishops and monasteries whose assets grew acre by acre until between them the upper strata of society owned practically the entire Allgäu. Finding themselves at a great advantage the tribal lords and monasteries took on a new importance after the decline of the Frankish Empire. The magnificent sacred buildings in Füssen, Kempten and Ottobeuren still bear witness to this age of power and prosperity.

In the era which followed, the 12ᵗʰ century, the Staufer dynasty came to power and with it Swabia as the nucleus of the Hohenstaufen empire. This brought with it a number of new privileges; Isny, Wangen, Kempten, Leutkirch, Memmingen and Kaufbeuren, for example, were all granted a town charter – although at the time they were not part of the Allgäu. Economically the region gained in significance during the Middle Ages; the discovery of iron ore at Grünten Mountain, the harbinger of the Allgäu Alps, and elsewhere gave rise to a new branch of industry: the production of ironware.

The processing of this precious natural commodity required vast quantities of wood, taking its toll on the forests which soon posed a threat to the local populace and wildlife. Many processing plants thankfully switched to water power so that in time the forests were able to recover. During times of peace the factories manufactured machines for agricultural and constructional use; in the event of war their output focussed solely on the production of weapons. Today the Allgäu metal industry still thrives and is a major pillar of the economy.

The church and the nobility were still the undisputed rulers of the land and time and again exerted great pressure on the towns and communities under their command. In an attempt to put an end to this totalitarian rule and to even out the distribution of power many of Swabia's towns and monasteries joined forces in the 15th century to form the Swabian League. After heavy fighting the emperor ordered the insurgents to disband in a dictatorial display of imperial might. Nothing had changed; the old leaders were yet to be moved.

The Allgäu failed to settle; on the contrary, the next century was to prove the bloodiest in its history. This time it wasn't the towns and monasteries who were a thorn in the side of the overlords; it was the rural population who took up arms and marched off to fight the Peasant War in 1525. There were many reasons for the revolt; one was that the nobles and clerics were constantly curtailing the peasants' traditional rights of access to the land they lived on. The farmers no longer had free use of the forest to collect firewood and building materials; they now had to apply for permission to the local potentate who usually watched the goings-on on his estates like a hawk – and was more often than not extremely mean in his dealings with his underlings. Jurisdiction was also no longer a matter for the local court; the aristocracy or church were now responsible for the application of the law. This meant that if members of the rural community were in dispute with those in authority they could expect harsh punishment. This weakening of their legal security was compounded by tighter regulations governing the manorial system and serfdom. The peasants now had their freedom considerably curtailed and found themselves in dire economic straits. In an effort to topple the old order in the hope of a better existence the peasants formed a league, organising themselves into groups and issuing their demands in the Twelve Articles. The powers that be were naturally not amused and responded with violence. The war which followed was horrific, costing several thousand lives. Despite making a number of initial gains

the peasants soon proved no match for the military superiority of their opponents and were bitterly defeated. In many regions this led to further infringements of rights for the rebels; only in a few areas were the peasants' demands met.

After the tumult of war the next hundred or so years were relatively quiet for the Allgäu as far as politics was concerned. But then came the Thirty Years' War. The Swedes, headed by Commander Wallenstein, raped, burned and pillaged their way through the Allgäu – and elsewhere. Entire towns, castles, monasteries and churches were razed to the ground. The region was also racked by the bubonic plague which claimed hundreds of lives; many of the chapels and cemeteries built to accommodate the dead still exist. This period, in which thousands met a terrible end, must be one of the worst in the region's history. Kempten alone, which before the beginning of the war in 1618 had 6,000 inhabitants, numbered just 900 survivors 30 years later.

The blossoming of the baroque

The 18th century was a much less violent affair with the tidal wave of destruction being replaced by gentle ripples of architectural activity throughout the region. A great number of monasteries and seminaries were erected and churches and chapels elaborately restored, many in the playful decor of the baroque. The Allgäu didn't blossom for long, however. As a consequence of the French Revolution the area was secularised, with churches and convents being sold and turned into flats, prisons and market halls, unique works of art being auctioned off or handed over to manufacturers as 'raw materials' for reprocessing. Valuable books from monastic libraries were vandalised or shredded and used to make recycled paper. To add insult to injury many of the Allgäu's priceless treasures were carted off to Munich, the capital of Bavaria, as the result of a decision made in 1803 by a special "Reichstag" commission dividing up Napoleonic territories in Germany in which the elector of Bavaria was made king.

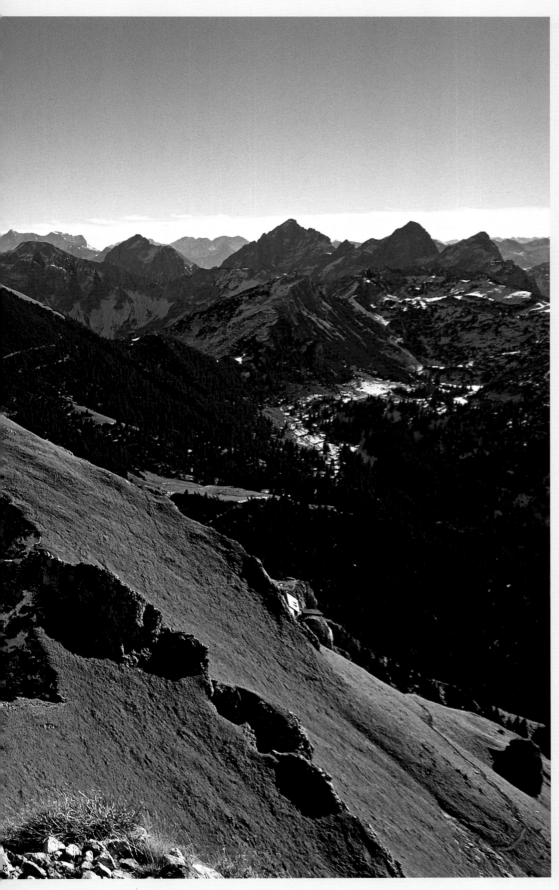

Culturally the 19th century brought little of value to the Allgäu; financially, however, the area experienced something of a boom. Dairy farming in the region had to date played a minor role, with enough milk and meat being produced to satisfy local requirements only. This was a form of agriculture which was not commonly practised in the valleys, however, where pastureland was extremely limited, but up in the mountains. As most farmers only had a few bulls or dairy cows it would have been totally unviable to put 'herds' of three of four animals out to pasture alone. Instead the Allgäu developed an early and efficient agricultural system in which the village farmers pooled their resources and swore in an "Alpmeister" or master herdsman who was entrusted with the care of their animals over the summer months. The elected cowherd then spent June to September in the mountains with the cattle who had ample space and plenty of lush pastureland to graze. The setup proved even more profitable when it was discovered that the various herbs growing in the Alpine meadows strengthened the cows' immune systems. Many of the mountain pastures or "Galtalpen" were devoted to the rearing of young animals; only on the "Sennalpen" where the dairy cows were farmed was cheese produced for local consumption. Farming up in the mountains was by no means without its dangers. Animals often lost their way and had to be led back to the herd in a feat of daring, with the occasional beast falling off the mountainside and plunging to its death hundreds of feet below. The return to the village of both "Alpmeister" and animals was thus awaited with great trepidation each year. Once all of his charges had been brought safely back to the valley a wreath of flowers was placed on the head of the prettiest animal. This tradition, known locally as "Viehscheid", has lost none of its significance – although the cows in all their floral splendour are often lost in the crowds of spectators eager to join in the celebrations.

From blue to green Alps

At the beginning of the 19th century dairy farming was a means to an end, providing a farmer and his family with necessary foodstuffs. Most of the work was done up in the mountains with little trace of it down in the valleys. The fields of the Allgäu during this period weren't green but blue – the blue of flax which was used to make linen. Its cultivation and processing proved such an important source of additional income for the farmers that the region came to be known as the "blue Allgäu". When the farming of flax was made economically redundant by the introduction of English cotton the majority

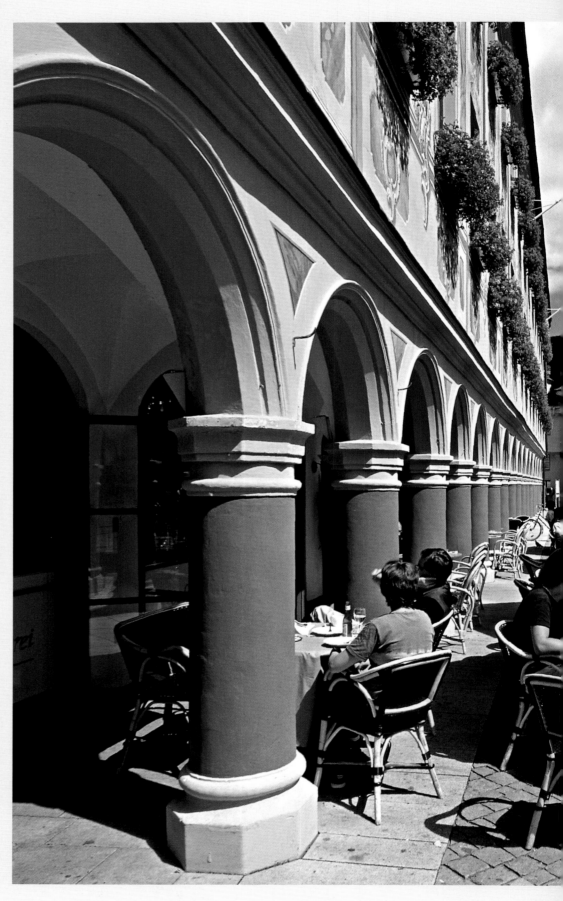

The Steuerhaus or tax office with its beautiful arcade on the market square in Memmingen was originally a shoe shop built to replace a jumble of market stalls. A café and several boutiques now share this exclusive location.

of the farming population found itself in financial crisis. Help was on hand, however. New methods of fertilising, new varieties of animal fodder and new breeds of cattle opened up a great new avenue: dairy farming! The pioneers of this new branch of Allgäu industry were Swiss dairy farmer Johann Althaus and merchant Carl Hirnbein from Wilhams near Isny who made it their aim to create a cheese which could be preserved for a long period of time. The cheese manufactured to date in the small Alpine farms was highly perishable and thus not suitable for sale on any grand scale. The two cheesemakers persevered in their endeavours until they found a way of conserving milk for the first time ever. News of their innovation spread like wildfire; with many farmers struggling to survive, this was a more than welcome means of making a living. At the beginning of the 20th century a butter and cheese trade hall was set up in Kempten, cementing the region's new image as the "dairy of Germany". The blue flax fields of the 19th century gradually disappeared, with the green Alpine pastures which characterise the area today taking their place. With them came a second distinguishing feature of this part of the country: the isolated farms built to service pastureland outside the villages by farmers hoping to reduce their workload by having their fields close at hand. This custom began in the 16th century: many of these original chalet farms are still dotted about the countryside today.

The second major source of income for the people of the Allgäu is tourism. There's hardly anybody here who doesn't let out a holiday cottage or at least offer bed and breakfast – especially in the southern part of the region. The tourist trend began in the mid-19th century when the first summer visitors arrived to take the mountain air. Some were local; many were not. The addresses inscribed in the guest books proudly kept by the first chalet owners included the distant North German metropolises of Hamburg and Berlin; even places as far afield as Moscow and Chicago featured. The number of holidaymakers grew rapidly and with it the importance of tourism to the region. More and more holiday accommodation was arranged, roads and hiking trails were laid out, chair lifts and cable cars built and taverns and inns opened to cater for hungry wanderers. The

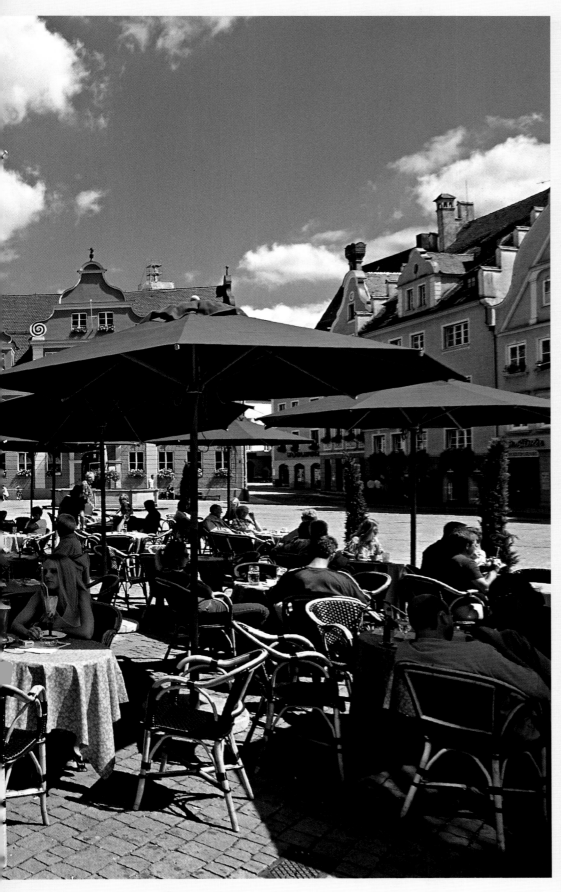

Allgäu is today still extremely popular and has much to offer its guests. Here you can go hiking, climbing, mountaineering, cycling, mountain biking, hang-gliding, paragliding, canoeing, rafting, swimming, skiing, snowboarding and cross-country skiing – or simply relax in a sauna, whirlpool or mud bath at one of the many spas. With so much going on, it's often busy here; there are quiet, secluded spots but you have to know where to look ...

The people of the Allgäu have realised just how important an intact, functioning and varied natural environment is – both for locals and visitors alike. Many of the farmers working the land here thus see themselves not just as manufacturers of milk and meat but as conservationists keen to deploy ecologically-sound methods of farming the Alpine slopes and pastures in an attempt to preserve this unique and historic cultural landscape for many generations to come.

The people of the Allgäu and their dialect

In the hope that these noble endeavours are continued, future generations of visitors will no doubt use the same battery of superlatives to describe the breathtaking scenery which awaits them as they alight from their journey. The "Allgäuer" themselves will probably respond to these gushing effusions with a mere affirmative grunt. The people here are not famous for their verbosity. Praise is also not a concept commonly applied to their use of language. They are men and women of few words, often said to be rather stubborn, solitary and even eccentric – which if you've grown up or still live on an isolated farmstead is hardly surprising. To be treated with such chill is, however, now rare; most of the people here are genuinely warm and friendly, keen to help and eager to please. Cosmopolitan visitors from the big cities may occasionally find their country cousins a little too bumpkin-like but this is not taken as an insult here. On the contrary: the people of the Allgäu are proud of their heritage and readily identify with their traditions and customs and the absolutely fantastic part of the country they are lucky enough to inhabit.

When some of the older generation, in a rare moment of conversationalist verve, do open their mouths to speak, the lingo proves as unique as the landscape. It is indeed so unique that no two villages share the exact same dialect. To speak of an Allgäu dialect at all is a contradiction in terms. In many of the towns, villages and valleys here very different forms of pronunciation have evolved, many with their own words and expressions. The trained ear can thus immediately recognise where somebody

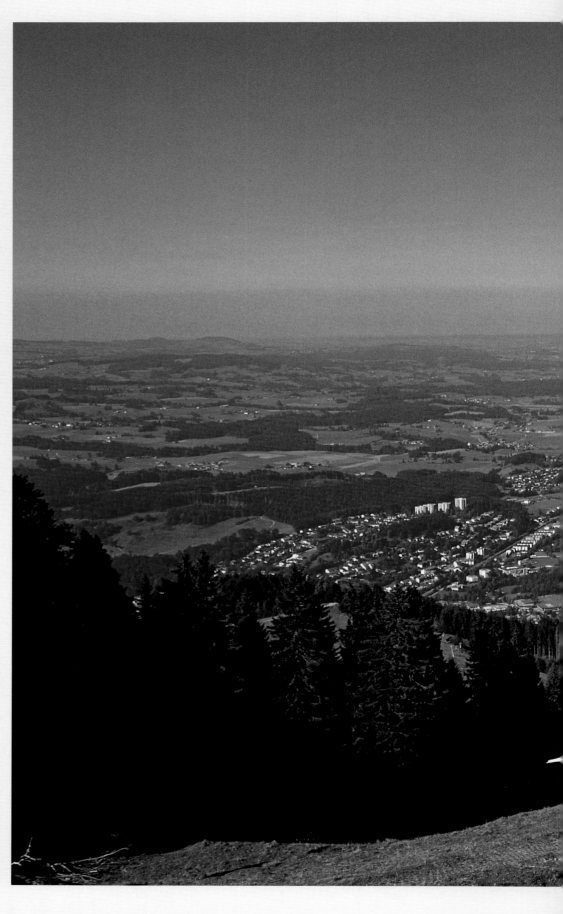

The Mittagberg south of Immenstadt is extremely popular with hang gliders and paragliders. Enthusiasts can enjoy breathtaking bird's eye views of the Allgäu on flights which can last several hours and cover no less than 100 kilometres (60 miles).

comes from; telling the difference between the patois of Füssen, Memmingen, Hindelang or Isny is no problem for a local. The reason for this is that the Allgäu is where two linguistic groups meet: Alemannic and Swabian. South and west of the imaginary border running between Wangen, Isny, Immenstadt and Ostrach Alemannic dominates; north and east of this the Swabian variant is spoken. The difference between the two is huge and has its roots in hundreds of years of linguistic development. If you're struggling to cope with your school German, the often impenetrable utterances which may greet you here could leave you completely stumped! But take heart: other German native speakers also have trouble discerning the words of their southern neighbours, probably adopting the same troubled expression as a Londoner in Glasgow or a Bostonian in the Deep South of the USA. And don't worry; most people here speak some, if not excellent, English and will be more than delighted to help you out when you're puzzling over a local menu or trying to find your way to the nearest mountain chalet ...

Page 22/23:
In the River Wertach basin at the foot of the Alpspitze lies the little town of Nesselwang. It was once traversed by a major Roman road, encouraging traders, merchants and innkeepers to set up shop here. Today Nesselwang is one of the most famous health resorts in the Allgäu.

Page 24/25:
Legendary Schloss Neuschwanstein lies shrouded in fog at the foot of Säuling Mountain, high up above Füssen and the Forggensee. The fairytale palace was begun in 1869 and was to be the ultimate Romantic interpretation of the medieval fortress. It was never finished; the necessary funds expired together with its owner, King Ludwig II of Bavaria, in 1886.

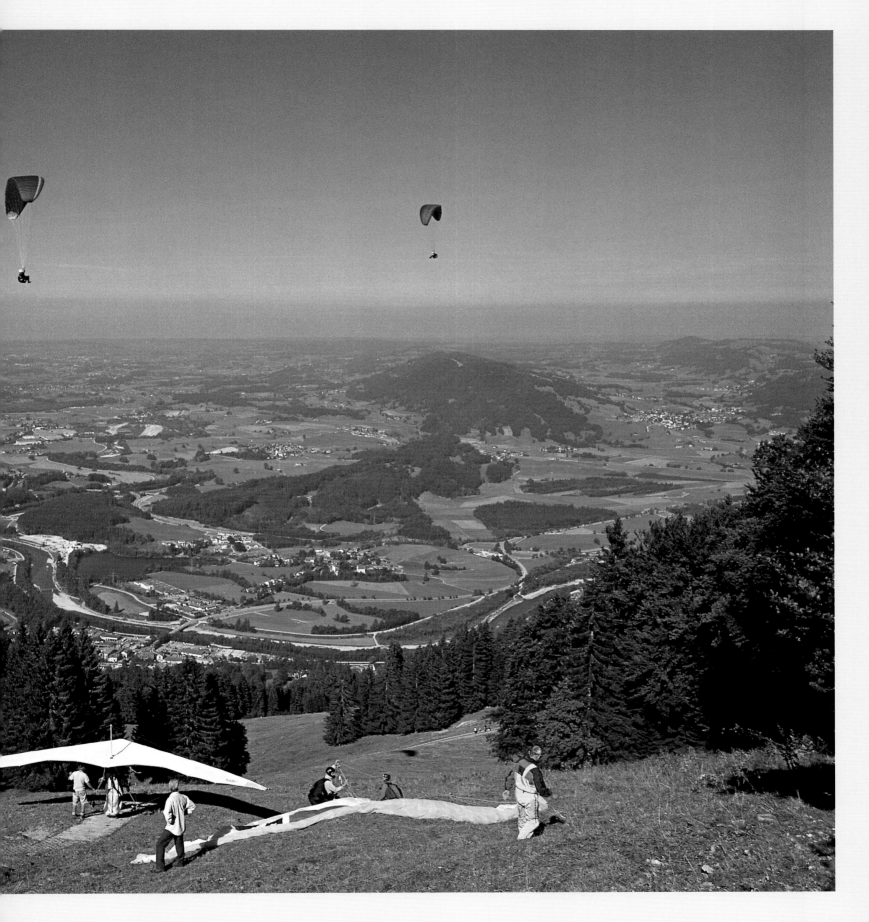

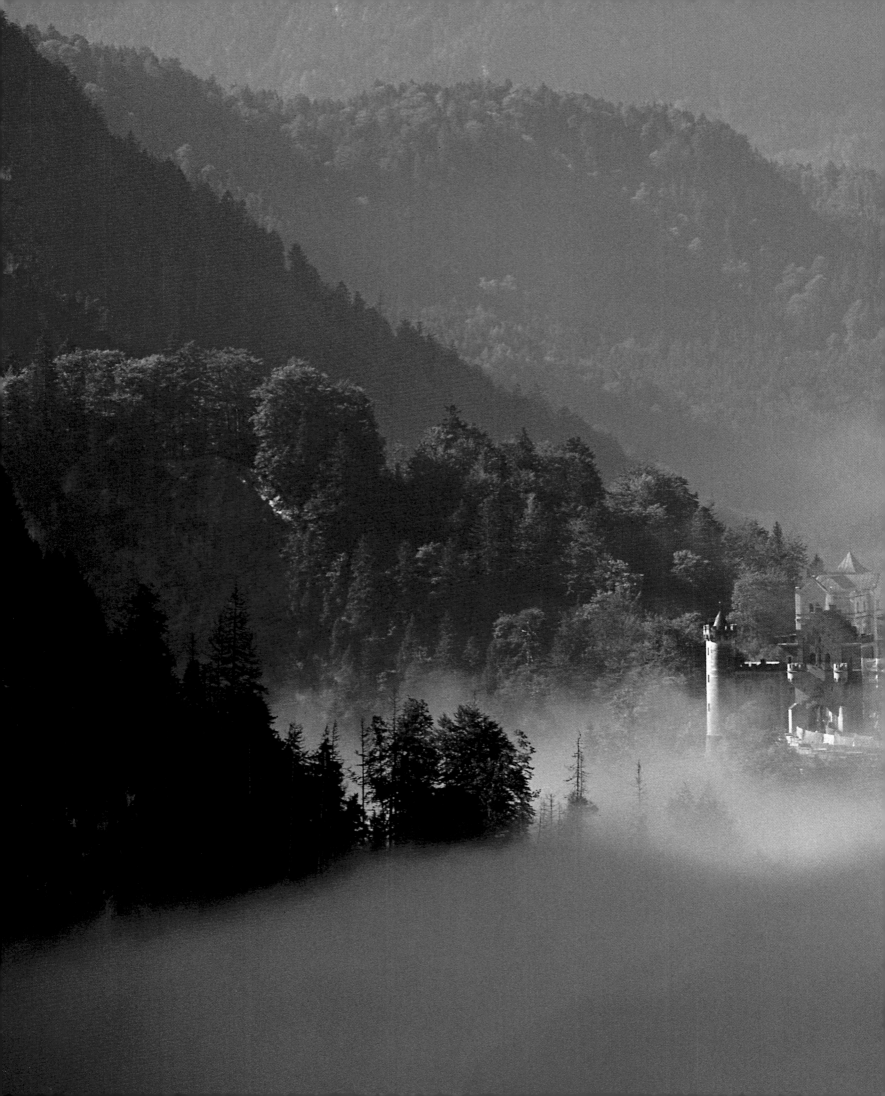

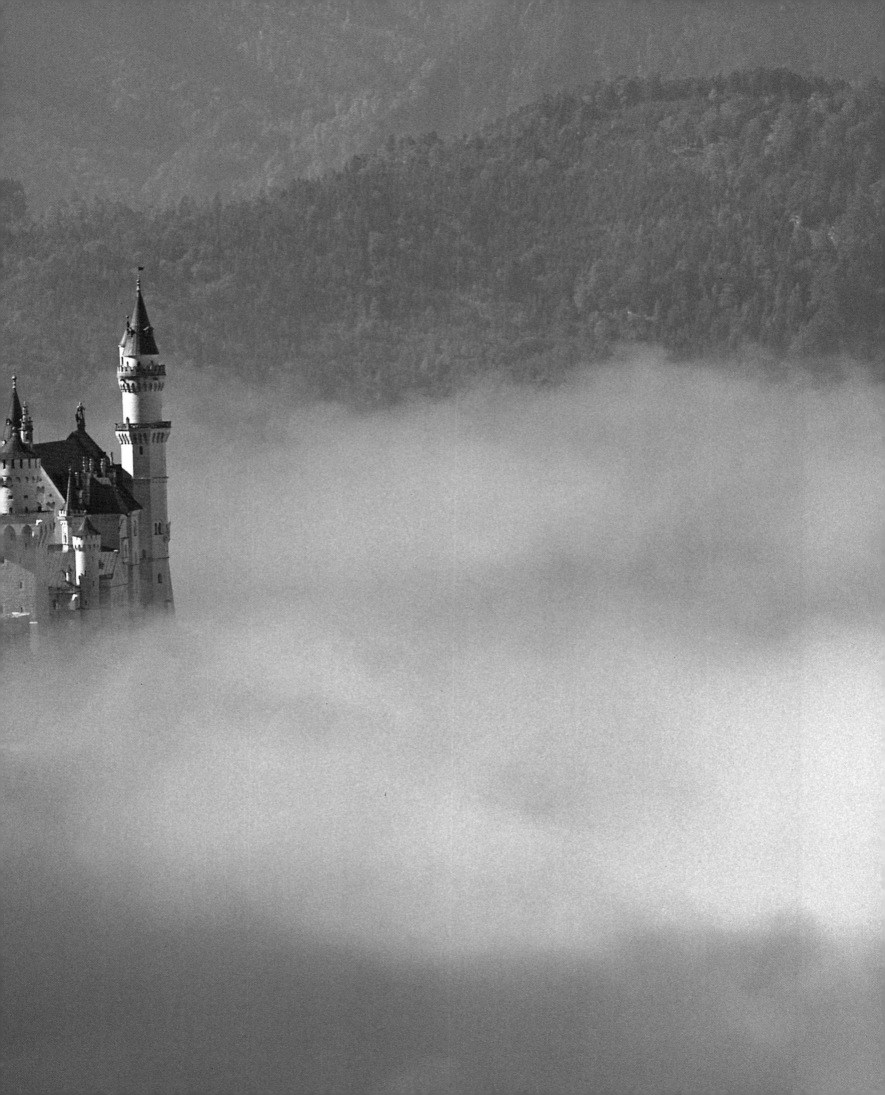

Rolling hills and architectural gems – the North Allgäu

Ottobeuren is a small market town in the north of the Allgäu with a historical centre. The latter is often overlooked, however, as Ottobeuren is primarily famous for its baroque monastery which draws huge crowds of visitors from all over the world.

The charm of the North Allgäu lies in its gently rolling hills and glistening rivers and streams which have carved their way through the Ice Age scree deposited here by giant glaciers. This scenic diversity is enhanced further by a colourful tapestry of forest, fields and meadows of wild flowers. The soil here is rich and fertile and has been used as grassland for generations. Everywhere you turn there are cows contentedly grazing green pastures, hay barns waiting to be stocked up for the winter and chalet farms dotted about the landscape. This is also a land of castles and ruins, churches and chapels and romantic towns and villages.

The "gateway to the Allgäu" is the proud epithet the second-largest town in the region has given itself: Memmingen, founded in the 12th century, whose patrician town houses and places of worship bear witness to the former glory of the old free city of the Holy Roman Empire. One of the region's architectural gems is the baroque basilica at Ottobeuren, famous well beyond the boundaries of Europe. This imposing edifice with its mighty towers is impressive from the outside but only really unfolds its full magnificence when you enter the building. The interior is an orgy of virtuoso ceiling frescos, fine stucco work and elegant statues embedded in a riot of colour. The metropolis of the North Allgäu is Kempten, an ancient Roman settlement notable for its split-level location. The older, secular part of town hugs the banks of the River Iller, with its 14th century town hall and spacious town square which is dotted with cafés and lined with historic buildings; above it towers the younger baroque quarter which sprang up around the monastic church dedicated to St Lawrence. The little town of Bad Wörishofen is dominated by its monastery and spa and has morphed into a resort of international renown thanks to the curative treatments developed by one Sebastian Kneipp.

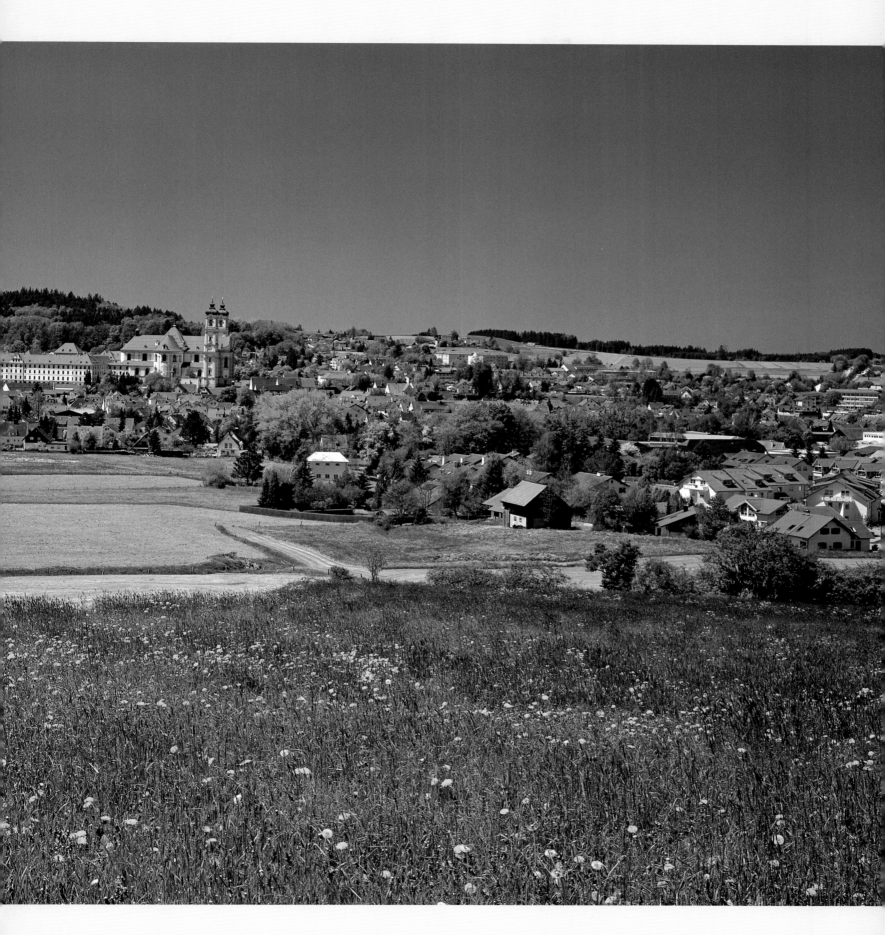

Below:
The Basilica of St Alexander's and St Theodore's at Ottobeuren's Benedictine monastery is a church and a half; its dimensions are huge (90 metres / 295 feet long and 80 metres / 263 feet wide) and its interior incredibly ornate, boasting a colourful baroque multitude of elaborate stucco, expressive frescos and an unbelievably decorative pulpit, all of which enjoy acclaim the world over.

Top right:
The Annakapelle is part of the Carthusian monastery in Buxheim near Memmingen. Founded in the 16th century, it was refurbished by the famous

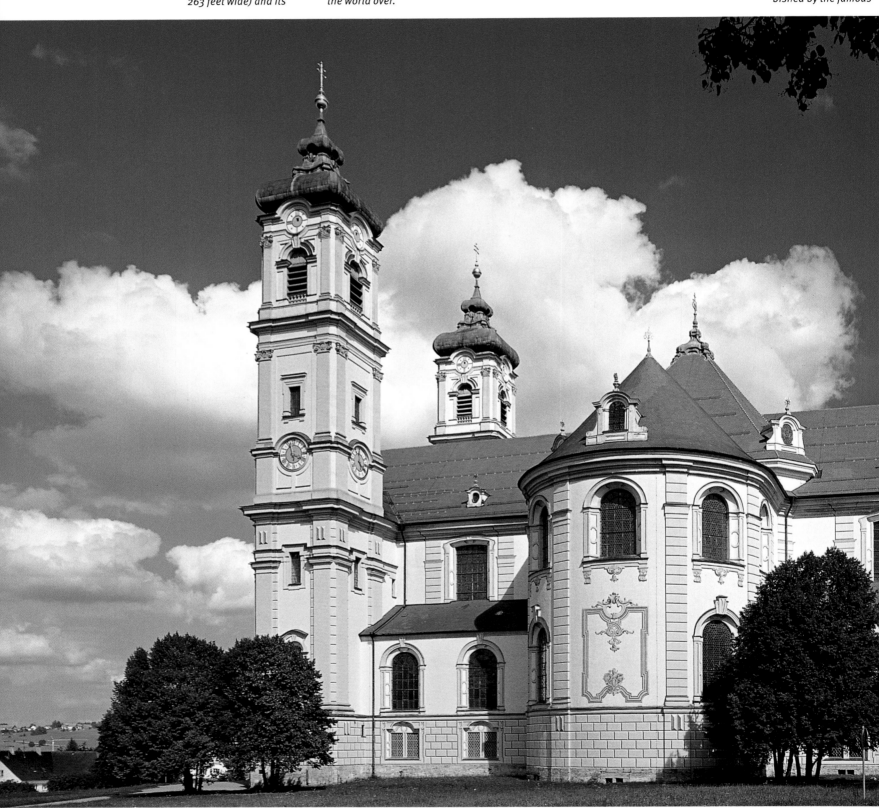

Dominikus Zimmermann from 1738 onwards and reborn as a jewel of the baroque, complete with fine stucco work, marble pillars and majestic statues.

Bottom right:
One of the major attractions of the Carthusian monastery at Buxheim are the choir stalls, an incredibly filigree work of art by Iganz Waibl and one of the most significant carvings of the Southern German baroque. Following the dissolution of the monastery in the 19th century much of the choir was shipped first to Holland, then France and finally England. The choir stalls were only returned to their original setting in 1980.

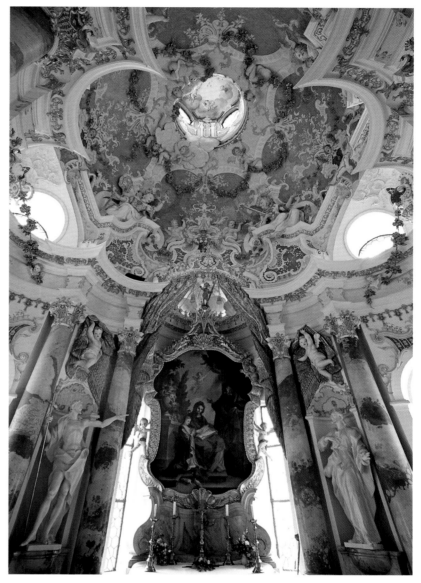

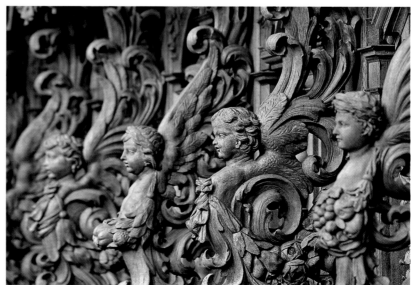

At the heart of the Lower Allgäu, between Memmingen and Ottobeuren, the Kronburg has defied over 800 years of turbulent history. It housed rebels during the Peasant Wars, Wallenstein's Swedish troops during the Thirty Years' War and later French soldiers during the War of the Spanish Succession. The 12th-century castle is now one of the best preserved in the Allgäu.

Right and far right:
The open-air museum in Illerbeuren is a village within a village, where the ancient farms, stables, barns, workshops, bakery, chapel and many other buildings are an integral part of the village proper.

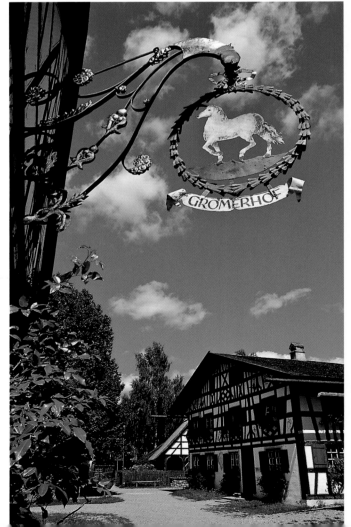

The interiors of the old farmsteads at the open-air museum have been painstakingly reconstructed, giving visitors a good impression of what life must have been like all those years ago.

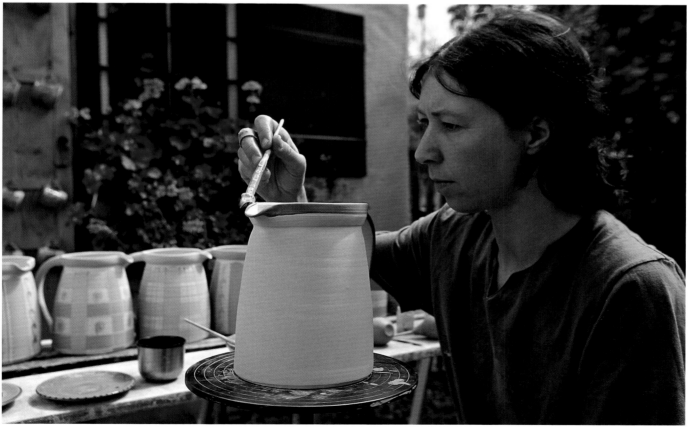

A demonstration of ancient crafts at the farmhouse museum founded in 1955 and affiliated with the open-air museum in Illerbeuren. Potter Sylvi Schwarzmann is making earthenware jugs according to old-fashioned methods.

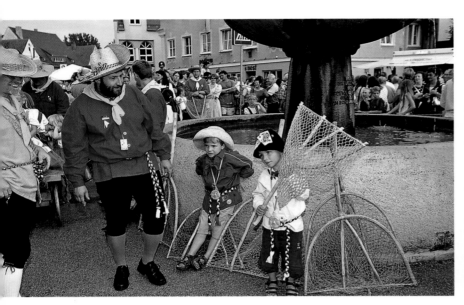

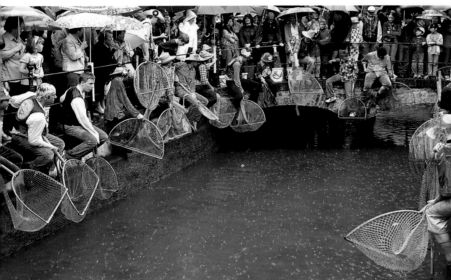

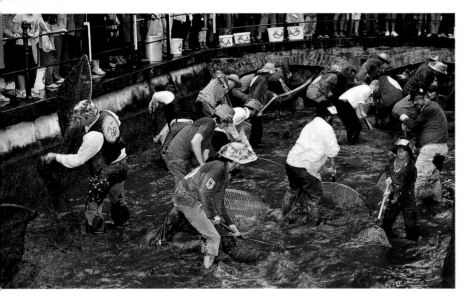

Small photos, left:
Once a year on a Saturday morning at the end of July Memmingen wakes up to the "Fischertag" or "day of the fishermen". At eight o'clock sharp hundreds of hardy locals leap into the river amid much ado to empty the water of trout using a simple fishing net. The women wait at the side of the river with buckets to collect the catch. At midday the trout are weighed and the person with the heaviest fish is crowned the fisher king amid much ceremony and celebration.

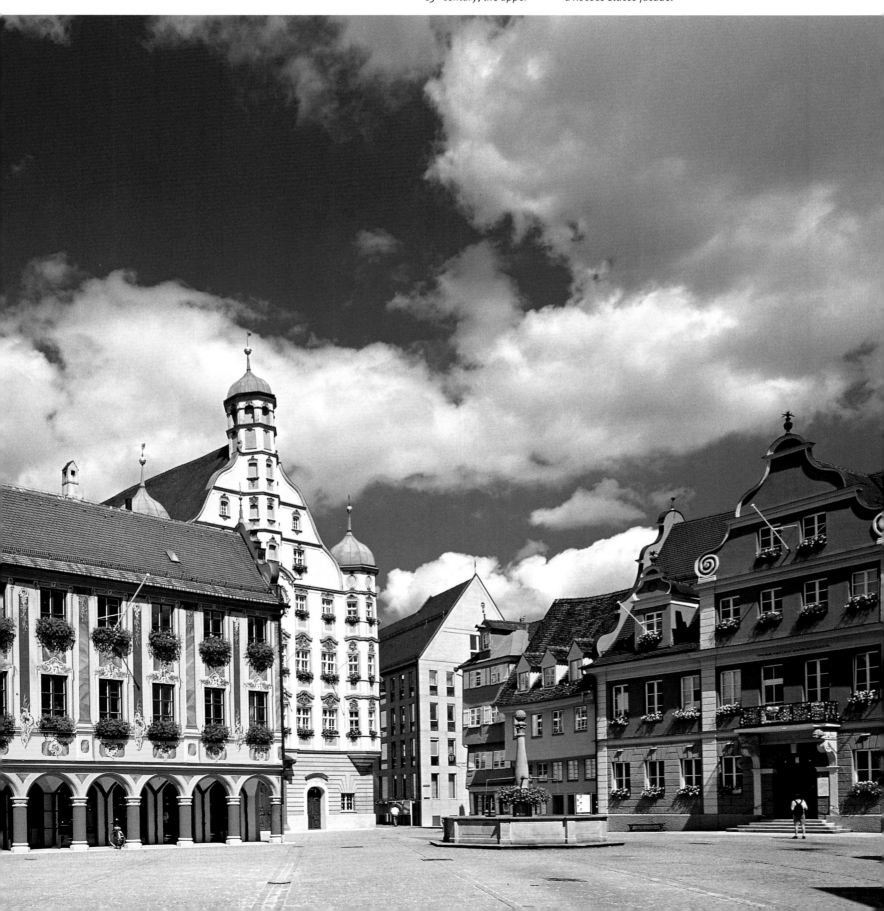

Below:
The Steuerhaus flanks the north side of the market place in Memmingen. The ground floor of the beautiful edifice with its stylish arcades dates back to the 15th century; the upper floors and attractive Rococo facade are 300 years younger. Set back to the right is the town hall, a four-storey Renaissance building with turrets and a Rococo stucco facade.

Right:
Schloss Mindelburg in
Mindelheim was begun
during the 12th century.
It was rebuilt and refur-
bished many times, such
as in the 15th century by the
lords of Frundsberg and at
the end of the 19th century
by Ludwig Schramm. It's
now leased out to various
commercial enterprises
and only the keep is open
to the public.

Below:
The many crucifixes dotted
about the wayside in
the Allgäu are pious testi-
monies to the devout
Catholicism of the local
populace which is upheld
in many traditions, festi-
vals and processions.

Below:
"One hour's walk to Zell"
is the inscription on this
milestone near Kronburg
Castle, helping many
generations of wanderers
to find their way about the
idyllic countryside.

Right:
The old market place in
Mindelheim, now Marien-
platz, is dominated by the
deep red of the town hall,
once the weavers' guild.

Thefacade was redesigned
in the style of the Renais-
sance in 1897. The statue
in front of it is of Georg
Frundsberg, the "father of
the lansquenets".

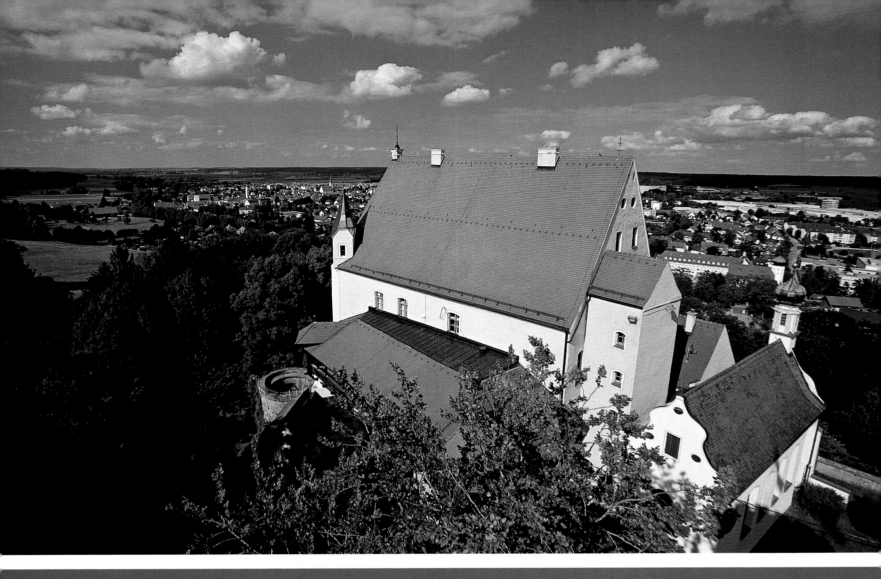
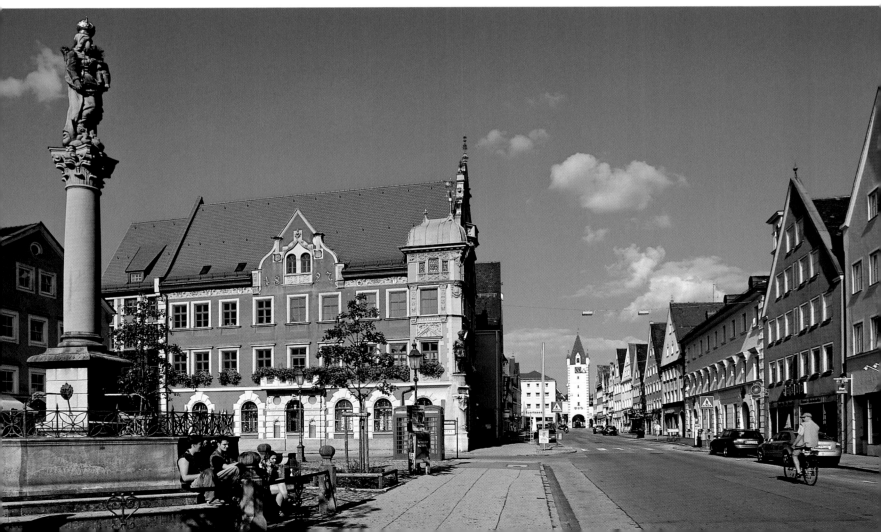

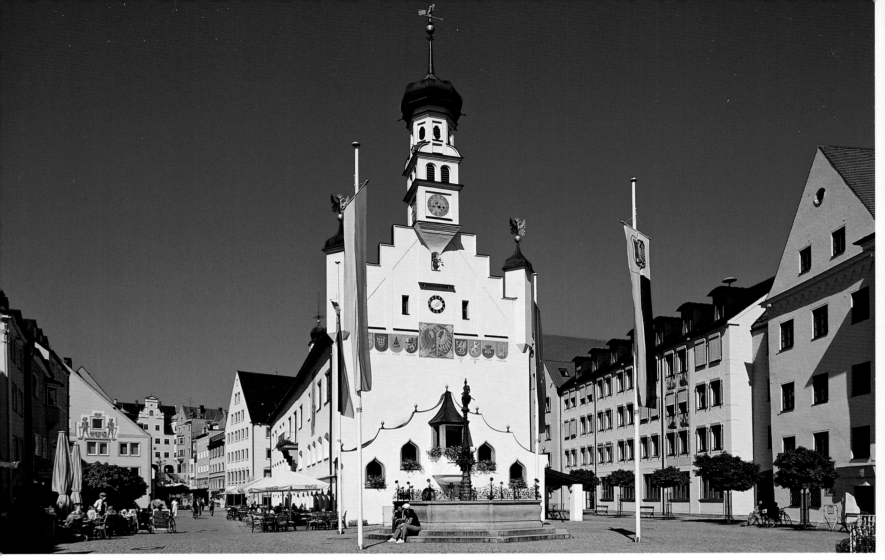

Above:

This impressive town hall
with its gleaming, turreted
facade forms the centre-
piece of Kempten's market
place. Dating back to the
15th century, the original
half-timbered building
was initially used as a
grain store. It has since
been revamped many
times, most recently
during the 19th century.

Right:

To the west of Kempten
atop a hill once surrounded
by the River Iller stands a
ruin with a long history.
The first construction on
this site was a Roman fort
built to thwart attacks
from the Alemanni. A pro-
tectorate was later erected
in its place which was
frequently destroyed and
rebuilt.

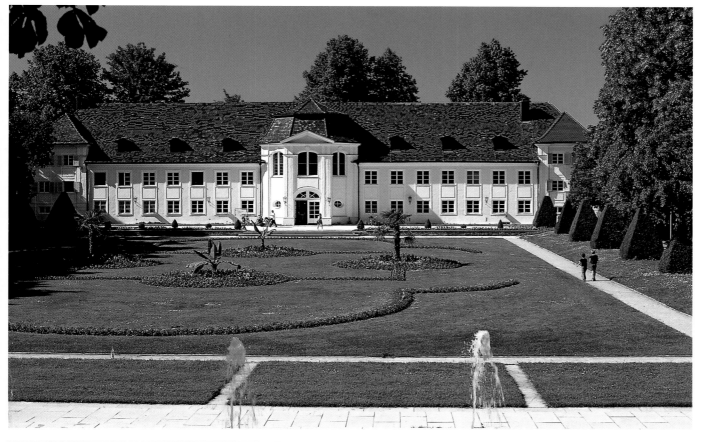

Left:
The orangery was the finishing touch added to the terraced royal gardens in Kempten in 1780. It now houses the city library.

Below:
Encircled by an ensemble of historical buildings made up of the orangery, former royal stables, collegiate church of St Lorenz and the residential palace the royal gardens (Hofgarten) still effuse an enchanting baroque charm.

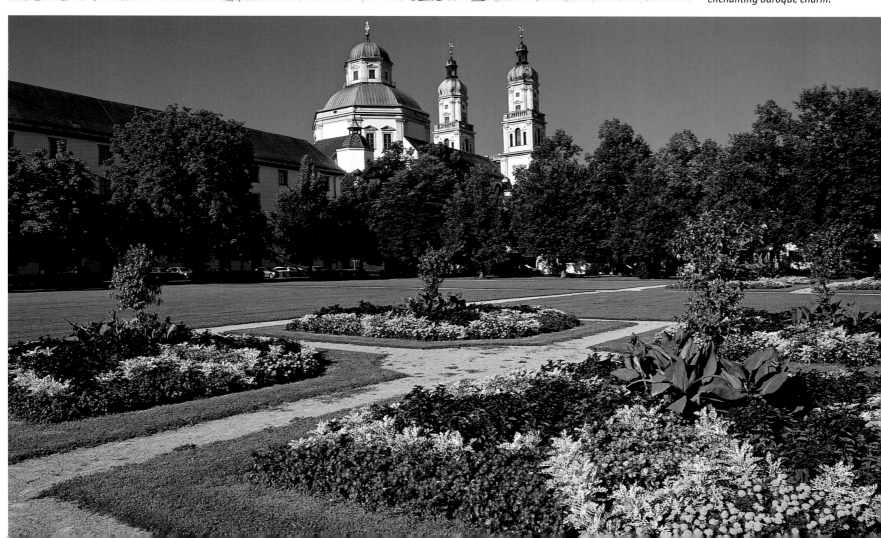

The "inventor" of wellness – pastor Sebastian Kneipp

Kneipp societies, Kneipp baths, Kneipp cures, Kneipp teas, Kneipp cosmetics: Kneipp is to holistic healing what aspirin is to orthodox medicine. The teachings and practices of Allgäu pastor Sebastian Kneipp are well known not just in Germany; throughout Europe and beyond his pioneering treatments have brought relief to many sufferers.

Fame – which continues long after his death – is something the son of a linen weaver from Stephansried near Ottobeuren had to work hard for. Born into relative hardship in 1821, there was no money for a good school education, with Sebastian instead frequently having to help his father at his trade. In his time away from the loom the literate weaver taught his son to read, write, add up and subtract but his intelligent and talented prodigy soon proved too clever for him. Herr Kneipp Senior began looking for a sponsor for his son's study fees. His search was long; it wasn't until Sebastian was 21 that one Herr Merkle, later a professor of moral theology, agreed to take the young man on and give him private tuition. Sebastian flourished and was soon able to fulfil his greatest ambition: to study theology. Yet despite being extremely adept and motivated Sebastian sadly couldn't devote his full energies to his studies; since a young boy he had been racked by tuberculosis of the lung. His illness became so serious that he began experimenting with water treatments in an attempt to lessen his affliction, inspired by the theories of Sigmund Hahn who in the mid-18th century had studied the use and effects of water. Kneipp's endeavours bore fruit and the word of his success spread. He soon had his fellow students asking him to heal their various ailments.

After graduating Kneipp moved to Boos near Memmingen. When a cholera epidemic broke out he selflessly dedicated himself to the sick, earning him the nickname "Cholera Chaplain". A year later he was made director of the girls' convent school in Wörishofen. In addition to his pastoral duties he continued to experiment with the curative properties of water in the convent wash room. He gradually developed a comprehensive form of therapy which was not limited to the application of water alone; medicinal herbs, sufficient exercise, a simple, healthy diet and a strict way of life became further essentials of the Kneipp doctrine. In it patients are not just subject to applications of hot and cold water, to hay compresses, herbal baths, saunas, teas, herbal juices and wholefoods; they are also encouraged to participate in gentle physical activity and to follow what is known as a "therapy of order". This is Kneipp's term for what we now call 'wellness', which in his view entails the leading of a harmonious existence which keeps to a specific rhythm and routine and is at one with a person's spirit and surroundings. This regularity aims to help the individual enter a state of equilibrium which benefits his or her physical and mental wellbeing.

An eminent authority on natural remedies

The success of Kneipp's ideas spoke for itself. Although at first accused of amateurism and officially reprimanded by the bishop for 'moonlighting', at the beginning of the 1880s the tables turned. Pastor Kneipp was recognised across Europe as an eminent authority on natural remedies. Fans of his teachings started Kneipp societies; the first Kneipp spa was opened in Wörishofen; Pope Leo XIII granted him a private audience and Archduke Joseph of Austria became one of his greatest champions. Despite his fame Kneipp remained devoted to ordinary people all of his life. In language which was plain and simple he wrote down the techniques and purpose of the treatments he had developed so that everybody could profit from his advice in their own home. Unlike many other fashions of the day, Kneipp's ideas weren't simply a fad of the 19th century; his continuing success is mirrored in the acceptance with which his extremely effective, entirely natural and totally inexpensive naturopathic methods of healing are still met today – by alternative and conventional medicine alike.

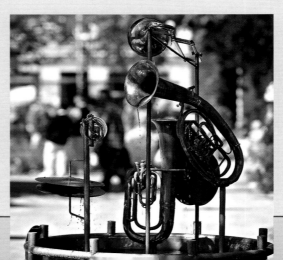

Left:
Water is an essential element in treatments developed by Sebastian Kneipp. There are thus plenty of fountains here, such as this one with its musical instruments.

Above:
Die Therme, a brand new thermal spa and sauna complex, is one of the highlights of Bad Wörishofen.

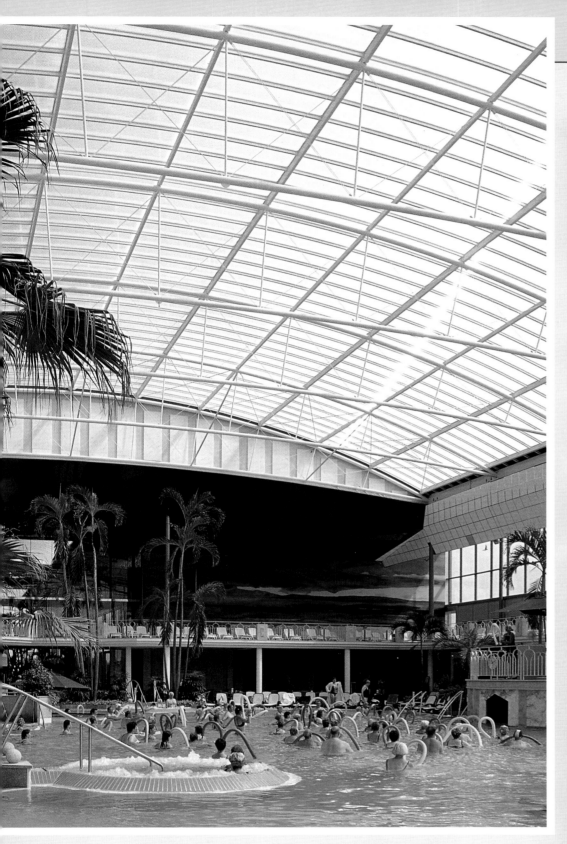

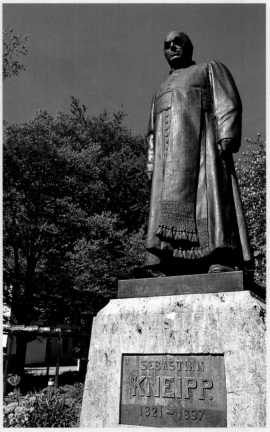

Top right and centre right:
Treading water or bathing arms at the Kurpark in Bad Wörishofen – an absolute must on any visit here!

Right:
Statue of Kneipp on Denkmalplatz, Kneippstraße, whose teachings have brought the spa of Bad Wörishofen international acclaim.

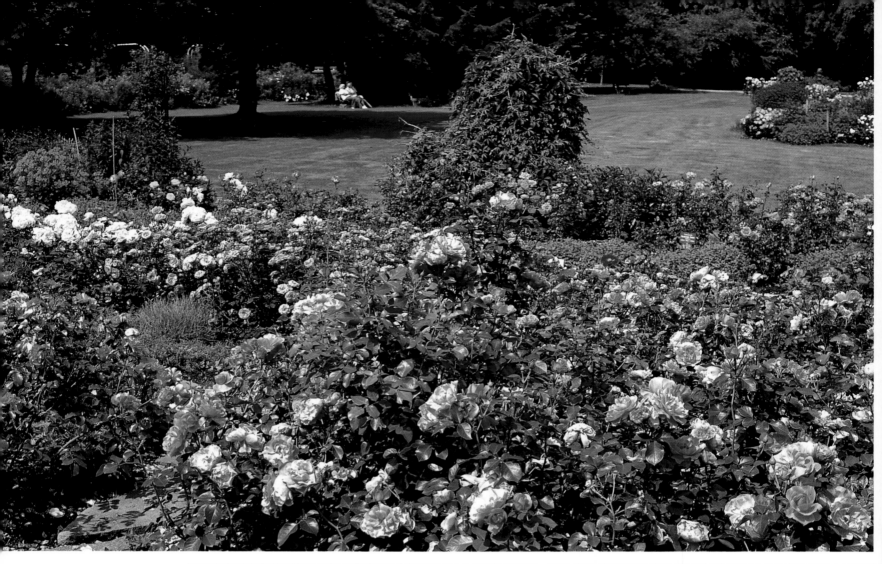

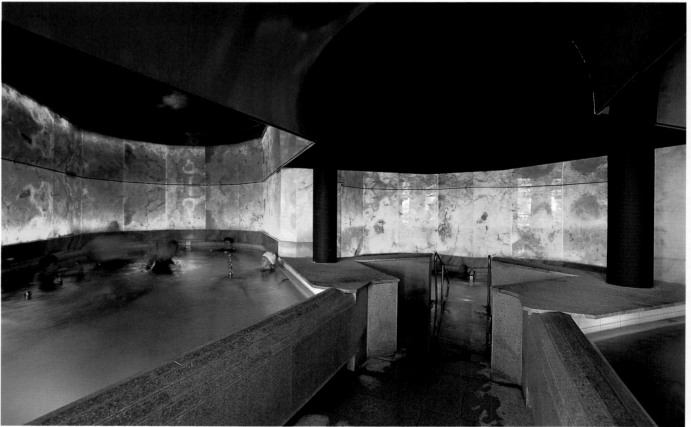

Above:
The rose garden in full bloom in Bad Wörishofen. The Kurpark has several theme gardens, including a sensory garden full of aromatic plants.

Right:
The saltwater baths at the wellness centre in Bad Wörishofen, die Therme, help to ease various skin ailments.

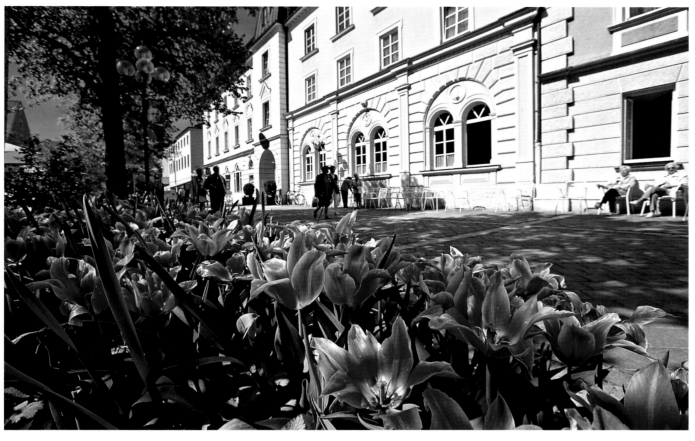

The Sebastian Kneipp Museum in Bad Wöris-hofen, housed in what was once a Dominican convent, is packed with information on the life and work of the great healer.

The sensory garden in the Kurpark at Bad Wörishofen is a great place to relax and take in the smells and tastes of the plants, per-haps gaining inspiration for your own herb garden at home.

Mountains, valleys and gorges – the West and South Allgäu

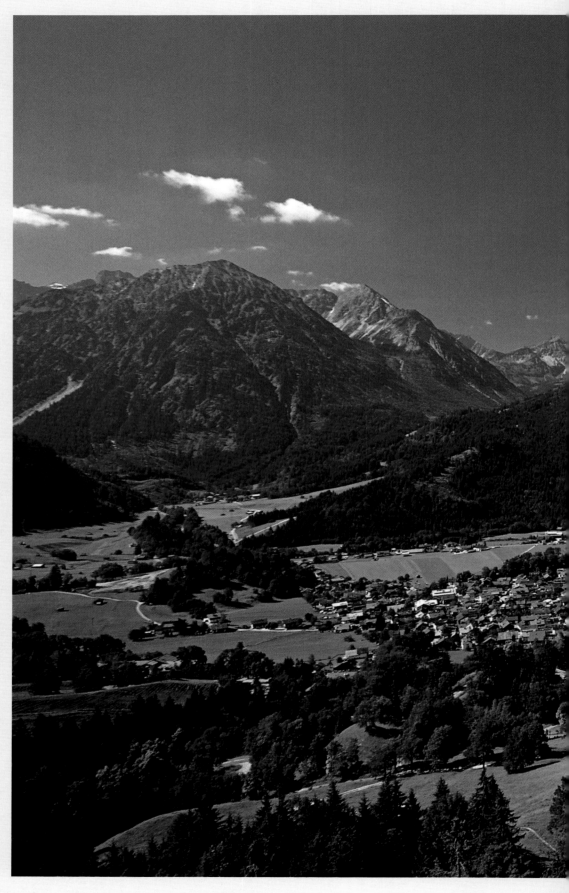

The River Ostrach has carved a wide valley out of the rock on its way to the Iller, leaving in its wake the distinctive Imberger Horn (1,656 metres / 5,433 feet above sea level). Peasants settled here in the Middle Ages, laying down the foundations of the present towns of Bad Hindelang and Bad Oberdorf, both spas denoted by the word "Bad" in front of their names.

A green patchwork of fields and meadows characterises the western part of the Allgäu. Reedy ponds and boggy moorland punctuate the grassland, with picturesque chapels, charming villages and lively market towns adding splashes of glorious colour. Many of these towns have a historical centre: Isny with its hidden courtyards, Leutkirch with its narrow winding streets, Wangen with its ancient fountains, towers, oriels, patrician houses and artisans' dwellings. All have one thing in common, lending them a unique sense of charm: the backdrop of the Allgäu Alps.

The majestic mountain ranges of the South Allgäu seem to reach for the sky, with the undulating hills at their feet a sea of green. This is picture postcard scenery to die for. The southernmost point in Germany can be reached via Immenstadt, Sonthofen and Oberstdorf or Bad Hindelang, hidden away in an Alpine valley, and is rich in diversity. Jagged massifs and imposing summits, among them the Hochvogel (2,592 metres/8,503 feet), the Mädelegabel (2,645 metres/8,678 feet) and the Hoher Ifen (2,232 metres/7,323 feet) with the famous Gottesackerplateau, tower above gentle valleys; precipitous ravines slice through plateaux of wild grass and Alpine flowers; turquoise lakes glitter in crass contrast to barren slopes of scree and snow-capped peaks. It's thus hardly surprising that the South Allgäu is one of the most popular holiday destinations in Germany. In winter snowboarders and skiers can whiz down pistes where snow is guaranteed; in summer hikers, climbers and mountaineers are drawn to the mountains in search of exercise and relaxation – or just to breathe in some fresh air and enjoy the magnificent Alpine panoramas.

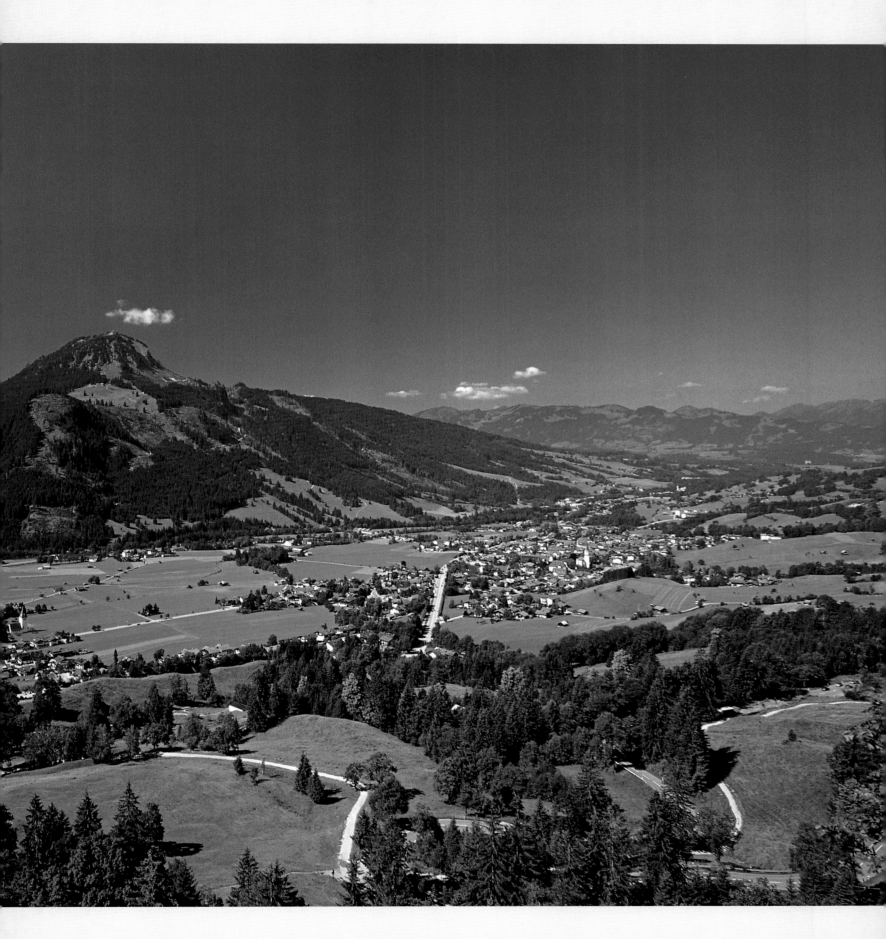

Right:

The yearly competition to see which village can erect the best maypole is a time-honoured tradition in the Allgäu. The pole bears colourful plaques depicting the various trades pursued by the villagers.

Far right:

You'll never go hungry (or thirsty) in the Allgäu! The area boasts a bounty of microbreweries serving delicious local fare and their own beer often made from recipes passed down from generation to generation.

Below:

Kranzegg near Wertach. There are countless paths and trails winding their way peacefully through the undulating countryside, tempting you to don your hiking boots and get out into the fresh air.

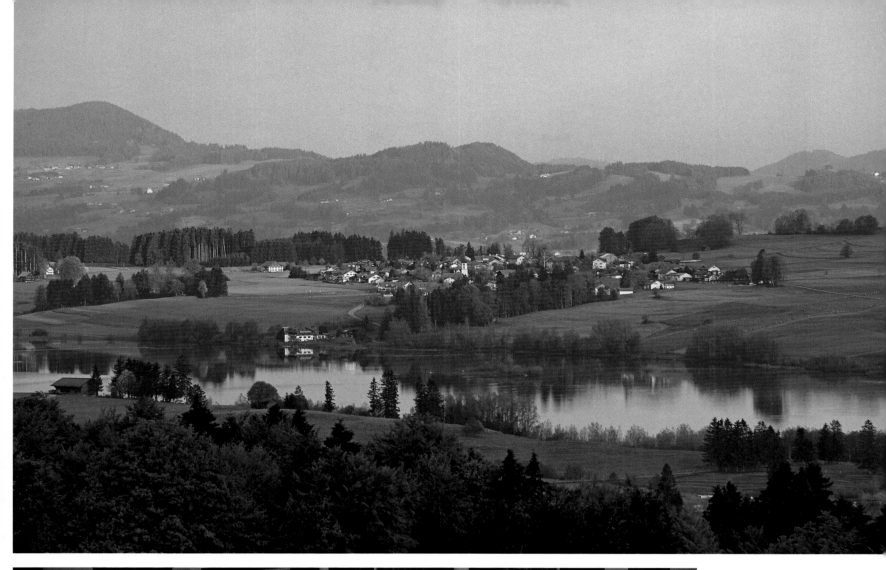

Above:
The Rottachsee shimmers serenely in the pale light as if it's always been part of the surrounding country-side. It is in fact the most recent and at almost five kilometres (three miles) long the largest man-made addition to the Alpine foreland, built in 1992 as a reservoir in an attempt to raise water levels in the Iller and Danube rivers.

Left:
Clinging to a ridge north-west of Kempten, Wiggens-bach offers splendid views out across the Iller Valley and the Alps. Both the panoramas from and of the village itself are rewarding, with plenty of historical houses to admire.

45

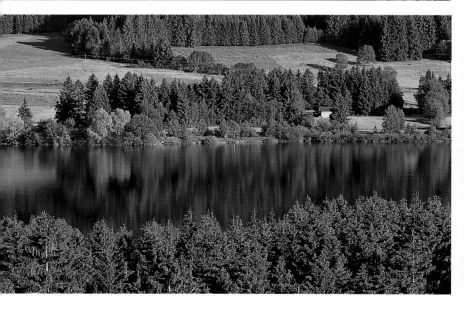

Bottom left:
Surrounded by a patchwork
of woods and meadows,
Grüntensee at the foot of
Grünten Mountain is an
idyllic spot to swim in the
summer and ice skate in
the winter.

Below:
Bad Hindelang, only
recently made a spa, has
long been one of the big
holiday spots in the Allgäu.
During the 15th century a
major trade route running
from Tyrol to Lake Con-

stance crossed the Joch
Pass just beyond Hinde-
lang, prompting coach
builders, saddlers and
also innkeepers to set up
business here to service
the needs of weary
travellers.

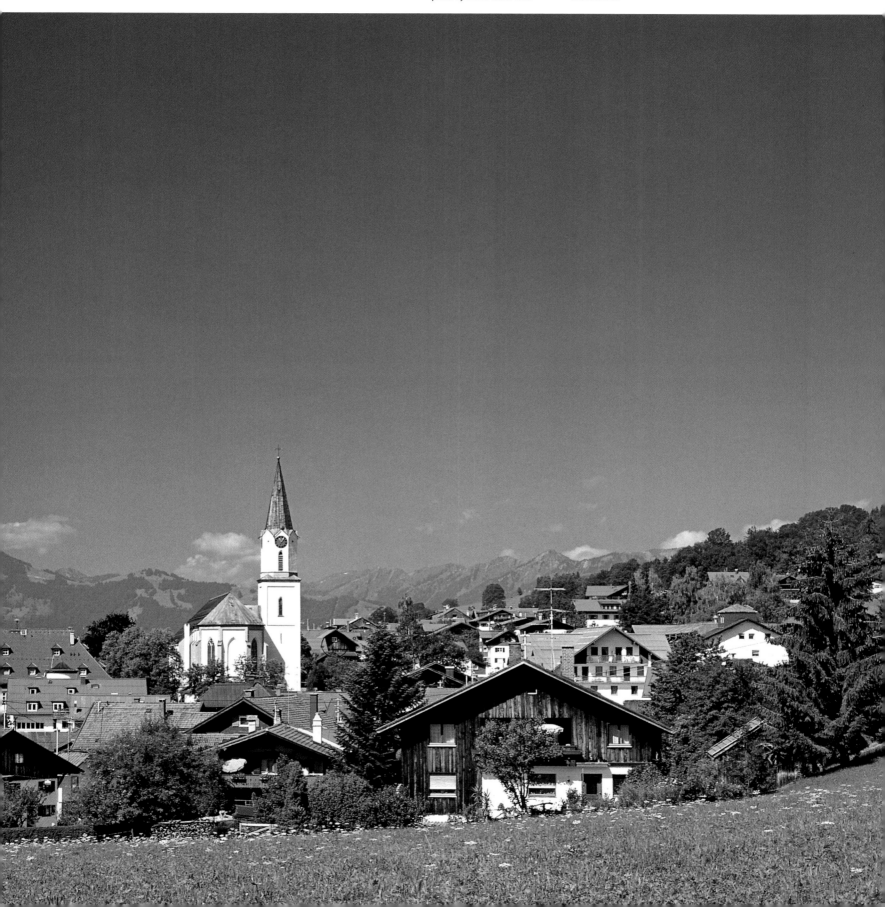

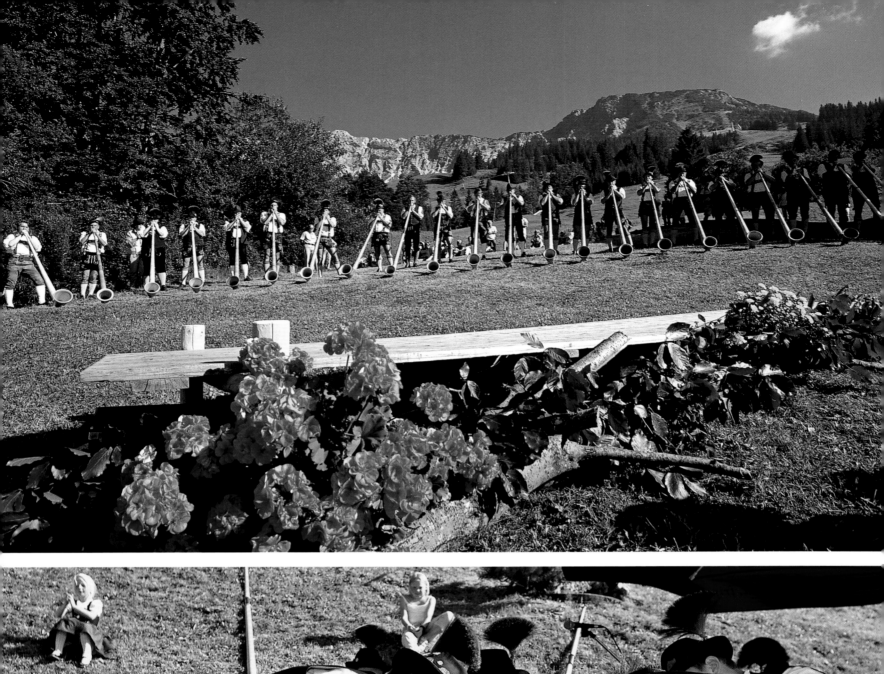

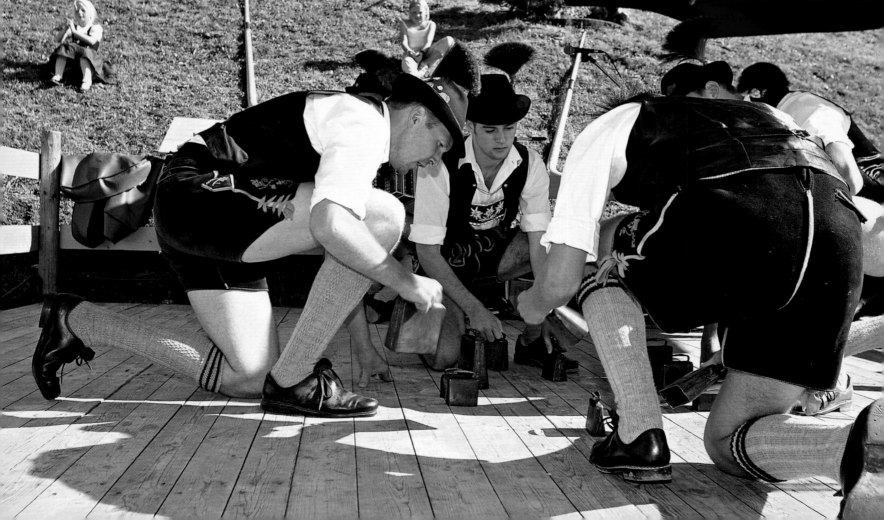

Left:
Tradition is writ large in the Allgäu. The summer sees countless festivals and celebrations of local customs, costumes and concerts, such as the alphorn gathering at Oberjoch near Bad Hindelang.

Below:
The alphorn, now no longer indigenous to the Alps alone, produces a noise which is a cross between the resounding trumpet of a brass instrument and the soft parp of the woodwind. Today's alphorns are 3.5 metres (11.5 feet) long on average, with different lengths for different keys. They are made of tree trunks which are halved lengthways, hollowed out and stuck back together again. As alphorns have no valves or holes, different notes have to be produced using embouchure and breathing alone, a skill which requires a great deal of practice.

Below:
Traditional houses decked with wooden shingles and adorned with wooden shutters, such as this chalet in Hinterstein near Bad Hindelang, are a frequent occurrence in the Allgäu. They take on a real charm in the late spring when window boxes of petunias and pelargoniums add glorious splashes of colour to the dark facade.

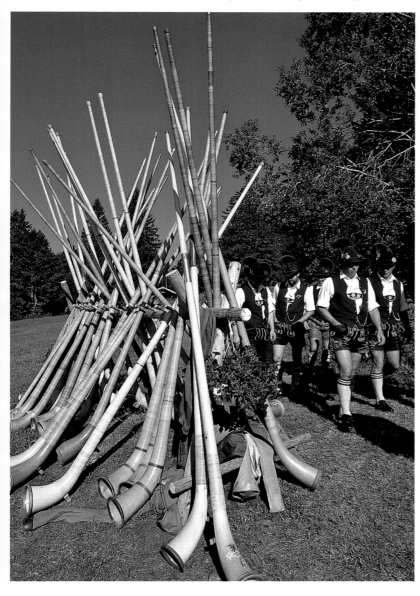

Left:
The "Schuhplattler" is an established folk dance in the Allgäu, even though it originated in Upper Bavaria and Tyrol. The purpose of the dance was for young bachelors to woo potential brides and show off their muscle and stamina in doing so – amid much stamping of feet, clapping of hands and slapping of strong thighs encased in short "Lederhosen".

49

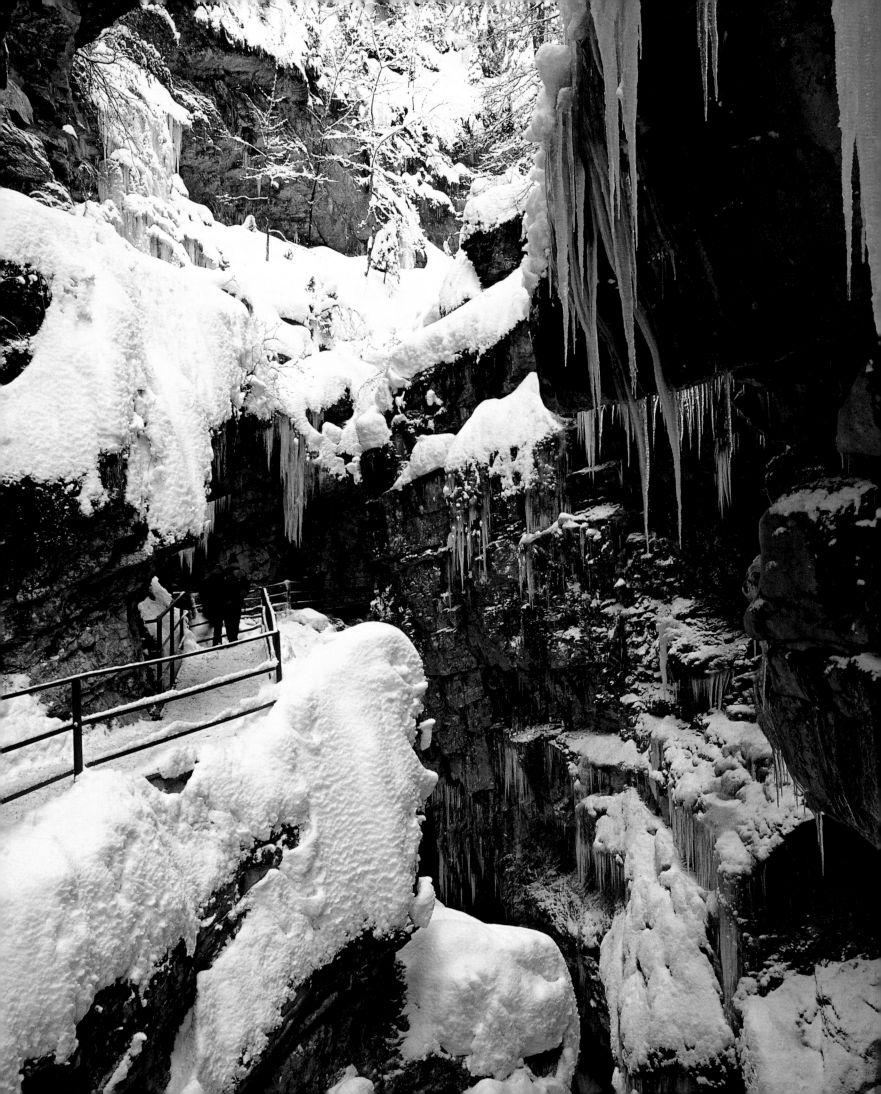

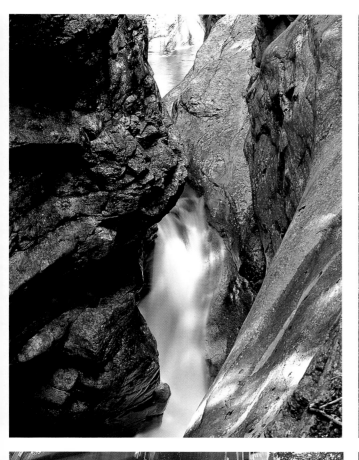

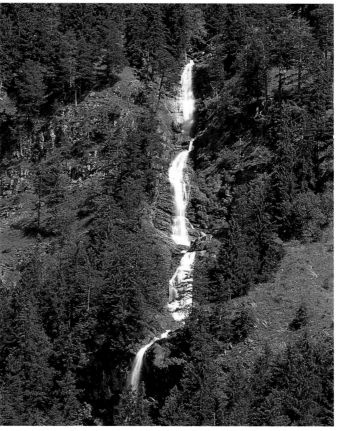

Left page:
The Breitachklamm, south-west of Oberstdorf, is one of the most spectacular gorges in Central Europe.

Far left:
The village of Winkel, north of Sonthofen, is where the rewarding trek through the Starzlach-klamm begins. The 2 ½-hour hike takes you through Alpine meadows to the ravine and back through dark forest.

Left:
The waterfall in Hinter-stein. The elongated village, part of Bad Hinde-lang, snuggles up to the foot of the Breitenberg in the Ostrach Valley and is a great place to embark on any number of gentle walks or mountain trails.

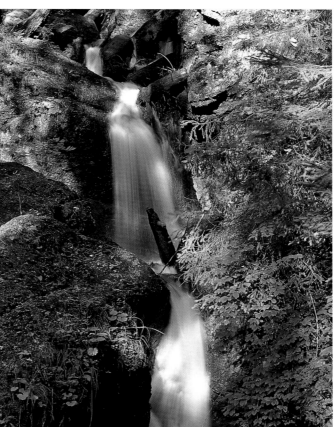

Far left:
The wheel of this mill near Bad Oberdorf is tirelessly turned by the rushing waters of the Ostrach. The mill is now a working museum where you can watch cheese being made.

Left:
From the village of Hinang south of Sonthofen you can walk along the banks of a babbling brook to the wild and romantic Hinang Falls.

Page 52/53:
Just beyond Oberstdorf, the southernmost and highest-lying town in Germany, the Nebelhorn rises an impressive 2,224 metres (7,297 feet) above sea level, with marvellous views of the Alps and Alpine foreland.

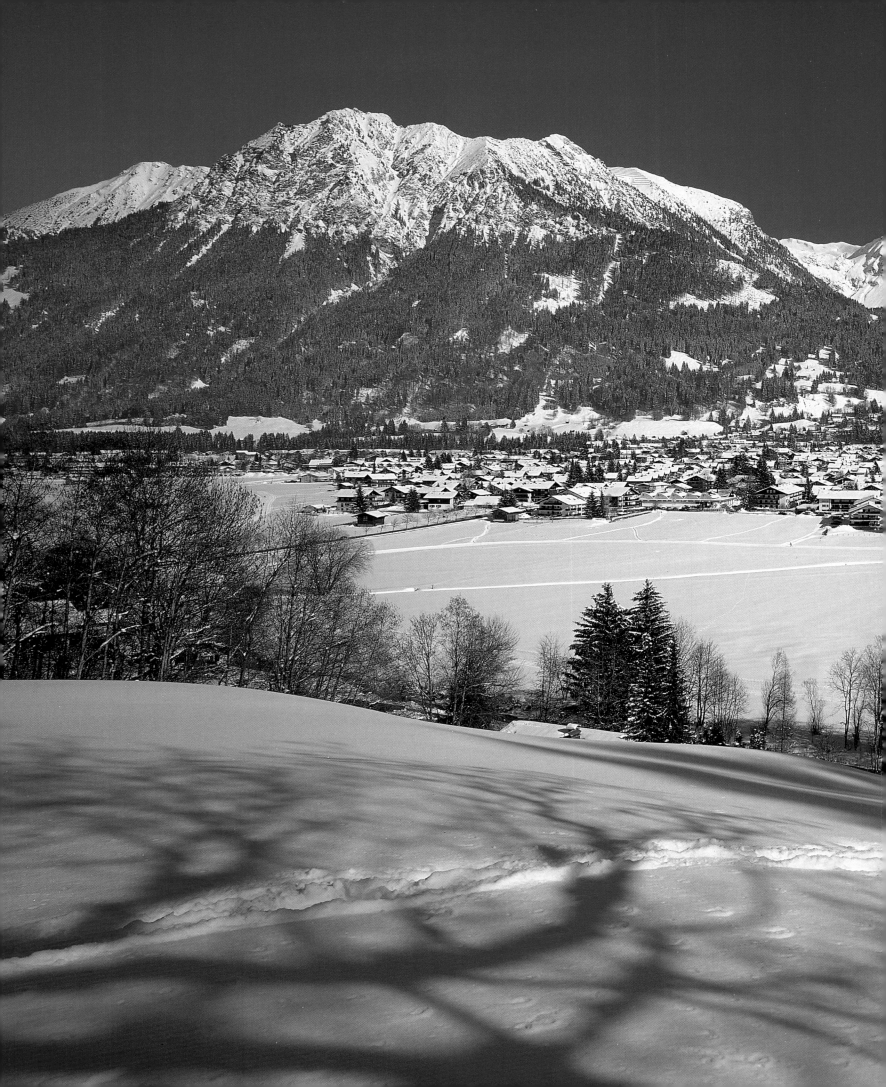

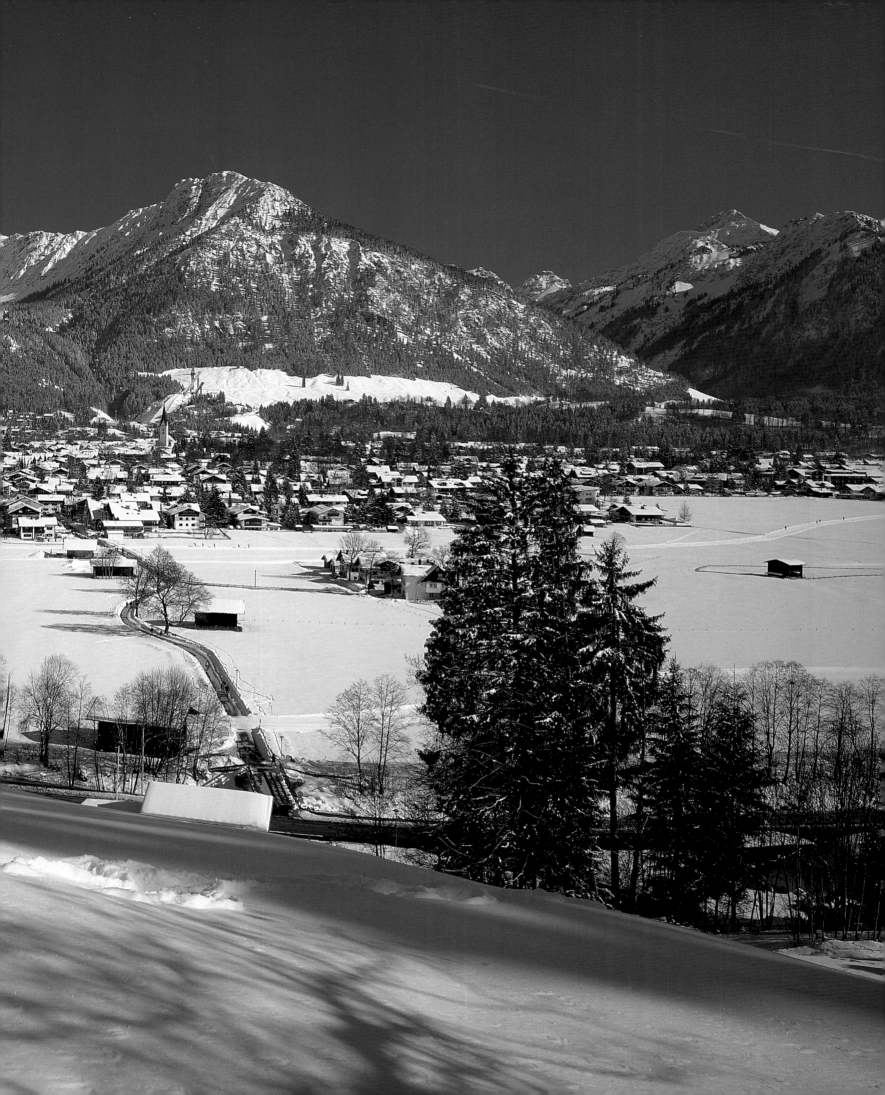

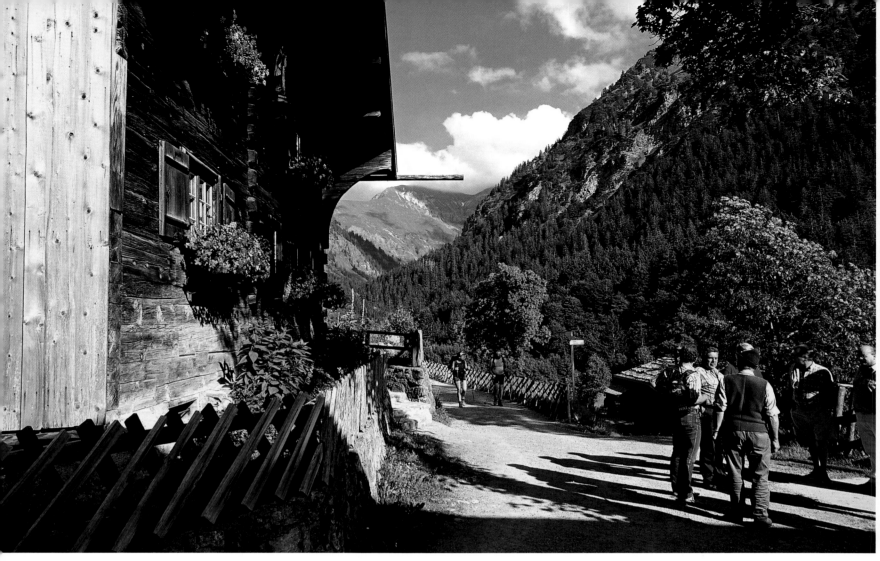

Above:

Time seems to have stood still in Gerstruben. In the heart of the mountains, south of Oberstdorf, parts of a tiny Alpine village founded by Lechtal emigrants in the Middle Ages have been preserved.

Right:

The 16th-century Seelen-kapelle next to the parish church is one of the oldest buildings in Oberstdorf to have miraculously survived the terrible fire of 1865 intact. The frescos adorning the north wall are magnificent and show scenes from the life of St Michael, Judas and the Last Supper.

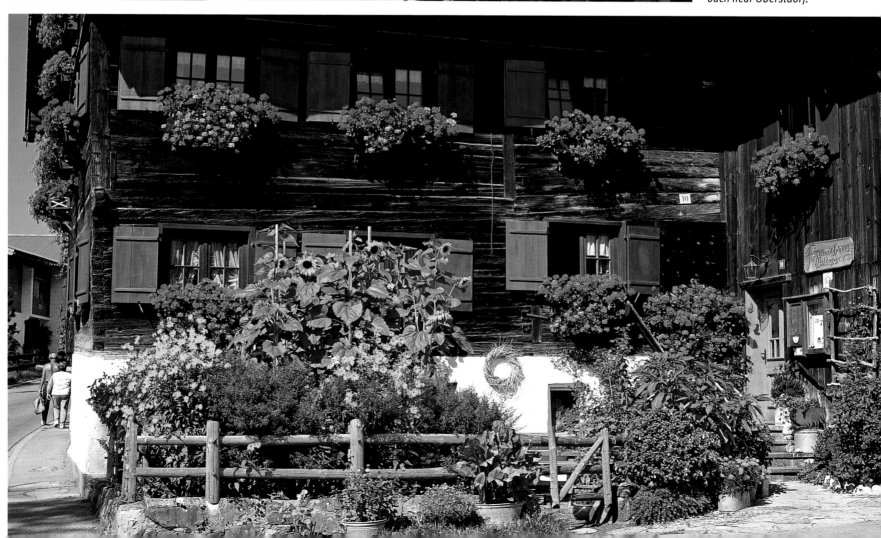

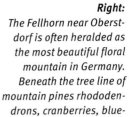

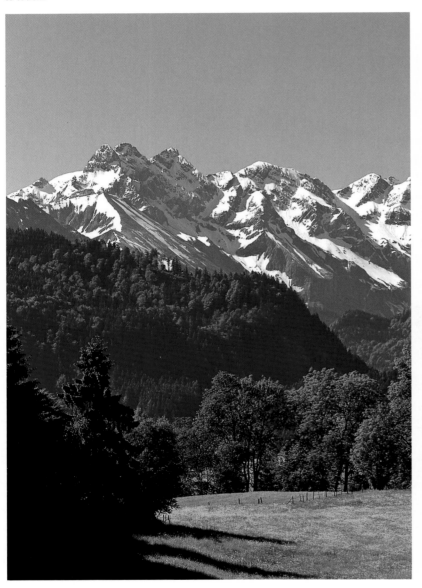

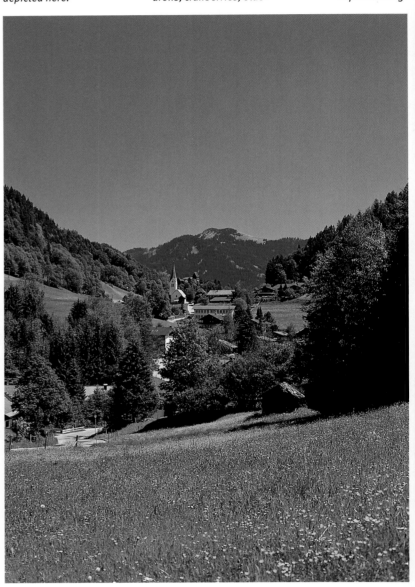

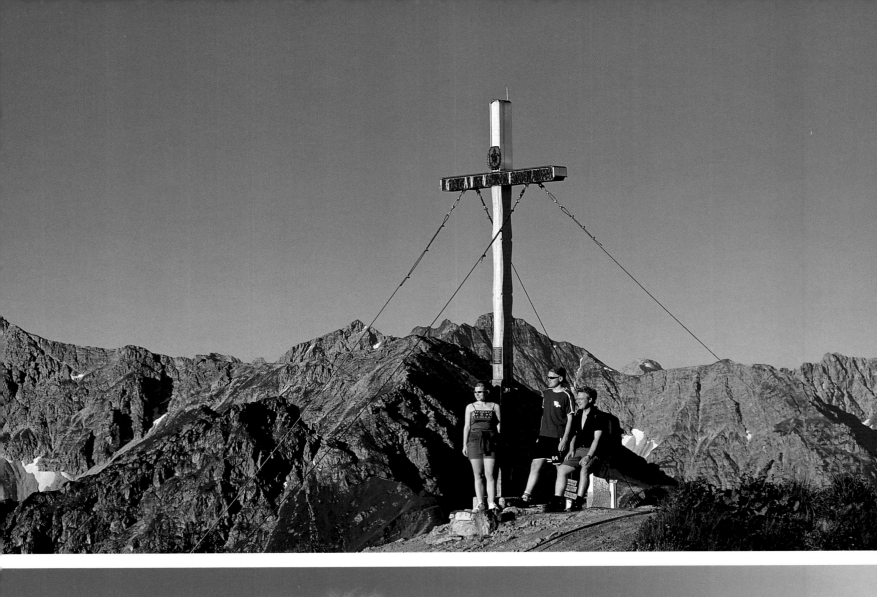

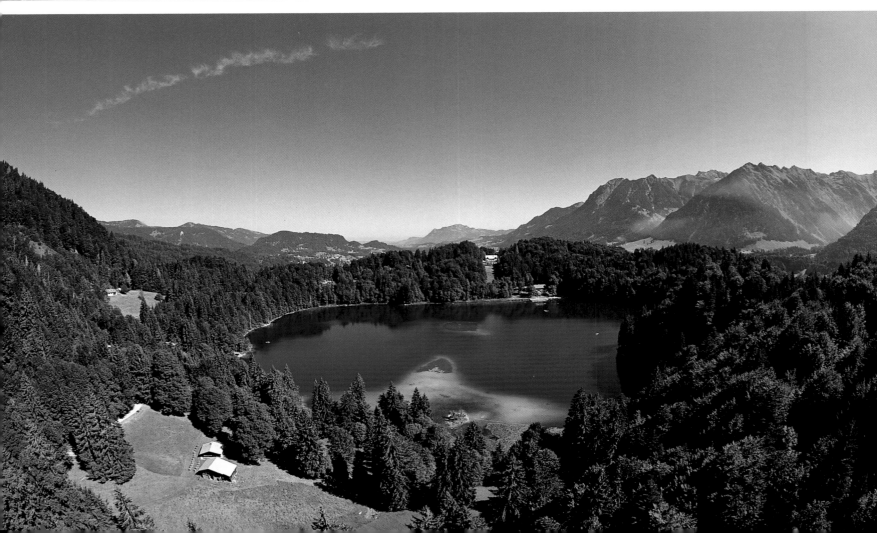

Left:
There are grand views of the village of Reichenbach and jagged Rubihorn Mountain from the old castle chapel in Schöllang. Almost 2,000 metres (6,500 feet) tall, the latter looms large above the valley of the River Iller and boasts one of the most spectacular mountain trails in the Allgäu region.

Below:
Faith and religion play a major role in many Allgäu communities. Some villages even celebrate mass in the mountains, rising early to greet the morning sun and join together in prayer, such as at this service held at the Schlappoltsee beneath the magnificent backdrop of the Fellhorn.

Below:
No festival would be complete without the local brass band. Here the Heimertingen brass and wind players serenade the Nebelhorn.

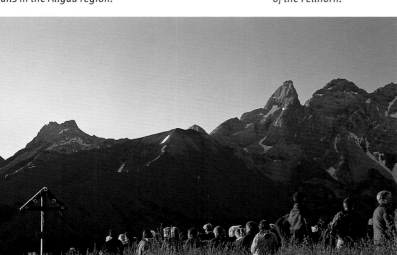

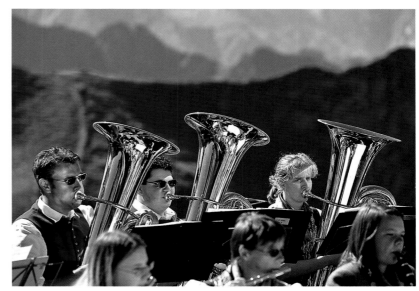

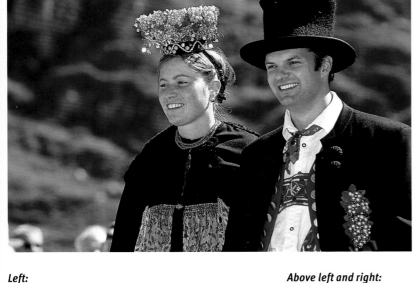

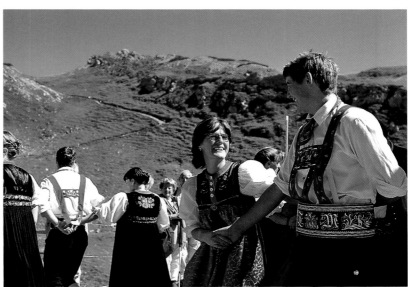

Left:
The Trettach River has forged a deep and idyllic valley through the Höfats and Himmelschorfen mountains south of Oberstdorf, the perfect spot for scenic walks.

Above left and right:
Coral necklaces are a typical accessory for the ladies of the Kleinwalsertal. Until a few decades ago this valley, part of both Austria and the German economic zone, was largely populated by dairy and cattle farmers who led a frugal existence. One of the few highlights of their lives was travelling to Italy to sell cheese where their modest profits allowed them to purchase jewellery for their wives. The corals are still a fixed feature of the national costume today.

Right:
It may not be luxurious but life up in the mountain pastures is certainly healthy, with plenty of fantastic countryside and fresh air. These inhabitants of the Vorsässalpe near Gunzesried certainly seem satisfied with life.

Below:
In the mid-19th century dairy farming in the Allgäu brought prosperity to an otherwise impoverished area. As the dairies are no longer economically viable the glory has now faded, however, with many of the Alpine farms having to be closed down or converted into chalet taverns for hikers and mountaineers.

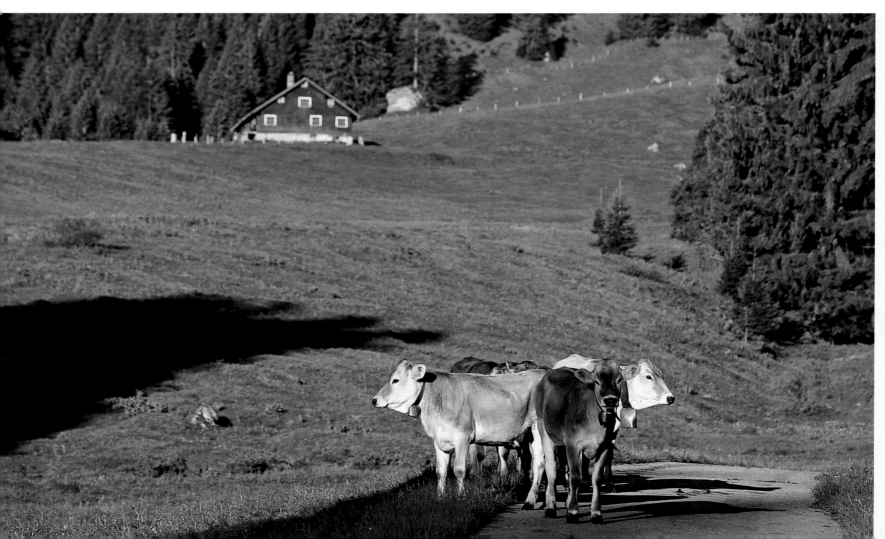

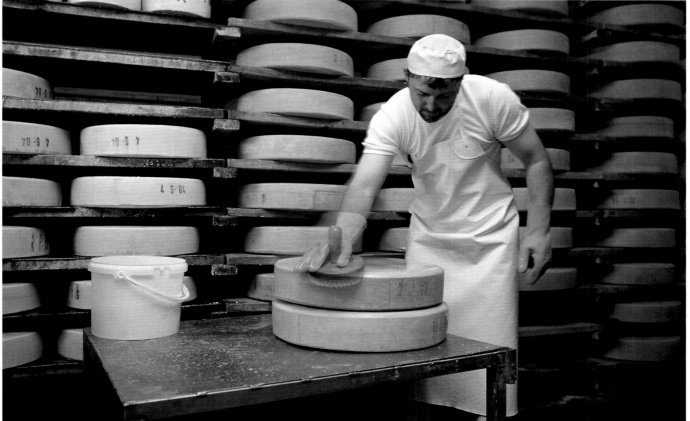

Above:
The Vorsässalpe near Gunzesried. "Vorsässalpen" or "Vorsetzalpen" were originally temporary pastures for cattle waiting to be driven up to the highland meadows of the Alps in summer.

Left:
This cheesemaker from Ofterschwang is practising a dying art. Only a robust few are nowadays pre-pared to spend months alone in the mountains, tending to the cattle and making cheese in a process which is both complex and laborious.

Cheese, Spätzle and cheese Spätzle – Allgäu specialities

When it comes to food, every region has its own particular preferences and specialities which are usually inextricably linked to the agricultural traditions of the area. When the Allgäu is mentioned in this context, most people immediately think of milk, cheese and brown Alpine cows grazing pastures green – and quite rightly so, for this is the dairy of Germany. The world here revolves around milk and what it can be turned into: namely cheese, from cow to milk tanker, from tiny museum dairies to big-time manufacturers who export worldwide, from cheese shops selling an assortment Monty Python would have been proud of to remote Alpine farms lining the Allgäu Sennalpenweg, a hiking trail devoted to the production of cheese. The manufacturing process is a complex affair. Milk is first filled into wooden vats, left overnight and creamed off the next morning. This skimmed milk is mixed with fresh milk and heated to a temperature of 32°C (90°F). Rennet made from calves' stomachs and bacteria are then added, curdling the milk without turning it sour. The curd is then separated from the whey using a cheese knife or harp. This is heated to 51°C (124°F) and stirred until the desired consistency is achieved. The cheese is removed from the vat in a cloth, pressed into a mould and turned several times to drain off the remaining whey. The following day the cheese is soaked in brine to enable it to form a rind. It is then stored in a cold cellar at about 12°C (54°F) to mature, turned, washed with brine and rubbed once or twice a week. The bacteria cause the lactose to ferment, forming bubbles of carbon dioxide which make the holes in the cheese. A good Alpine cheese needs five or six months to mature. As a rule of thumb ten to eleven litres (17 to 19 pints) of milk, just under the daily production of the average cow, go into making one kilo (about two pounds) of cheese.

Complicated the procedure may be but it has proved extremely successful, as the election of Allgäu Emmentaler as Cheese of the Year 2002 illustrates. Connoisseurs also love its slightly more aromatic little brother, "Allgäuer Bergkäse" or mountain cheese, and also Romadur, Camembert and the curiously named "Backsteinkäse" or "brick cheese", among others, all products of the Allgäu. This vast range may mislead you into thinking that cheesemaking enjoys a long culinary tradition here. This is not the case; dairy farming – and subsequently the manufacture of cheese – was only introduced to the area during the 19th century. The real core of authentic Allgäu cuisine – and a staple long before the 'invention' of cheese – are its pastry dishes. The Allgäu was long a poor region, its relatively harsh climate placing severe limitations on the farming of fruit and vegetables. Cheap foodstuffs which were easy to grow, such as flour, fat, eggs and sauerkraut, were thus permanent fixtures on the menu. Despite its simplicity much of this poor man's fare has become popular far beyond the confines of the Allgäu – albeit in a more elegant guise.

By far the most successful of these is the Swabian noodle or "Spätzle". Many claim that local preference for these small blobs of pasta dough as opposed to the large imperialist dumplings common to the rest of Bavaria is a matter of regional pride and Alemannic eccentricity. Whether this is true or not, there are certainly many variations on the Spätzle theme. You can have them plain with your goulash or made with eggs, flour, apple, spinach or sauerkraut; indeed, the national dish of the Allgäu even contains Spätzle in an Alpine version of macaroni cheese. "Käsespätzle" are made from a dough of flour, eggs, water and salt which is squeezed through a special "Spätzlehobel" or pasta press into a pan of boiling water. The cooked noodles are drained off, layered in a casserole with a mixture of cheese (usually "Bergkäse" and "Weißlacker"), topped with fried onions and baked in the oven. They are delicious but extremely rich; you either need a strong stomach or a couple of glasses of schnapps to wash them down with.

"Nonnenfürzle" and "Versoffene Jungfern"

Even if many of the local recipes seem to feature cheese and Spätzle the Allgäu has much more to offer on the culinary front. Other much-loved dishes are "Schupfnudeln mit Kraut", fat fingers of pasta fried with sauerkraut and onions, or "Armer Ritter" (literally: poor knights), stale rolls dipped in batter and fried in fat. If these are eaten with sweet fermented apple juice they become "Moschtküchle", a mouth-watering dessert. There are many other tasty but calorific puddings, some with rather coarse names, such as "Nonnenfürzle" (nun's fart), small dumplings made of choux pastry and fried in fat, and "Versoffene Jungfern" (drunken virgins), tiny balls of dough baked in fat and drenched in hot cider. Yet the cooking of the Allgäu is by no means bound by regional convention alone; international cuisine is also popular and many an inventive chef has married the traditional with the exotic to produce such curious (and rather less lewd-sounding) creations as flower soup and cider gratin.

Above:
The museum of Alpine farming in Diepolz illustrates what life used to be like in the Allgäu, taking visitors on a journey through time (and through the mountains) in its museum dairy.

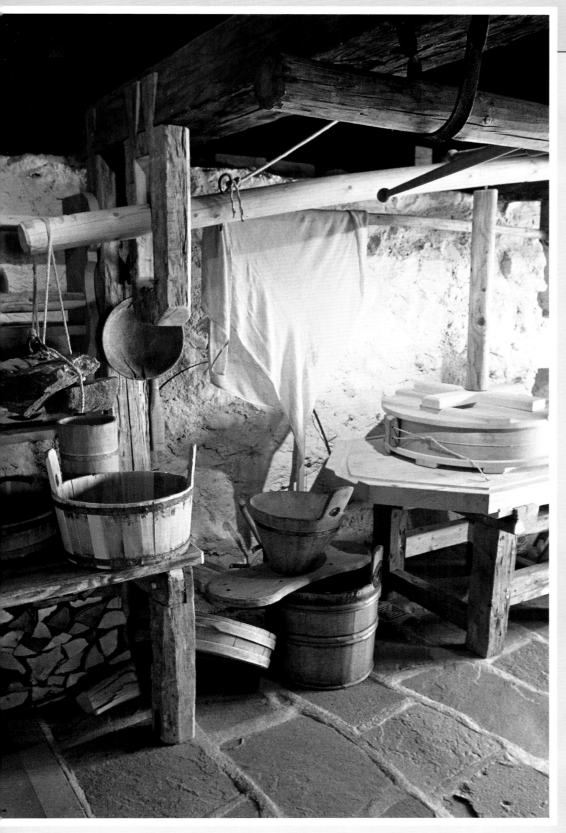

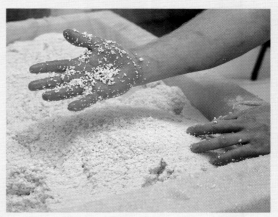

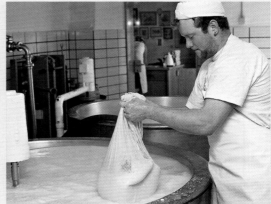

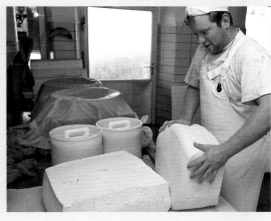

Top right:
The Allgäu is paradise for vegetarians! Long a poor region where meat was only eaten on feast days, its limited food-stuffs were put to a wide variety of use. The local traditional dish is guar-anteed to be meat-free: Swabian noodles with cheese or "Käsespätzle", the Allgäu's answer to macaroni cheese.

Right:
Much of the cheese-making process is still done by hand, such as here at the Alpine dairy in Ofterschwang. Here the cheese is being removed from the vat in a cloth before being pressed into moulds and turned to drain off the whey.

63

Above:
From Berghaus Schwaben on the way up to the summit of the Ochsenkopf (1,662 metres/5,453 feet above sea level) there are grand vistas of the Iller Valley and Wannenkopf and Riedberger Horn mountains.

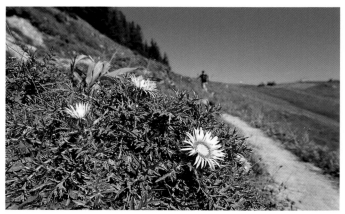

Right and far right:
Autumn is when the carline thistle is in full bloom. The Grasgehrer Hütte was once the haunt of smugglers (far right).

Right and far right:
Spring brings a riot of colour to the Alpine meadows of the Allgäu. Marsh marigolds (far right) are among the early bloomers, with the brilliant reds and pinks of the rhododendron turning the highlands ablaze in summer.

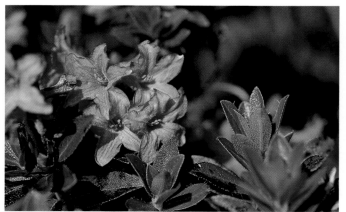

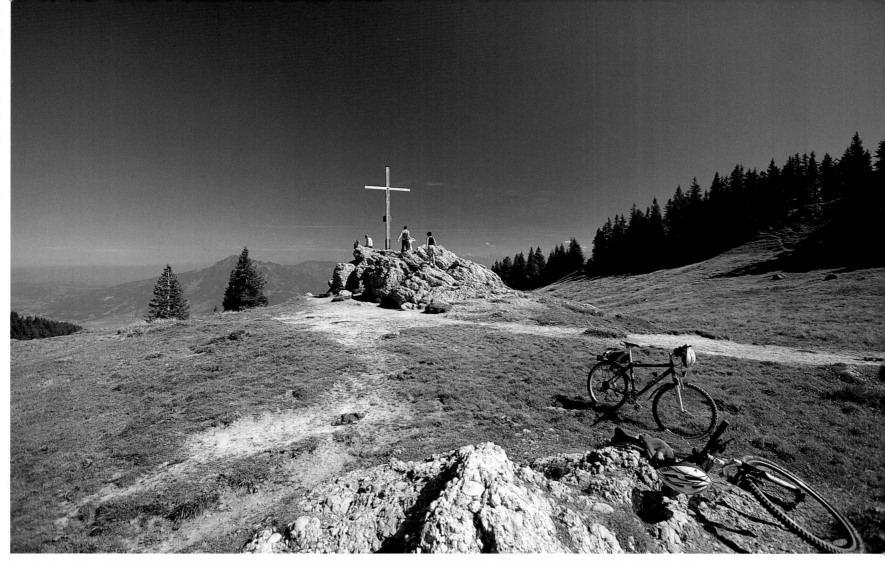

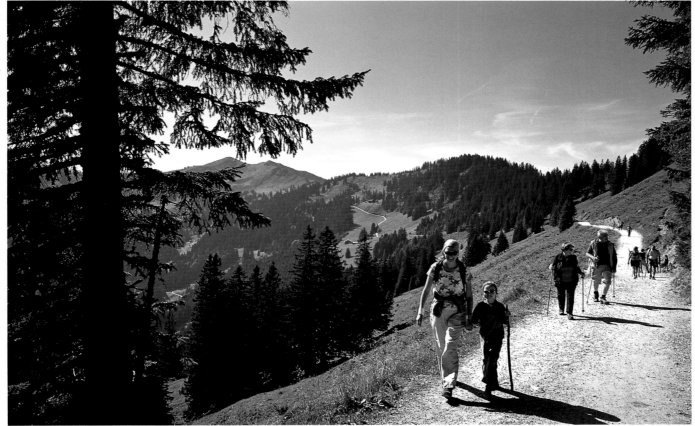

Above:
At 1,493 metres (4,800 feet) above sea level the Bären-kopf or bear's head is slightly taller than its famous neighbour Mittag-berg Mountain and gets its name from the last bear shot in the area in 1760.

Left:
A gentle highland trail runs from the Bolster-langer Horn to the Großer Ochsenkopf.

Page 66/67:
Just a few miles from Immenstadt is Rettenberg, 800 metres (2,600 feet) above sea level. Here you have wonderful views of the Iller Valley and fantastic panoramas of the Alps. With its two microbrew-eries Rettenberg is also the southernmost village in Germany to make beer.

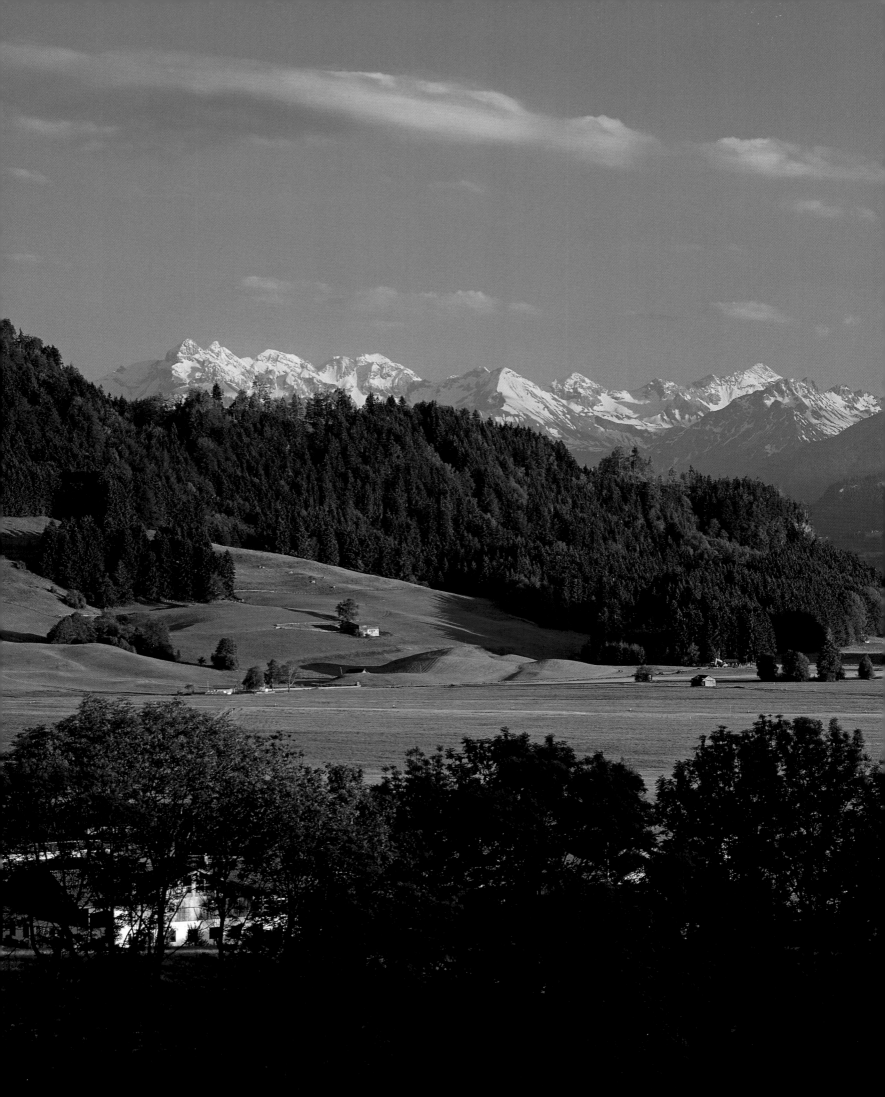

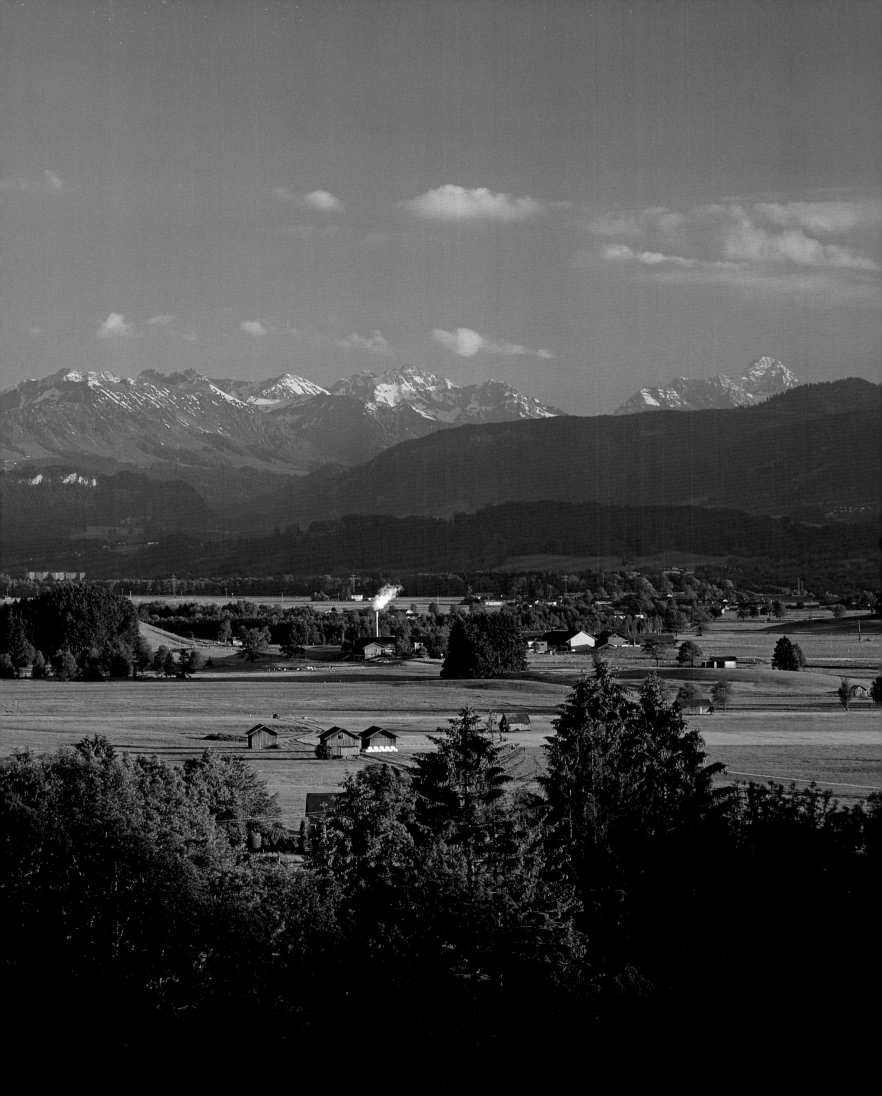

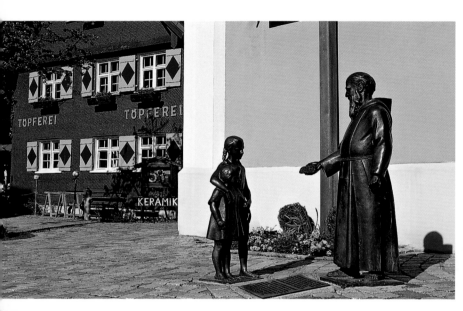

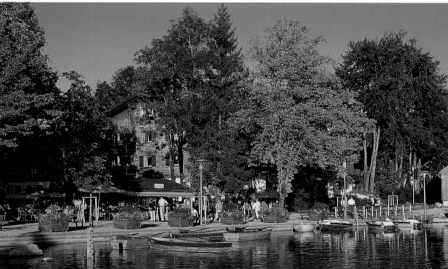

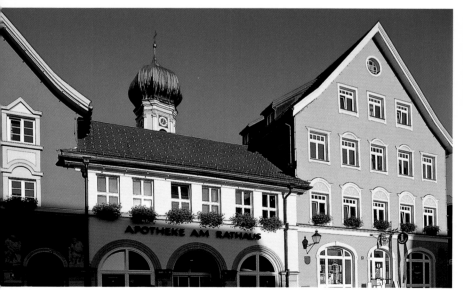

Top left:
Immenstadt has had a lot of work done on it over the past few years. The ancient facades have been given a lick of paint and there are many spruce squares and gleaming statues dotted about the town providing plenty of pleasant spots for contemplation and repose.

Centre left:
The health resort Bühl has a wonderfully scenic setting on the shores of the Alpsee with its marvellous views of the Mittagberg, Immenstadt's local mountain.

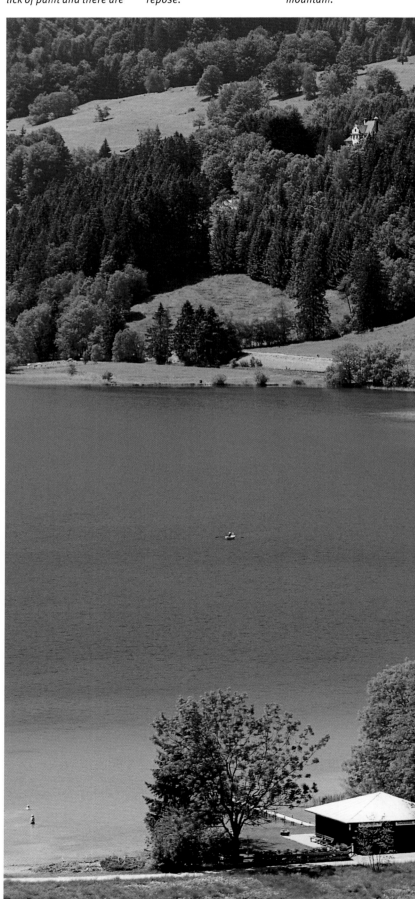

Bottom left:
Marienplatz, the old
market place, forms the
historical centre of Immen-
stadt. Among the build-
ings cluttered around its
edges are the town hall
from 1753 with its onion
dome and the former
residence of the counts
of Königsegg-Rothenfels,
now the town library.

Below:
The Großer Alpsee near
Immenstadt is the largest
of the Allgäu's natural
lakes. In summer it's a
haven for swimmers,
sailors and surfers of all
ages – and for those
fancying a leisurely stroll
along its grassy shores.

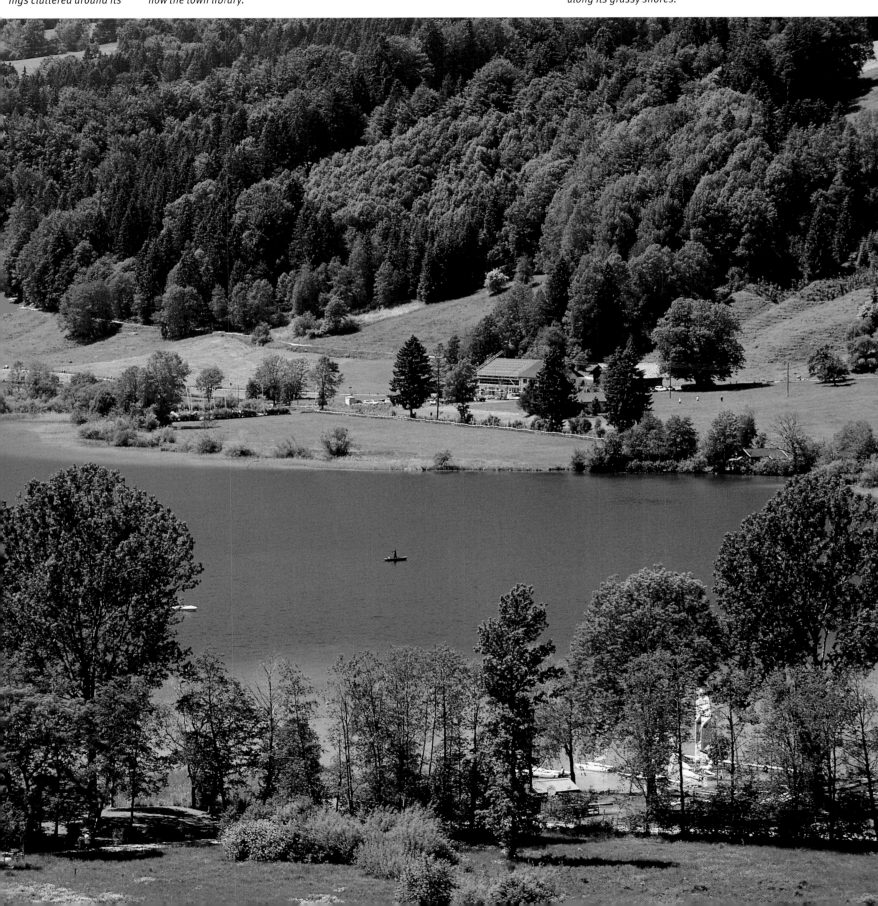

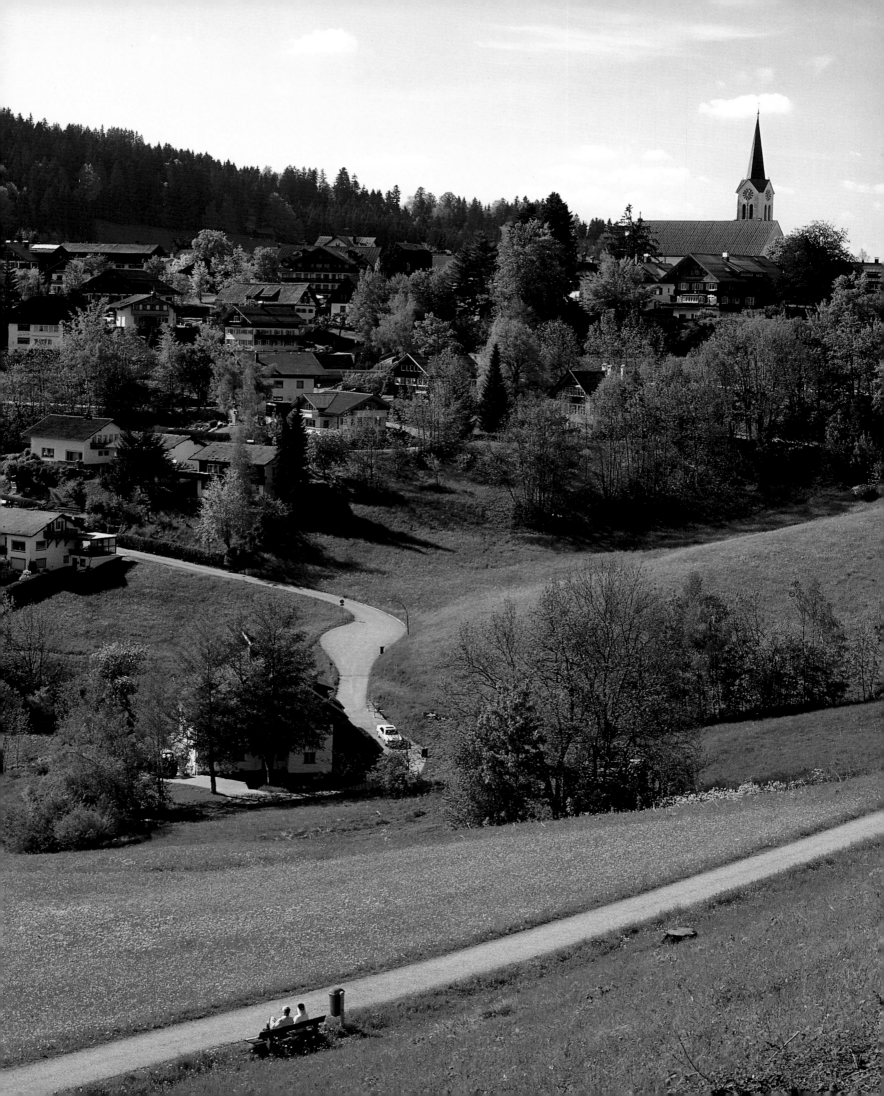

There are chalets like these aplenty in the Allgäu, their window boxes bursting with cheerful bedding plants in the summer. This one is in Krebs near Oberstaufen.

Left page:

In 1991 the health resort of Bad Oberstaufen, huddled in a natural basin of land, was made an official Schroth spa, the only one of its kind in the world. The Schroth health cure is a classic natural remedy for all kinds of ailments. It's named after the doctor Johannes Schroth who at the beginning of the 19th century came up with a curative process which combined water treatments with dieting, physical exercise and relaxation. The Schroth cure was introduced to Oberstaufen in 1949 by Hermann Brosig.

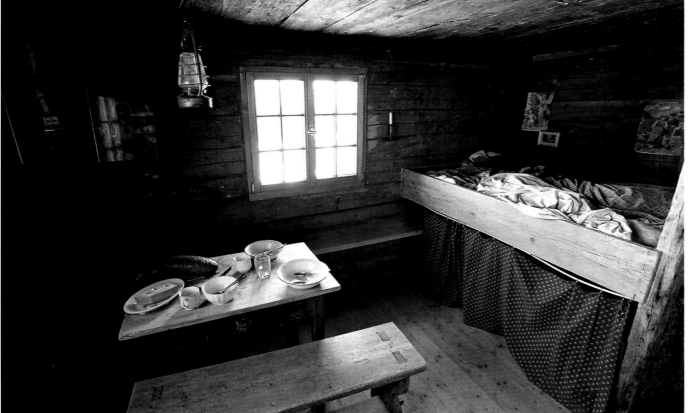

If you pay a visit to the museum of Alpine farming in Diepolz near Immenstadt, make sure you allow plenty of time for its many attractions. The complex has beehives, a herb garden, an Alpine meadow, a barn and much more, providing young and old with a comprehensive insight into the day-to-day life of the men and women who farm the slopes of the Alps.

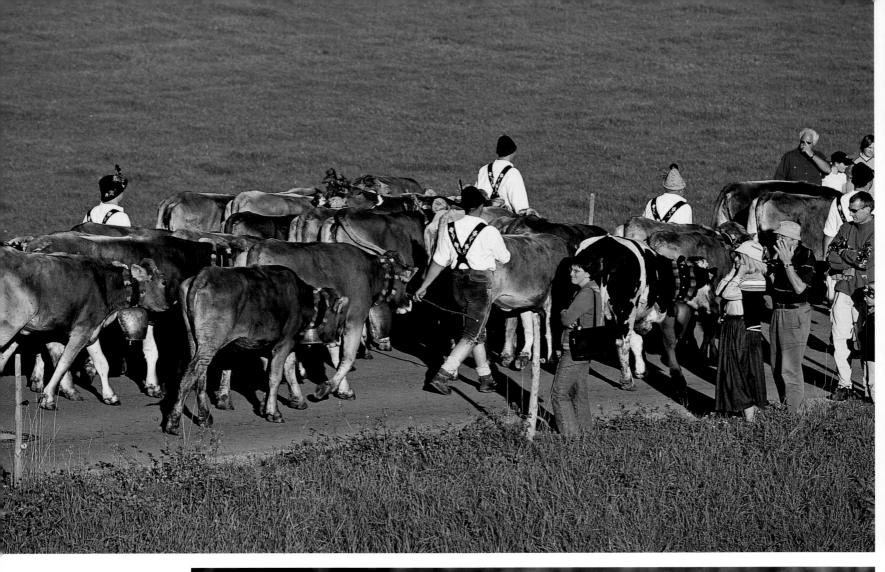

In late summer Allgäu farmers herd their cattle down from highland pastures to the shelter of the valleys, removing cowbells before stabling the animals for the winter. The occasion is cause for great celebration and much music and dancing, with the farmers donning traditional Alpine dress in honour of the event.

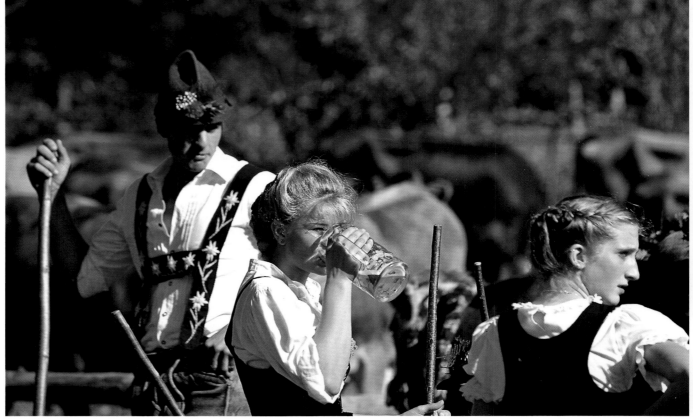

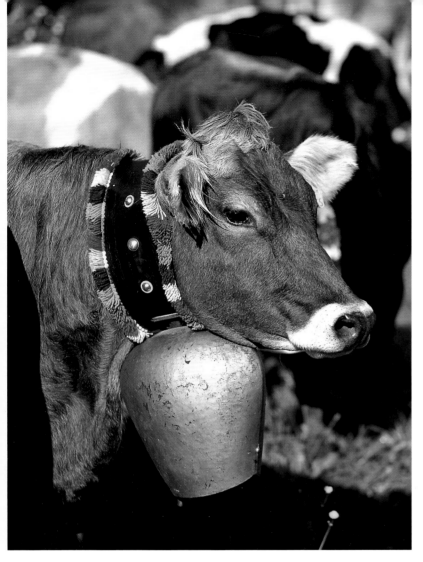

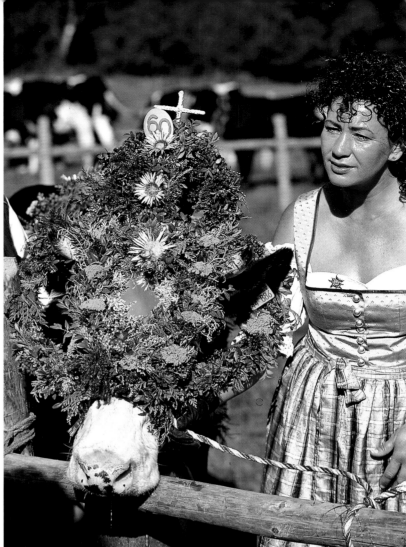

The farmers are not the
only ones to put on their
Sunday best; the cattle,
too, are dolled up for the
day. Once all the animals
have been safely returned
the most handsome beast
is adorned with a wreath
of flowers and proudly
paraded around the village.

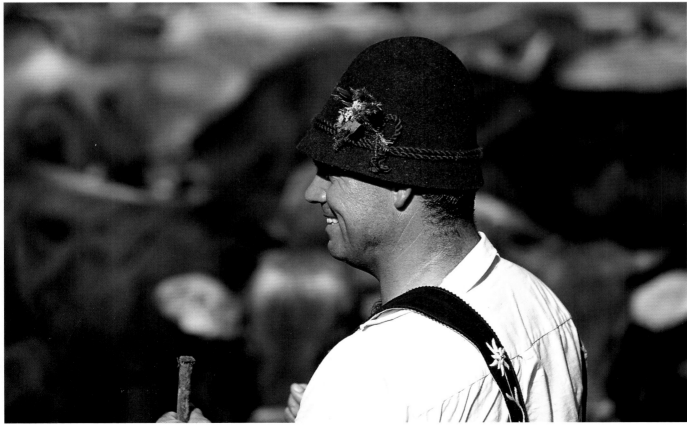

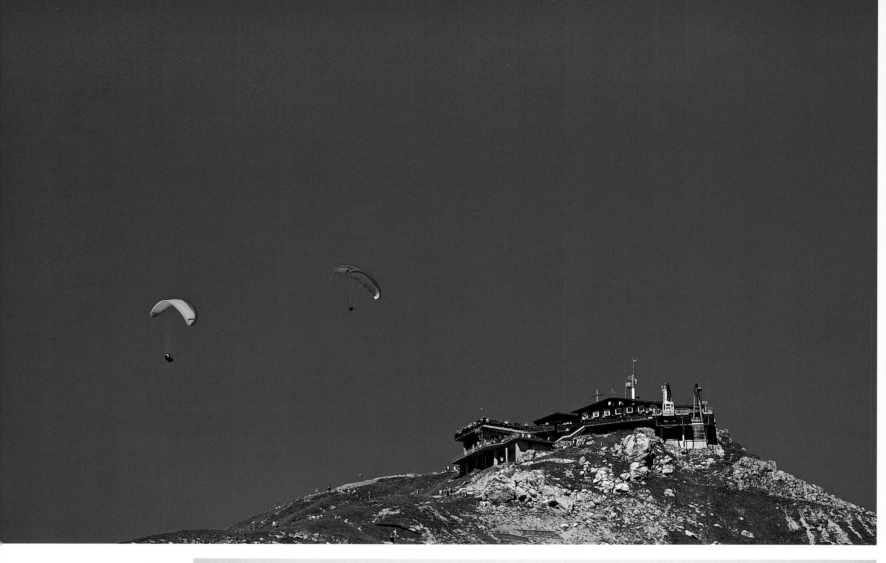

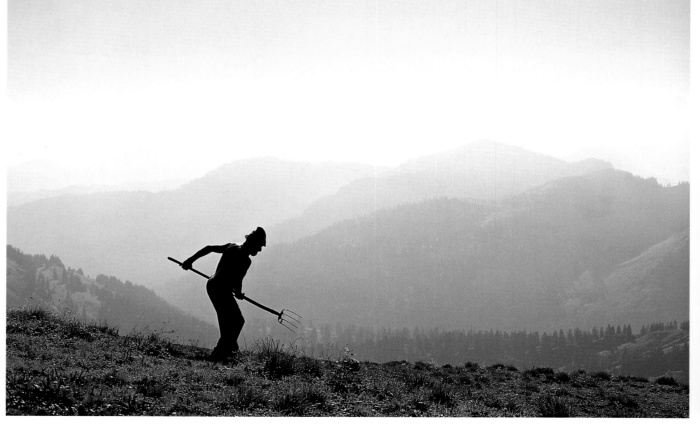

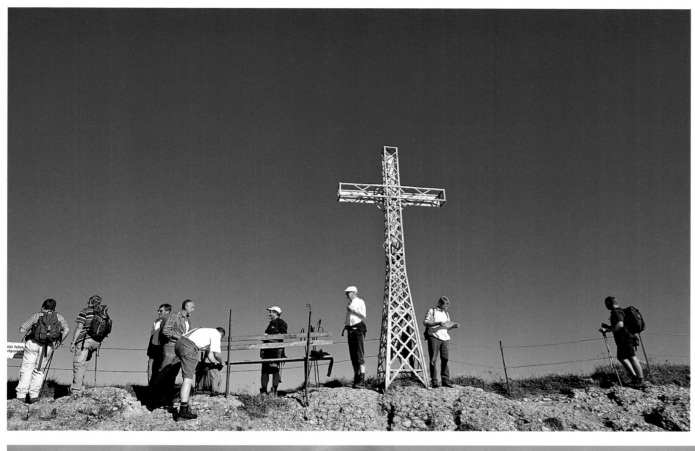

At 1,832 metres (6,011 feet) above sea level the Hochgrat is the highest of the West Allgäu mountains and the most readily distinguishable pinnacle in the Nagelfluh Range. Nagelfluh or gompholite is a type of rock composed of scree and a clay and lime binding agent which evolved with the Ice Age glaciers. Positioned bang in front of the high Allgäu Alps, hikers who tackle this range are rewarded with spectacular views of distant, more loftier summits from the Zug-spitze to the Säntis and of Lake Constance and the undulating countryside of Upper Swabia.

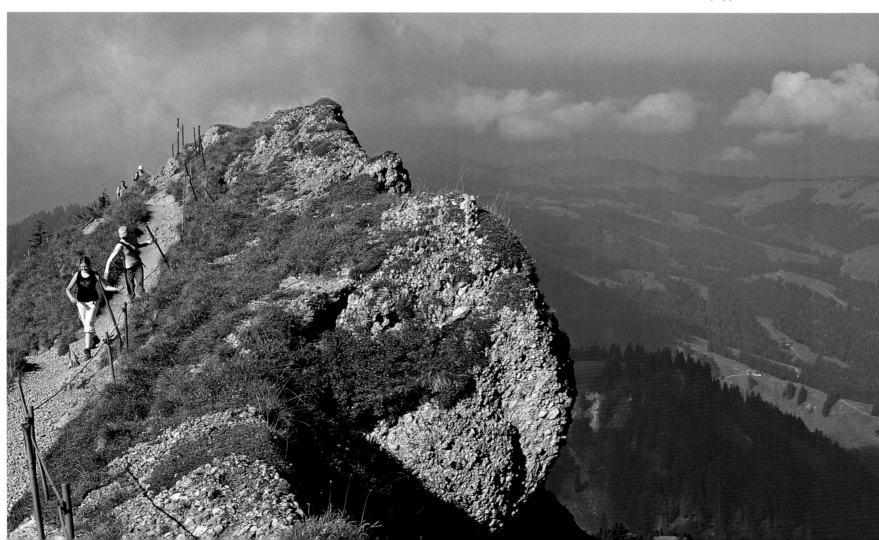

Right:
In Hirschegg, one of the
four villages of the
Kleinwalsertal, all of them
graced with breathtaking
panoramas, the white
facade of the parish church
mirrors the brilliance of its
snowy surroundings.

Below:
The Kleinwalsertal is
surrounded by imposing
peaks, among them the
Hoher Ifen, Walmendinger
Horn, Widderstein and
Kanzelwand. It's extremely

popular with cross-country
skiers, both for its abun-
dance of snow and its
marvellous panoramic
trails. Mittelberg (depicted
here) is the oldest village
in the valley.

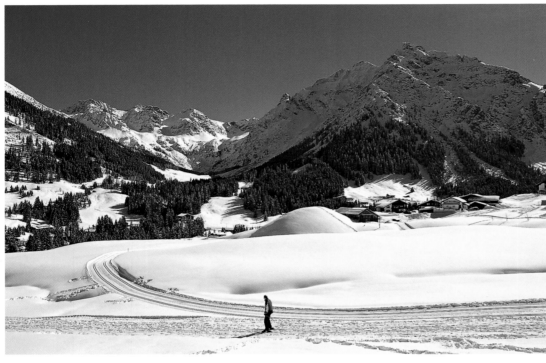

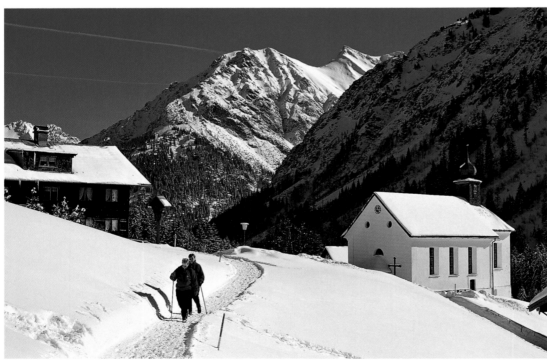

Above:
Hidden away at the end of
the Kleinwalsertal at an
impressive height of over
1,200 metres (3,900 feet)

above sea level the charm-
ing village of Baad almost
seems to disappear under
feet of snow in the winter.

Page 78/79:
In winter you can find
plenty of unspoilt scenery
in the area around
Mittelberg and isolated

mountain huts set against
the unique backdrop of
the Allgäu Alps. Here the
view is of the Zwölferkopf
(2,224 metres / 7,297 feet).

76

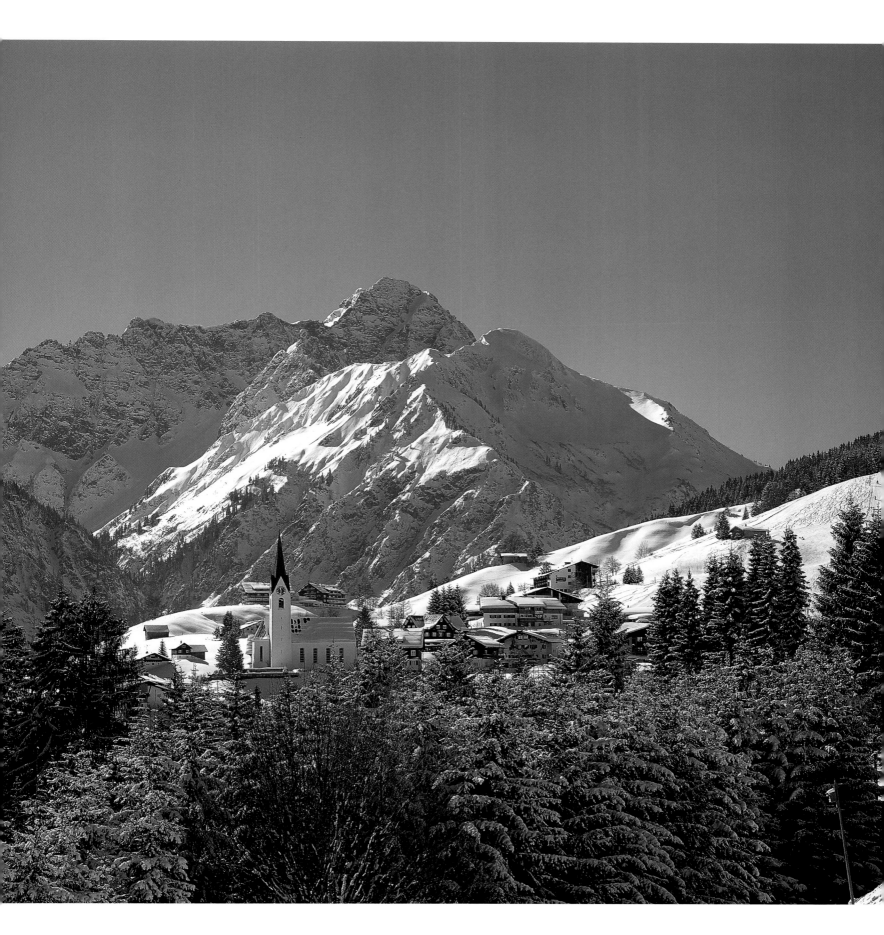

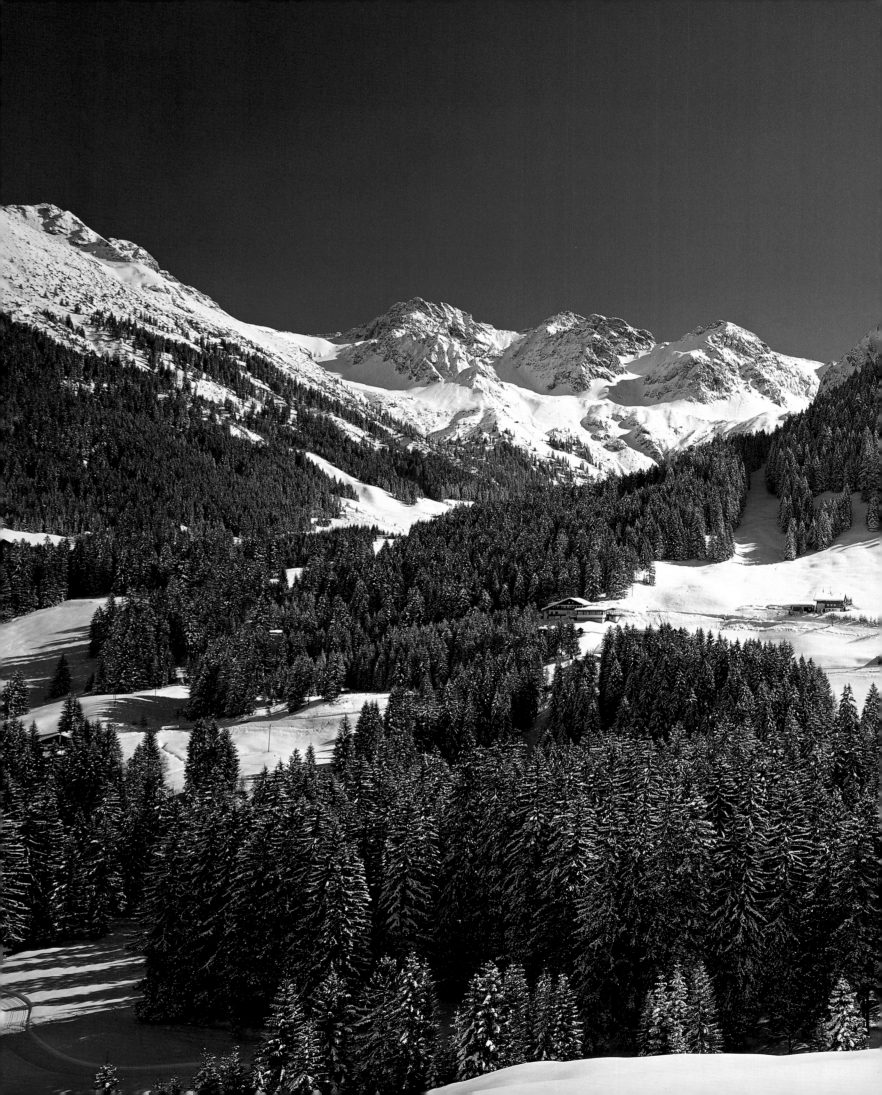

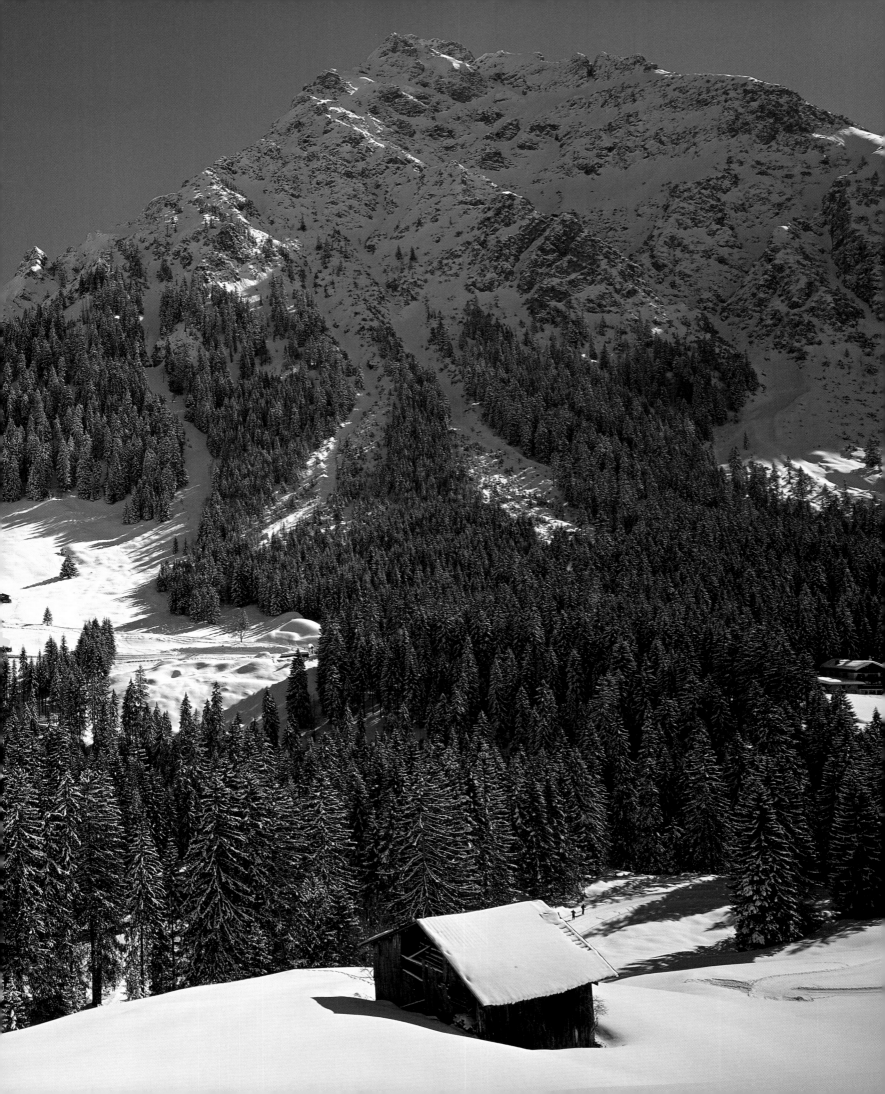

Below:
The Hoher Ifen is classed
as one of the most eccen-
tric mountain formations
in the northern limestone
Alps. Like an enormous

upturned tray it sprawls
across the southern edge
of the Gottesackerplateau,
a jagged limestone plate
weathered out of the rock.

Top right:
The ridgetop trails winding
along the grassy slopes of
the Walmendinger Horn
are treacherous after
heavy rainfall. The views

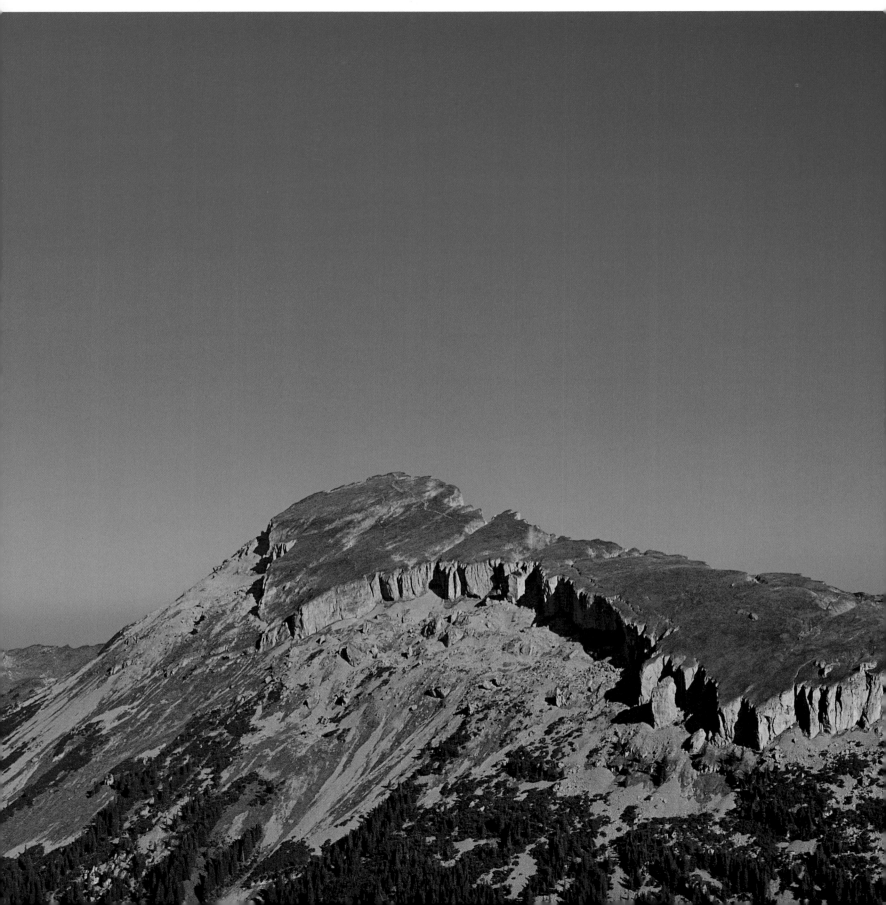

from the summit, however, are well worth the climb, with the Hoher Ifen, Gottesackerplateau and Kleinwalsertal spread out before you.

Centre right:
Battered by the elements for many, many years, this ancient stone cross near Mittelberg is a place for weary travellers to pause for a moment's prayer and reflection.

Bottom right:
The cable car servicing the Walmendinger Horn provides comfortable and easy access to the fantastic panoramas of the Kleinwalsertal and the limestone and flysch Alps surrounding it.

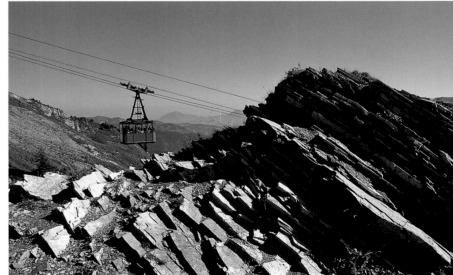

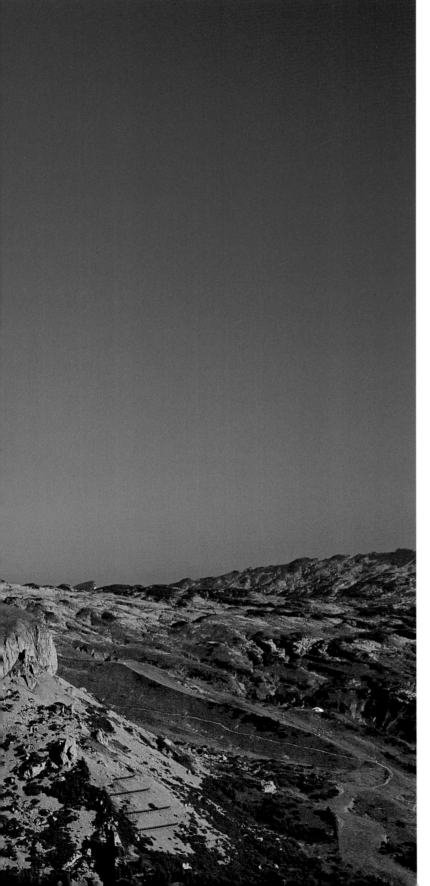

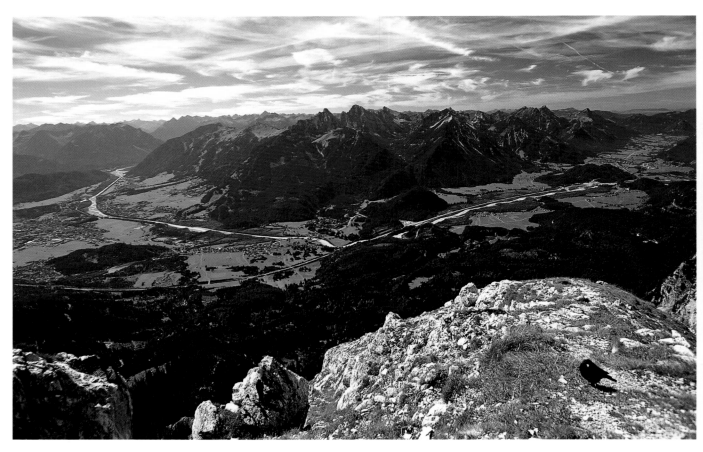

The small spa and tourist town of Scheidegg is spectacularly located, with grand vistas of the neighbouring Austrian Alps.

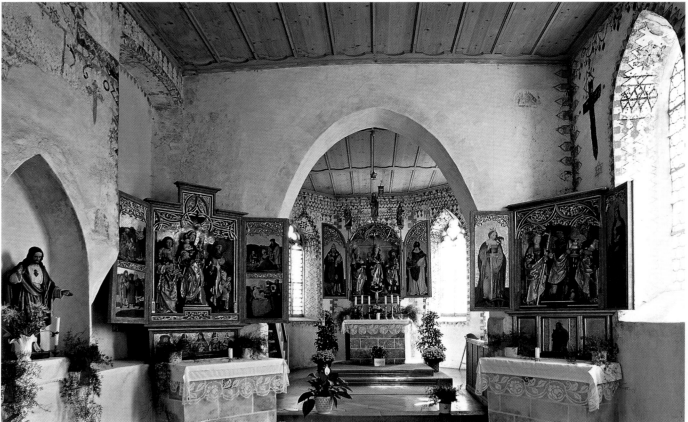

Dotted along the old salt route which ran from Hall in Tyrol through what is now the Upper Allgäu to Italy are a number of tiny churches and chapels, such as this one in Genhofen near Bad Oberstaufen. The 15th-century interior of the church, dedicated to St Steven, is impressive, with sections of the chancel walls adorned with folk ornaments, traditional symbols and depictions of animals.

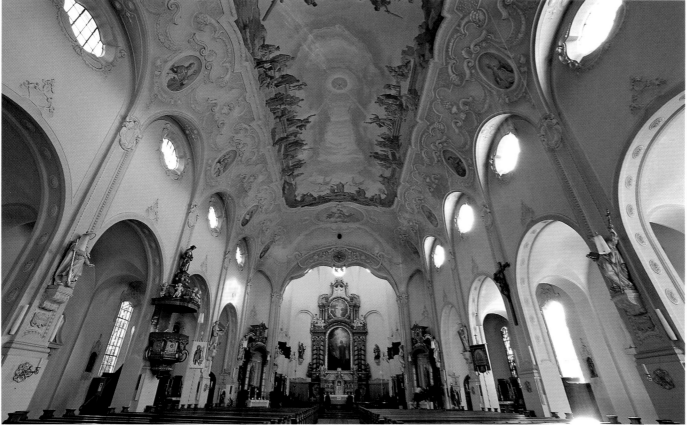

Lindenberg boasts both marvellous panoramas and the resplendent parish church of St Peter and Paul. Appearances can be deceptive, however; the seemingly baroque decor is in fact a creation of the early 20th century.

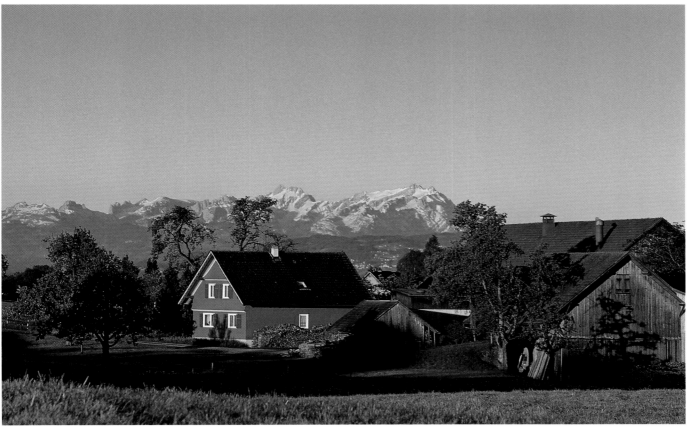

Rooms with a view are aplenty in Niederstaufen near Lindenberg, which overlooks the nearby snow-capped peaks of the Austrian mountains.

Page 84/85:
View of "paradise" on the Kapf near Oberstaufen-Lauffenegg. It really is heavenly here on that famous bend in the Deutsche Alpenstraße or German Alpine Route. A hiking trail leads up from the Schroth spa town of Oberstaufen to the summit of the Kapf (998 m/3,274 ft) and wonderful views of the surrounding countryside.

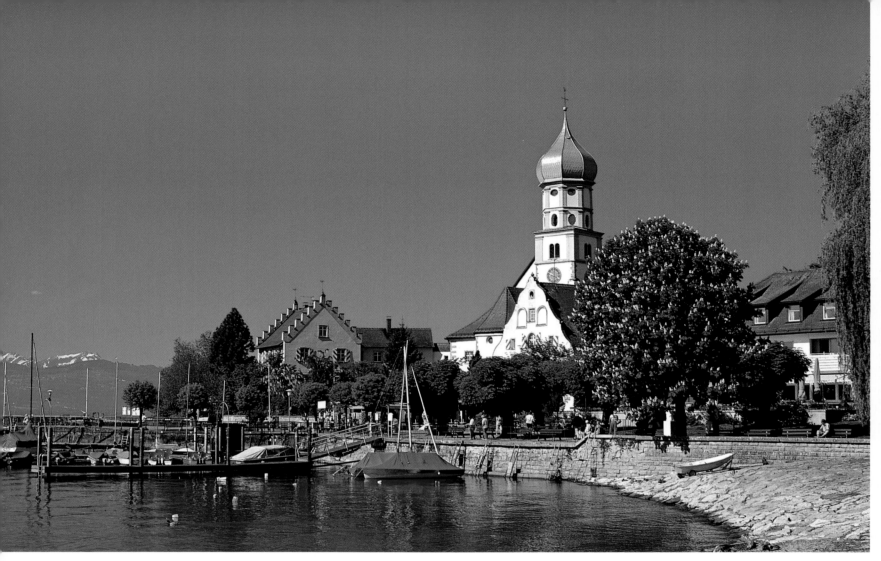

Above:
With its fruit tress and vineyards, Wasserburg on the shores of Lake Constance has a distinctively Mediterranean flair.

Right:
Isny is the smallest of the old free cities of the Holy Roman Empire. As the result of a terrible fire in the 17th century the remaining original medieval buildings are interspersed with handsome baroque dwellings.

Page 88/89:
Lindau's lakeside harbour was laid out in 1856, with its Bavarian lion and lighthouse (the only one in Bavaria and not shown here) erected as local landmarks.

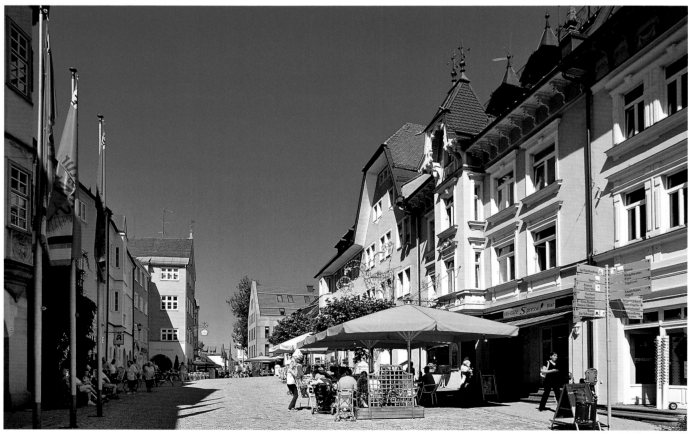

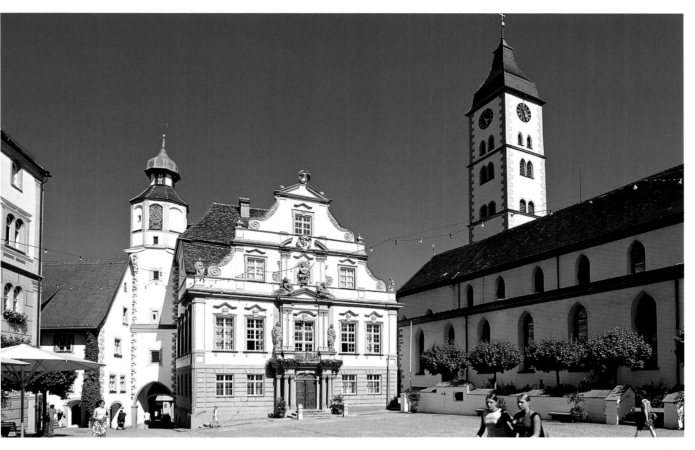

Left:
There's an old saying in Wangen that once you're here, you'll never want to leave. And it's easy to see why. Its medieval towers, artisans' houses and patrician palaces with their oriel windows and ornate gables, its narrow winding streets and inviting squares have magnetic qualities which are hard to resist.

Below:
The staircase in the Neues Schloss in Bad Wurzach is heralded as the most beautiful of its kind in Upper Swabia for both its twin set of spiralling steps and its elaborate ceiling fresco showing Hercules ascending to the heavens.

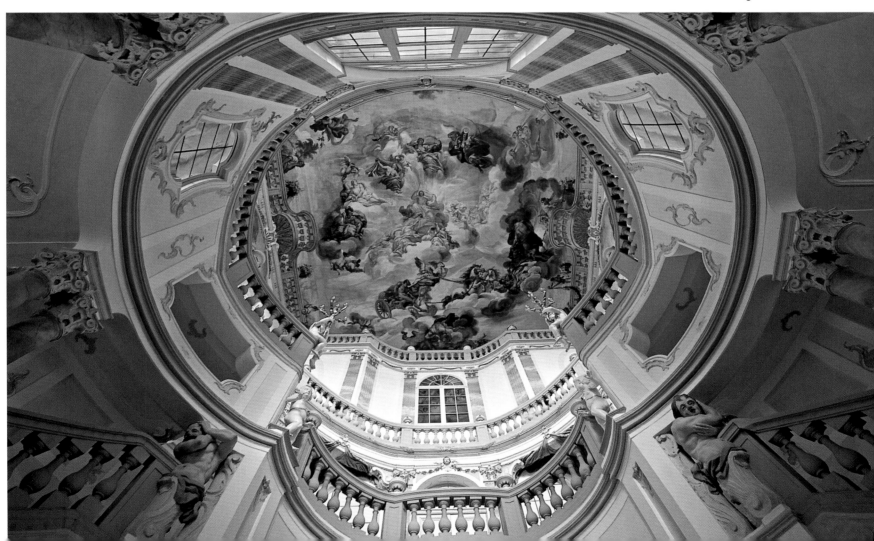

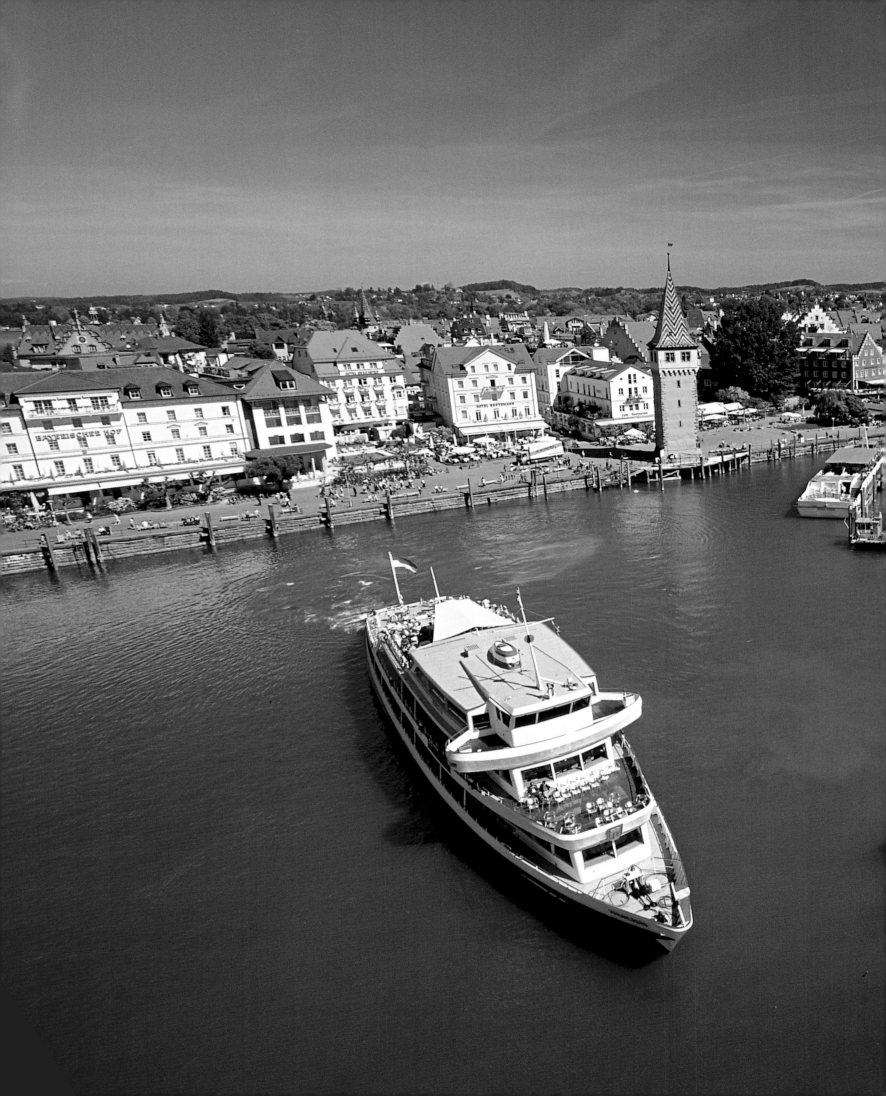

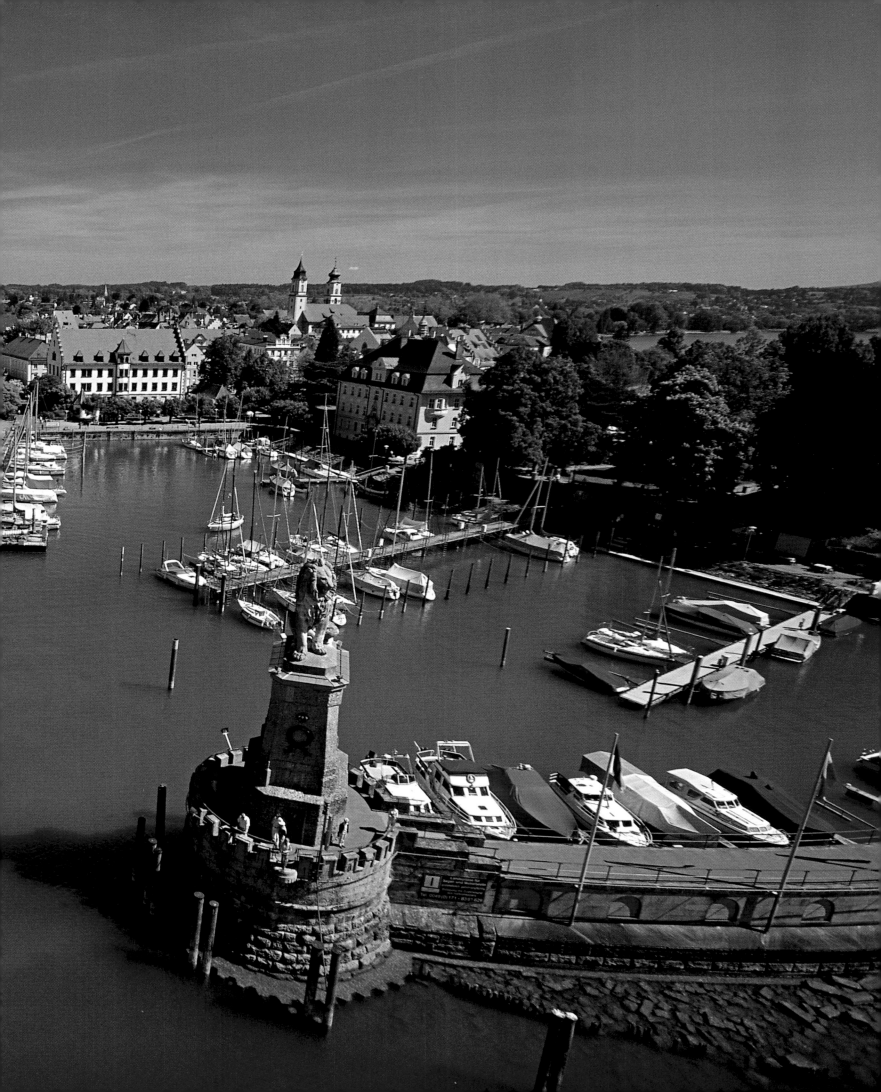

Fairytale castles and sparkling lakes – the East Allgäu

Page 92/93:
Up to 60 metres (200 feet) deep in places, the turquoise Alpsee, watched over by the castles of Hohenschwangau and Neuschwanstein, was one of King Ludwig II's favourite spots. He often swam or rowed across the lake and on his 20th birthday had scenes from Wagner's "Lohengrin" specially staged on its waters.

Right:
Dizzily spanning the precipitous ravine of the Pöllat Gorge, the Marienbrücke provides those with a head for heights with the best views of Schloss Neuschwanstein in all its splendour and glory.

The hallmark of the East Allgäu are its royal castles. Nestled in dark swathes of forest the squat ochre Schloss Hohenschwangau and its virgin white, elegant counterpart Schloss Hohenschwangau are impressively situated against a marvellous Alpine backdrop. The highest peak in the area and King Ludwig II's nearest mountain is the Säuling which towers 2,047 metres (6,716 feet) high up above the many villages and lakes of the region. The largest and youngest lake is the Forggensee which unlike most of its peers is not a relic from the Ice Age but an addition from the 1950s when it was dammed. Built to generate electricity and to prevent flooding it now has another important function – namely as a lido for windsurfers, sailors and swimmers. The baroque town of Füssen clings to the shores of the lake to which numerous 'followers' of King Ludwig II from all over the world still flock almost 120 years after his death. Nearby are the Hopfensee, Bannwaldsee, Alpsee and Schwansee lakes and many others, making the area an eldorado for water sports fanatics.

A little further north it is the medieval towns which lend the region its charisma. Kaufbeuren, once a free city of the Holy Roman Empire, is special for two reasons; it has both a historical town centre with a bevy of richly ornamented facades and a new town, Neugablonz, created on the drawing board for Germans driven from the Sudetenland at the end of the Second World War. In Mindelheim, the northernmost town in the Allgäu, tourism has a modest role to play; the charm of its medieval centre with its proud town houses, painted facades and narrow streets lies in its great sense of calm and contemplation.

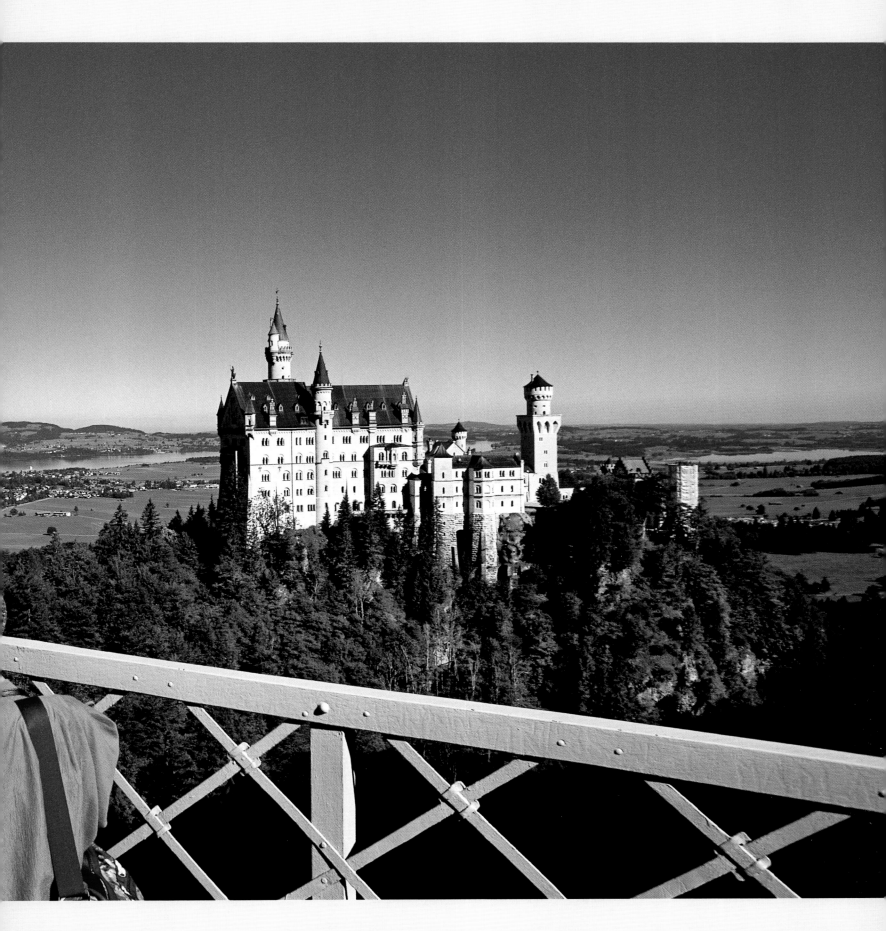

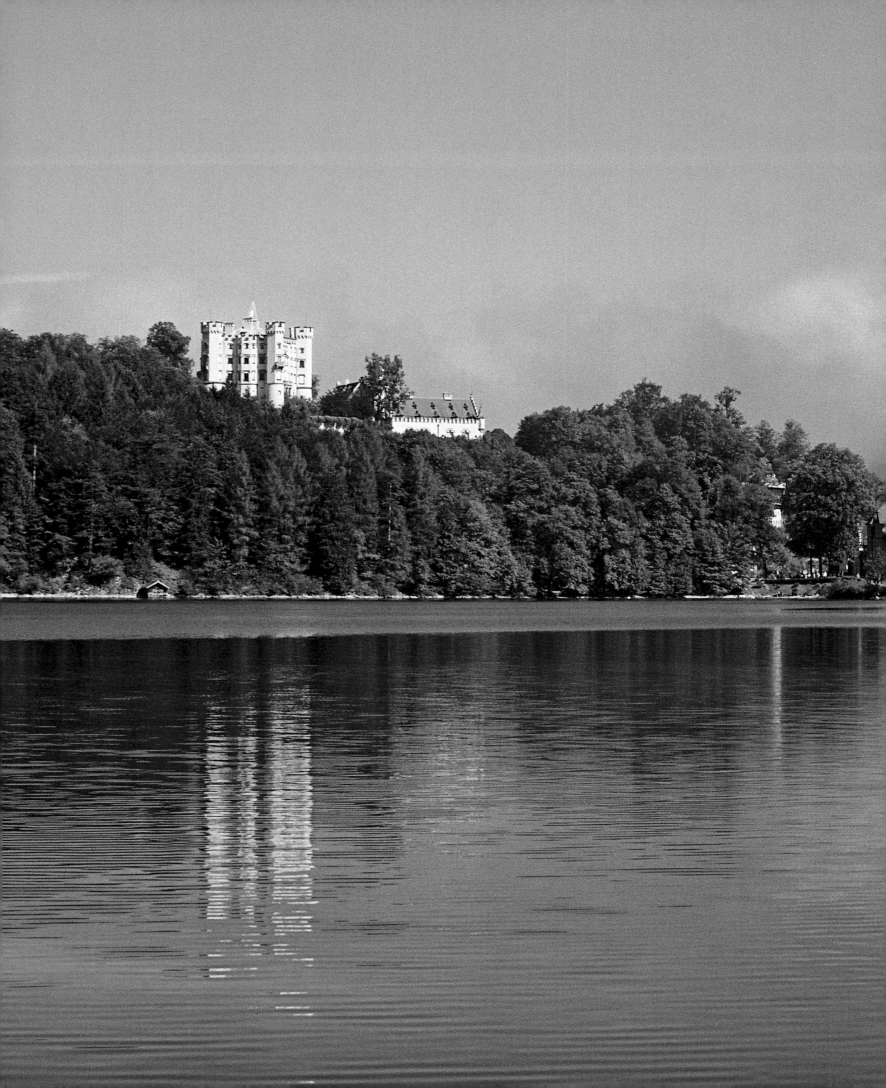

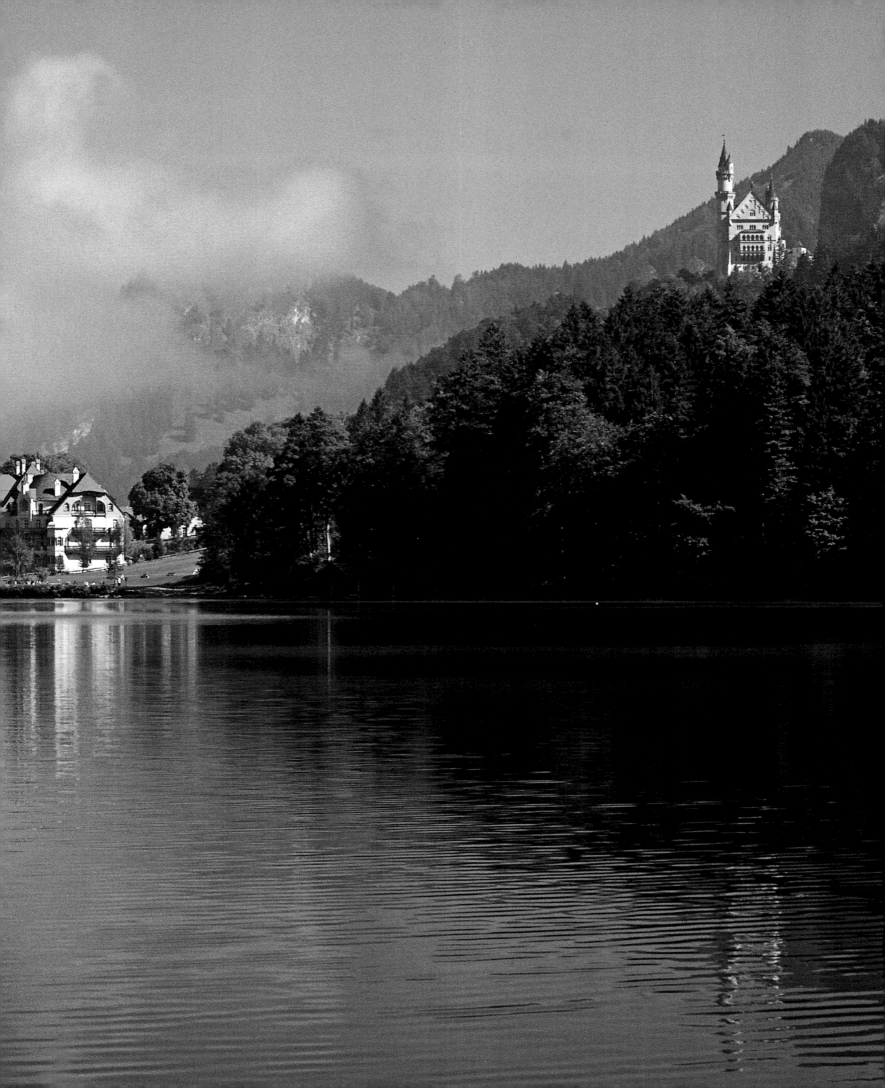

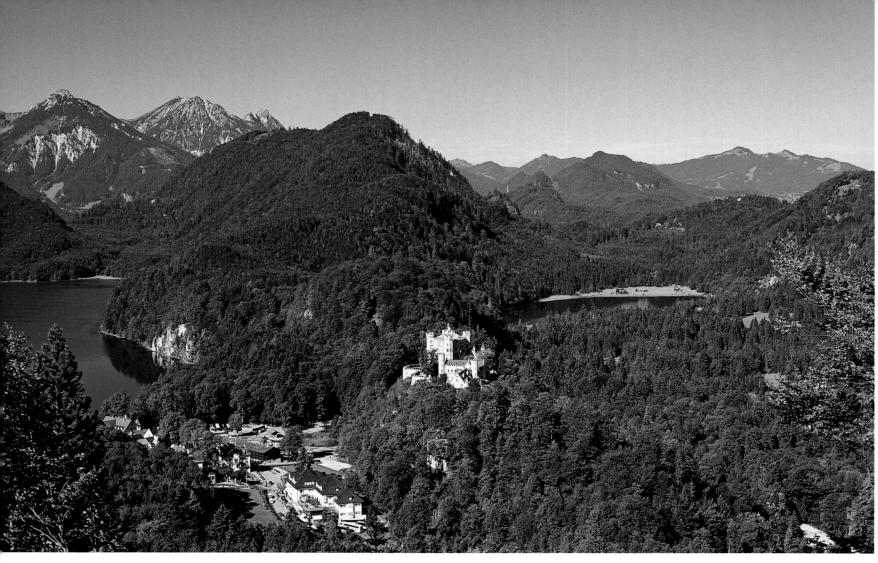

Above:
En route to Säuling Mountain there are spectacular views of the Alpsee, the Hohenschwangau and its castle of the same name dating back to the 12th century. Schloss Hohenschwangau took on its present guise in the 1830s when Crown Prince Maximilian II discovered the ruin and had it turned into a mock-medieval fortress.

Right:
Jutting up into the sky like a giant pyramid, the limestone Säuling in the Alpine foothills of the East Allgäu is visible for miles around. 2,047 metres (6,716 feet) high it's a popular destination, not least for its breath-taking views of the Tannheim Alps and the valley of the River Lech.

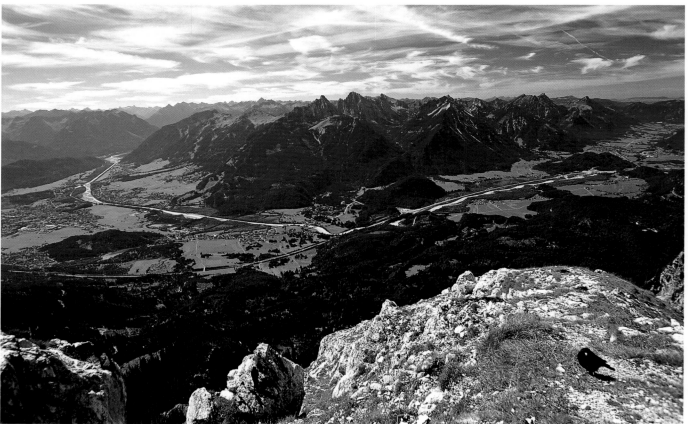

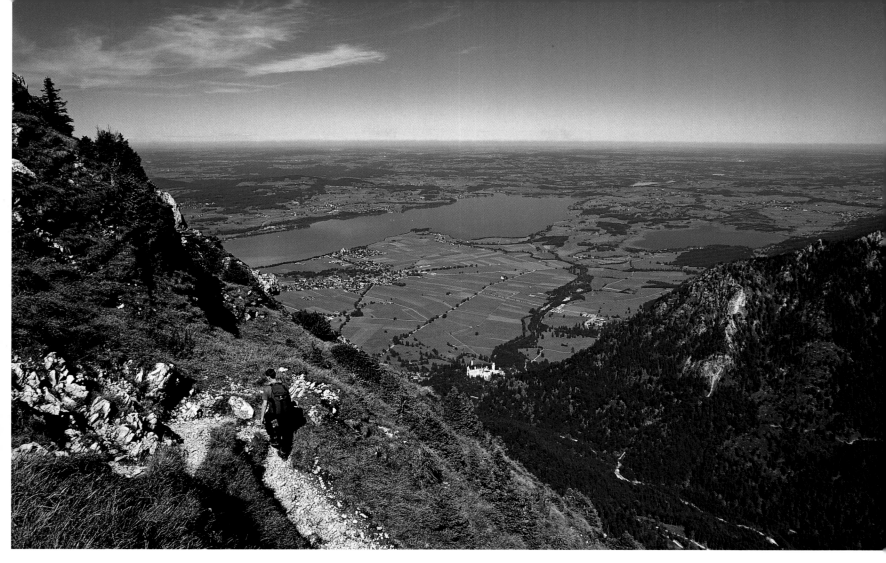

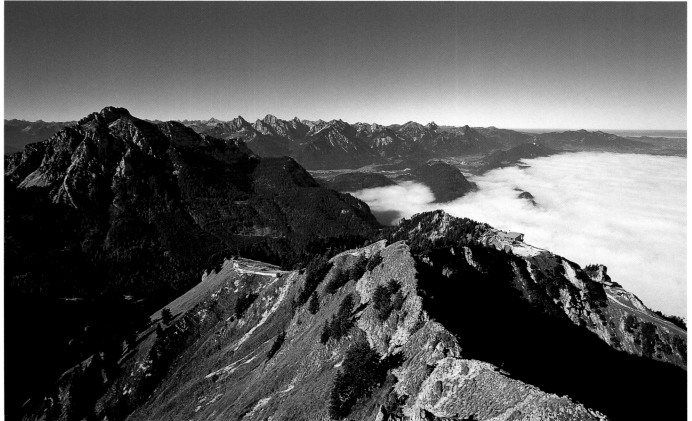

Above:
Surrounded by forest, Ludwig II's fairytale castle looks out across the Forggensee to the Alpine foothills. Originally built as a retreat for the king, his private residence is now a tourist magnet for visitors from all over the world.

Left:
Whichever way you look at it, the pyramid massif of Säuling Mountain is absolutely unmistakable. In the background are the Tannheim Alps.

FIT FOR A KING — THE CASTLES OF HOHENSCHWANGAU AND NEUSCHWANSTEIN

Stately homes, ruined castles and regal residences are aplenty in the Allgäu, all with their own exciting tales to tell of knights in shining armour, peasant revolts, mighty prince-bishops and powerful local lords. Yet none exert as great a magnetism as the two royal castles of Hohenschwangau and Neuschwanstein. Both magnificent and majestic, they stand proud against their breathtaking Alpine backdrop, a homage in stone to the Romantic transfiguration of the Middle Ages with its legendary tales of heroic deeds and courtly romance.

And as the two castles epitomise a romantic desire to relive the past, they too are inextricably linked to the name of King Ludwig II of Bavaria. The young prince spent much of his childhood at Schloss Hohenschwangau and later had Schloss Neuschwanstein erected at great expense, living in his castle in the air for just two short years. Although at a first glance they may not appear so, both Neuschwanstein and Hohenschwangau are products of the 19th century, idealised interpretations which despite their relative youth look back on a long tradition. Where Hohenschwangau now stands was once an 11th-century castle built by the knights of Schwangau. When the dynasty died out in the 16th century their mighty fortress fell into decline. It changed hands several times and had been restored, destroyed and again reconstructed when in 1829 the 18-year-old Crown Prince Maximilian of Bavaria came across it idyllically hugging a forest slope between Alpsee and Schwansee lakes. It was love at first sight. The prince bought the sorry remains and had them resurrected as a mock-medieval castle, placing great value on the remaining historic fabric and on the memories and legends surrounding this magical place. Royal artist Domenico Quaglio pulled out all the stops to please his master and created a neo-Gothic masterpiece, complete with towers, turrets and ramparts, a rose garden with tinkling fountains and a swan spouting jets of water. The royal apartments of the "fairy palace", as Ludwig I, Maximilian's father, referred to it, are still adorned with the original ornamental frescos, bringing a blaze of colour to every single room. They depict among other things the saga of Lohengrin, ancient myths, tales from the Orient and various historical events.

Fairytale hamlet for a royal recluse

The pensive and playful Crown Prince Ludwig II spent much of his time as a young boy in splendid isolation at Hohenschwangau, a place which undoubtedly greatly influenced him in his formative years and probably precipitated his retreat into an imaginary dream world of mountains and castles. The king loved art and music and the legends and poetry of the Middle Ages much more than he did politics or current affairs. In 1868 he announced to his friend Richard Wagner, a man he greatly idolised and admired, his "intention of rebuilding the old ruin of Hohenschwangau at the Pöllat Gorge in the genuine style of the ancient German castle". A palace was to be created which "in all respects (shall be) more beautiful and more accommodating (...) than the lower Hohenschwangau which (...) has been violated by the prose of my mother".

Inspired by the Wartburg near Eisenach and Château Pierrefond at Compiègne, an army of builders headed by royal secretary Düfflipp, royal builder Eduard Riedel and theatrical painter Christian Jank set to work restoring the high-lying ruins of Hohenschwangau, a mere stone's throw from the king's lower palace of the same name. The project at what is now Neuschwanstein proved prohibitively expensive, slowing progress to such an extent that on the king's mysterious death in 1886 his fairytale palace was only finished in part. In time, in a monumental setting of mountains, lakes and

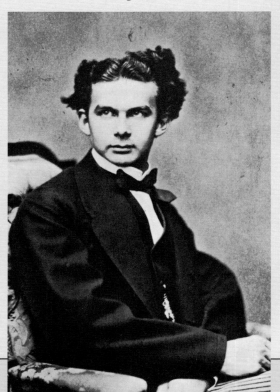

Left:
A man who tried to make his dreams come true: King Ludwig II (1845– 1886), whose castles in the air were an escape from the all too real responsibilities of kingship and politics.

Above:
Schloss Neuschwanstein under construction. This view of the upper courtyard from 1886 illustrates the huge scale of the project.

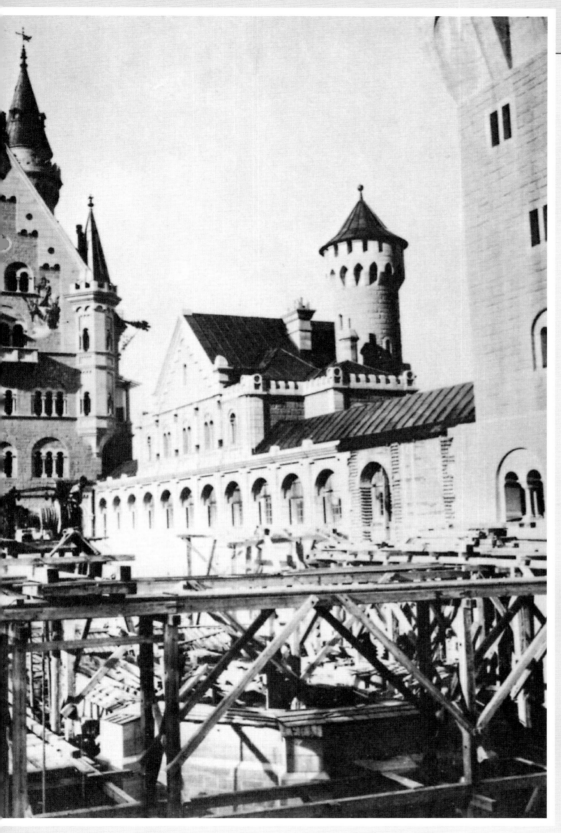

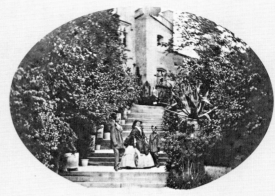

forest, an absolute gem was created which still fascinates today, its unique location, highly imaginative, elegantly complex architecture and its sumptuous, richly ornate interiors never failing to impress and astound. At Ludwig's request the motifs and designs for his palace furnishings were all taken from the epics of the Middle Ages, such as "Tristan and Isolde" and "Parsifal", manifestations of the king's desire to escape into a fantasy world devoted to a romantic vision of the past. "Preserve these rooms as you would a holy relic; let them not be desecrated by the inquisitive, for here I have spent the bitterest hours of my life", the king begged his servants shortly before he was taken from his castle of the Holy Grail, robbed of office and declared insane. His final wish has been denied him; since the death of Ludwig II, the place where no stranger shall dare to tread has been stormed by over 50 million visitors.

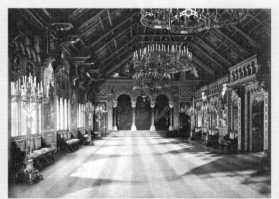

Top right:
Born in Schloss Nymphenburg in Munich, King Ludwig II of Bavaria spent much of his childhood at his parental home of Schloss Hohenschwangau. He stands here with his mother and brother (right) on the castle steps.

Centre right:
The Throne Hall at Schloss Neuschwanstein is a lavish affair built in the style of the Byzantine period.

Right:
Schloss Hohenschwangau seen from the Alpsee, captured on film in the days when photography was a long and complicated undertaking.

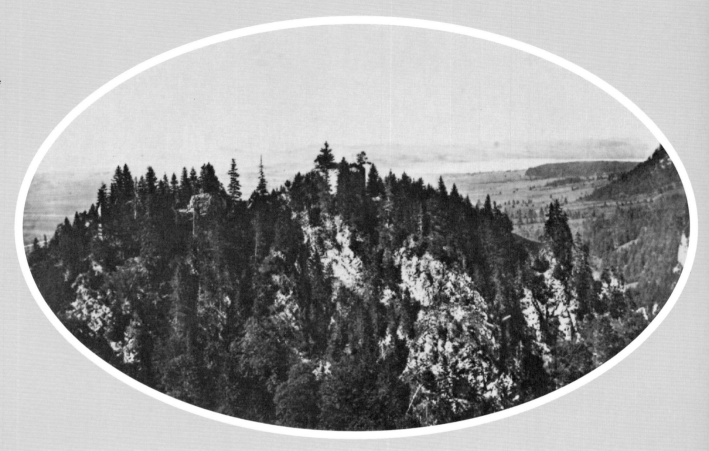

Seen here before construction began, Neuschwanstein was erected high up above a valley on top of the ruins of Vorderhohenschwangau Castle.

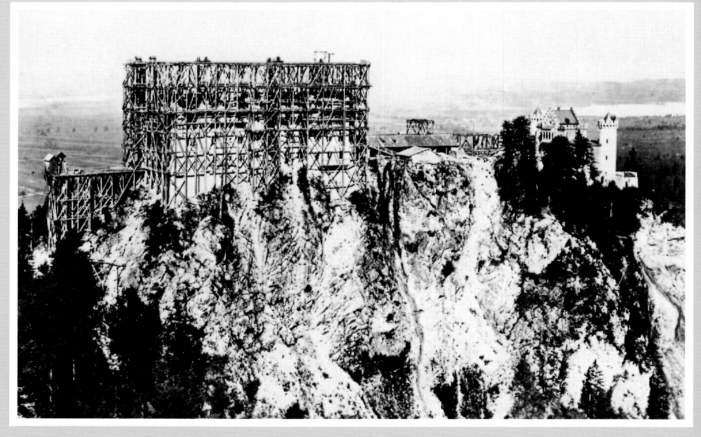

Huge sections of dizzy scaffolding were needed to erect theatrical designer Christian Jank's mock-medieval castle fit for a king.

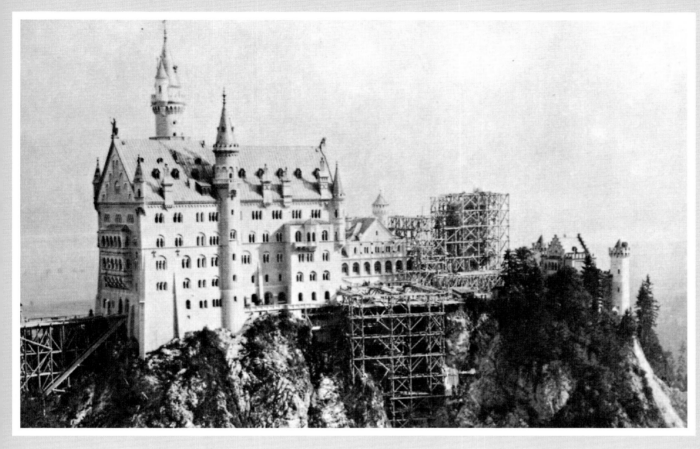

The exterior of Schloss Neuschwanstein was faced with blocks of white limestone. On the king's death neither the chapel nor keep had been built and are still missing today.

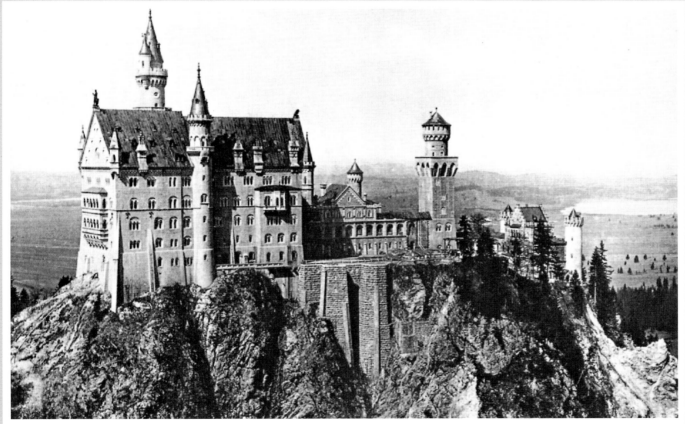

Barely two months after Ludwig II's untimely demise his sumptuous home was opened to the public. This photograph from 1886/87 shows the state the castle was in at the time.

Page 100/101: Neuschwanstein at dawn. With its gleaming white bays and turrets visible from afar, the castle towers high above the countryside on its rocky spur. The name Neuschwanstein comes from King Ludwig II's fascination with swans ("Schwan" in German). During his lifetime, however, the fairytale palace was known as Neue Burg Hohenschwangau or the new castle of Hohenschwangau.

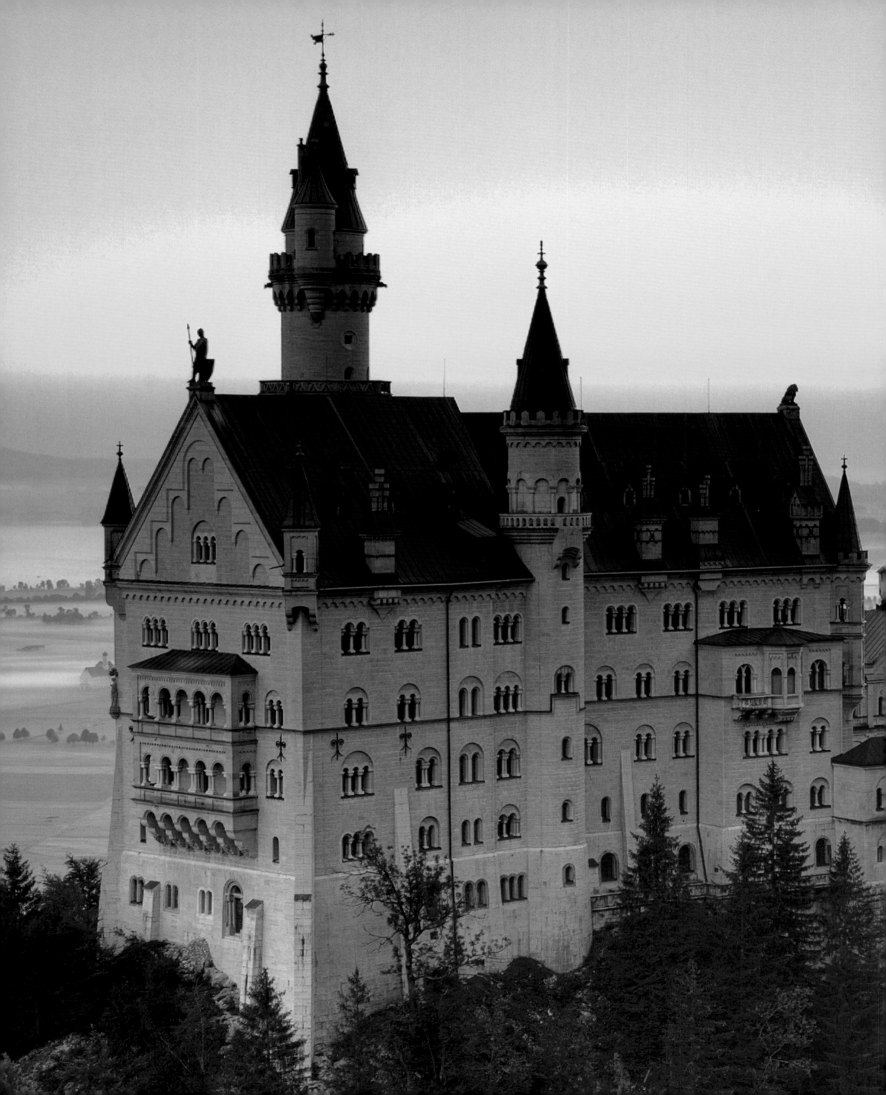

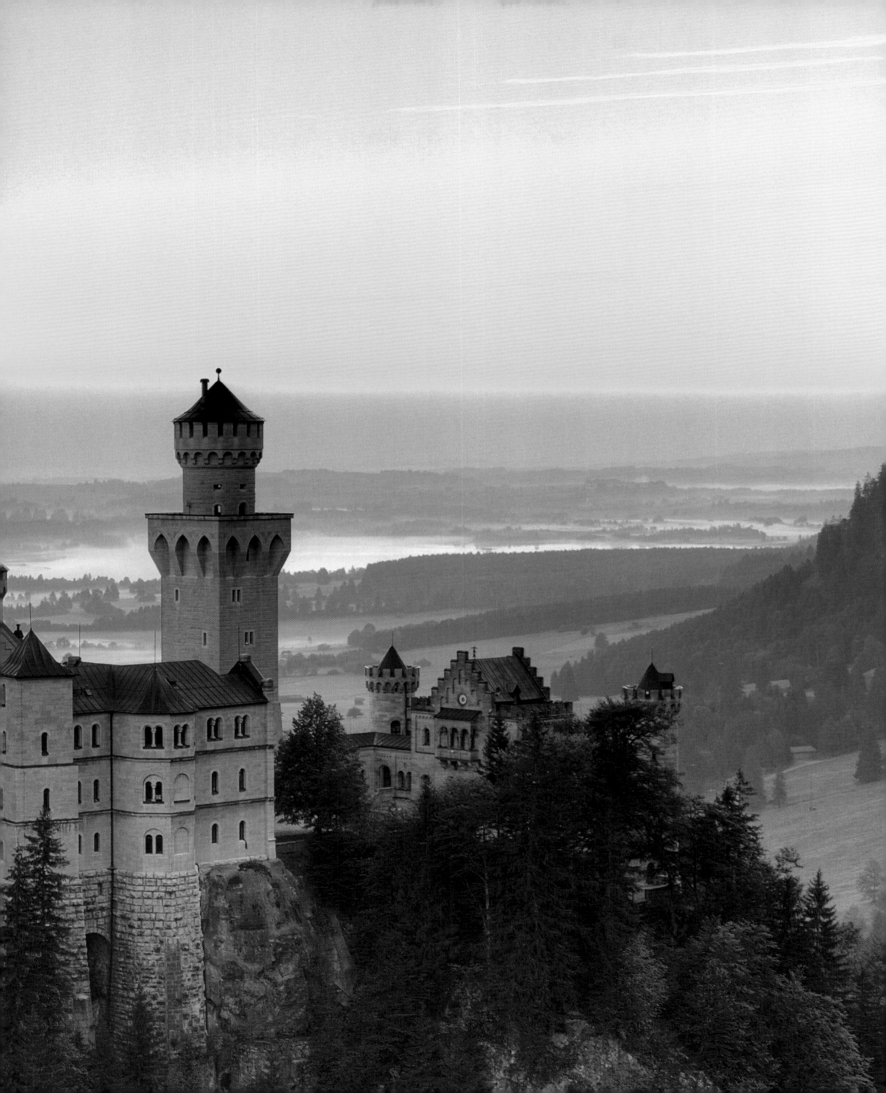

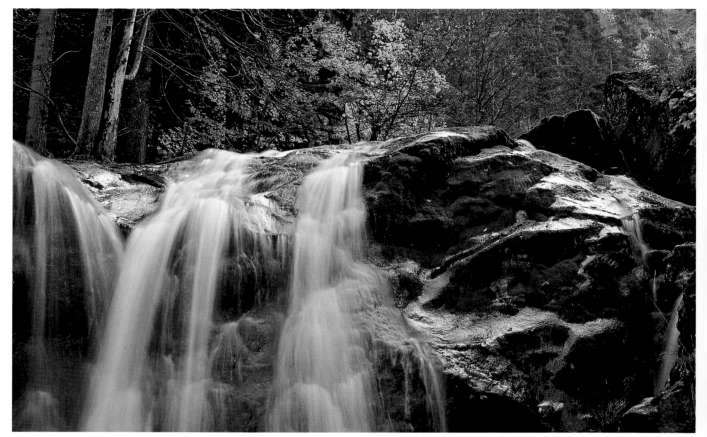

Right:
The Pöllat River hurtles down a steep gorge, its waterfalls and cascades battering anything in its path. King Ludwig II was immediately entranced by this wildly romantic setting, deciding to incorporate the ancient ruin of Vorderhohenschwangau into a new castle here. "This spot is one of the most beautiful there is", he enthused.

Below:
The spectacular scenery played a major part in Ludwig's choice of location for his dream home – a magical castle in the midst of enchanted forest.

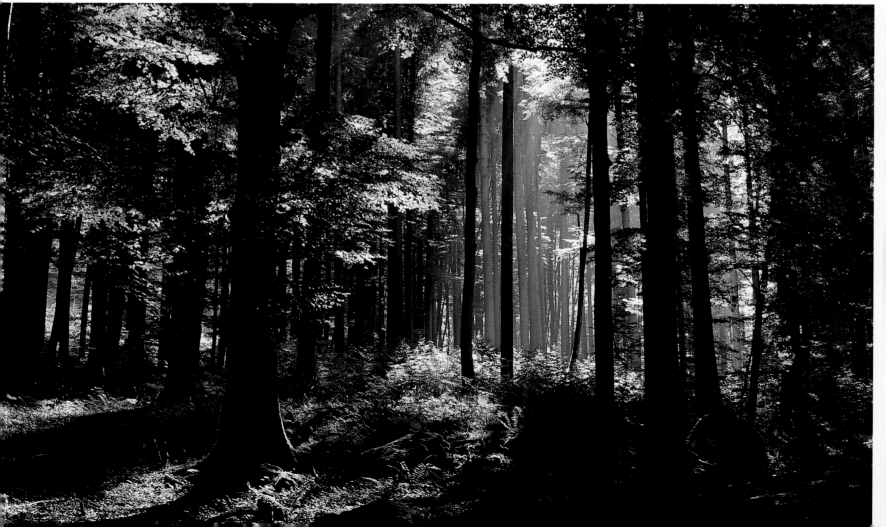

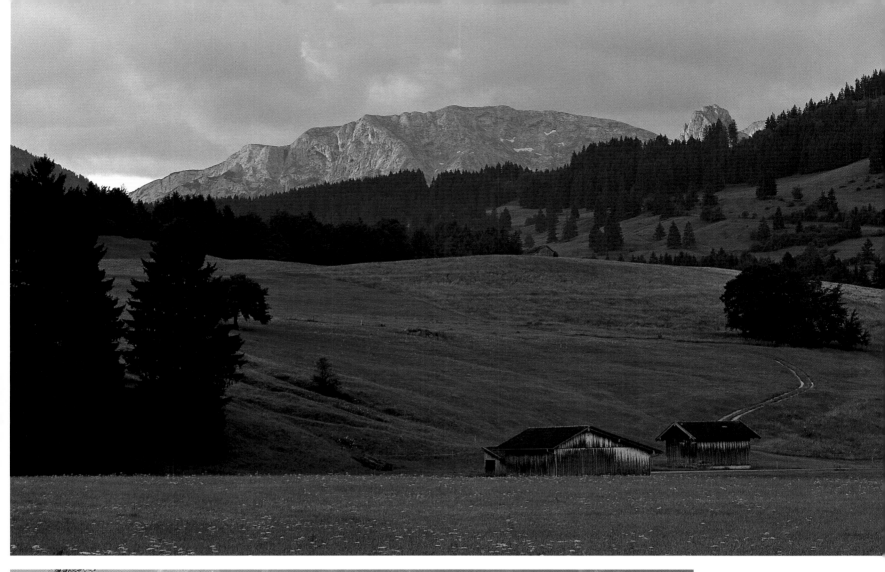

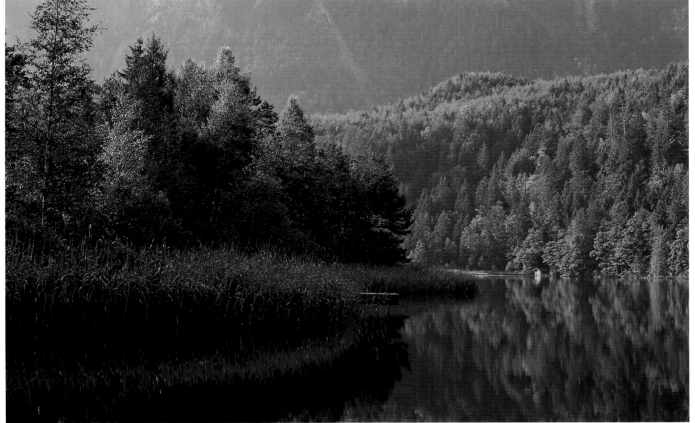

Above:
The morning sun kisses
the peaks near Halblech,
not far from the famous
royal castles of Hohen-
schwangau and Neu-
schwanstein. A recognised
health resort, Halblech is
the gateway to the Ammer-
gau Alps nature conserva-
tion area.

Left:
In the middle of the former
park encircling Hohen-
schwangau Castle is the
tiny Schwansee, the royals'
swan lake, surrounded
by the wooded slopes of
the Schwarzenberg and
Kienberg mountains.
A mile-long trail traces the
shoreline which has been
left in its natural state for
man and beast to enjoy.

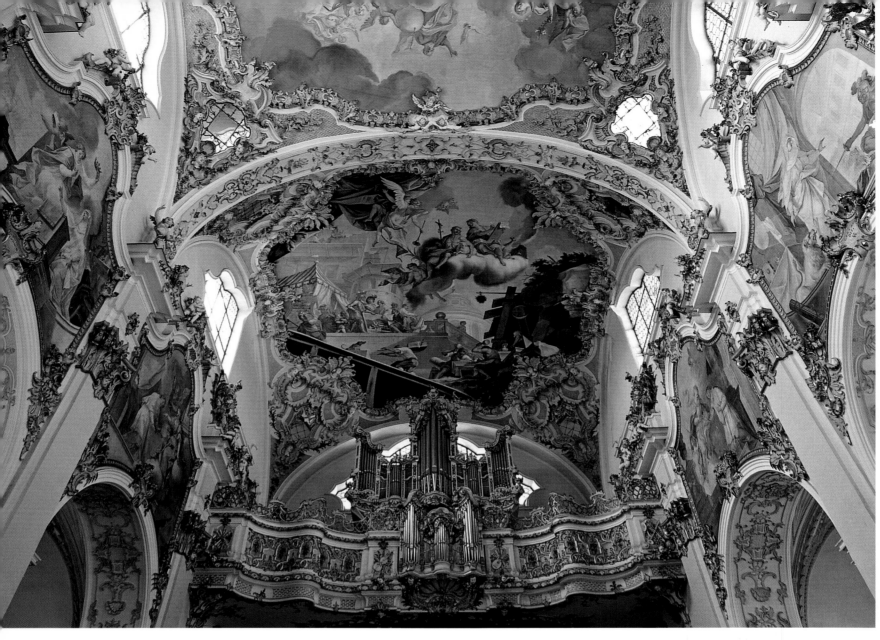

Above:
The simple Romanesque exterior of the collegiate church in Steingarden is a stark contrast to the extreme playfulness of the Rococo interior. The ornate frescos are the work of Augsburg royal artist Johann Bergmüller.

Right:
As at the pilgrimage church of St Coloman near Schwangau, Wessobrunn master of stucco Johann Schmuzer has excelled himself here too at the baroque pilgrimage chapel of Mariä Heim-suchung (the Visitation of Mary) in Ilgen near Steingarden.

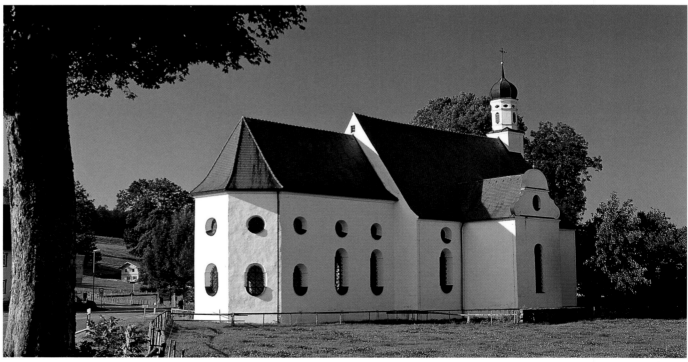

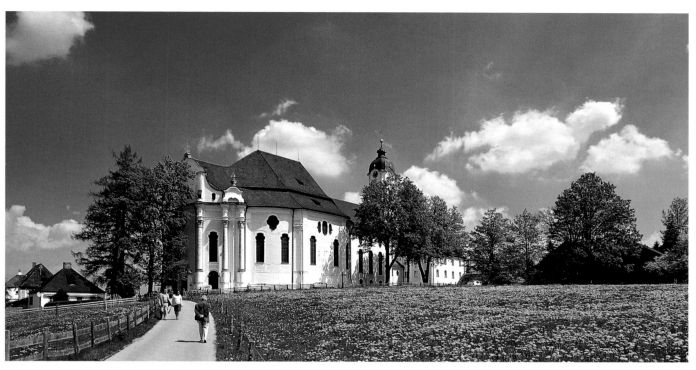

Left and below:
In the Pfaffenwinkel, the area between the Ammersee and Ammergau Alps famous for its many churches, the Wieskirche gleams a brilliant white against a blue Bavarian sky. The architecture, stucco and frescos expertly combine to form what is probably the most famous work of the Bavarian Rococo. The pilgrimage church was built in celebration of a miracle in which a local farmer's wife allegedly saw a statue of Christ shed real tears. Pilgrims flocked to the site, prompting the commissioning of a suitable place of worship in 1746.

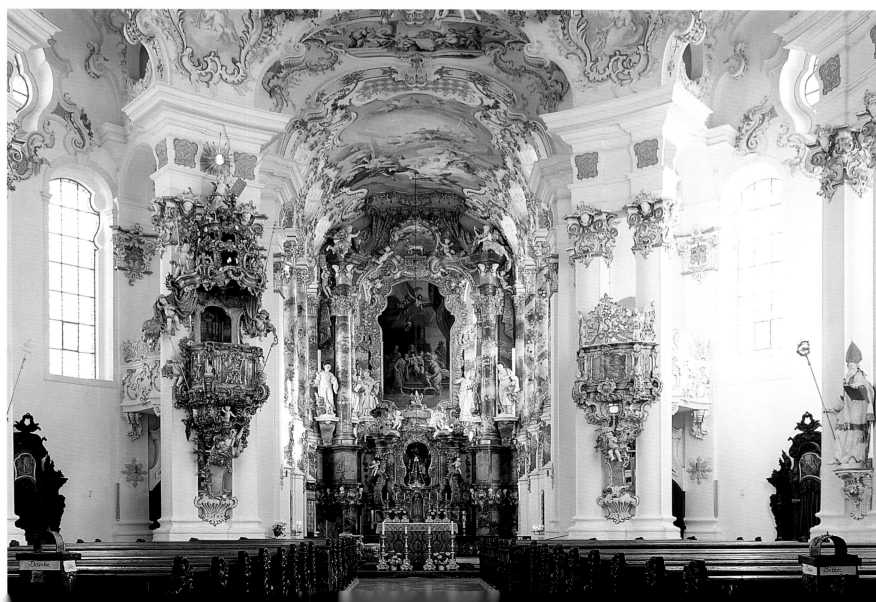

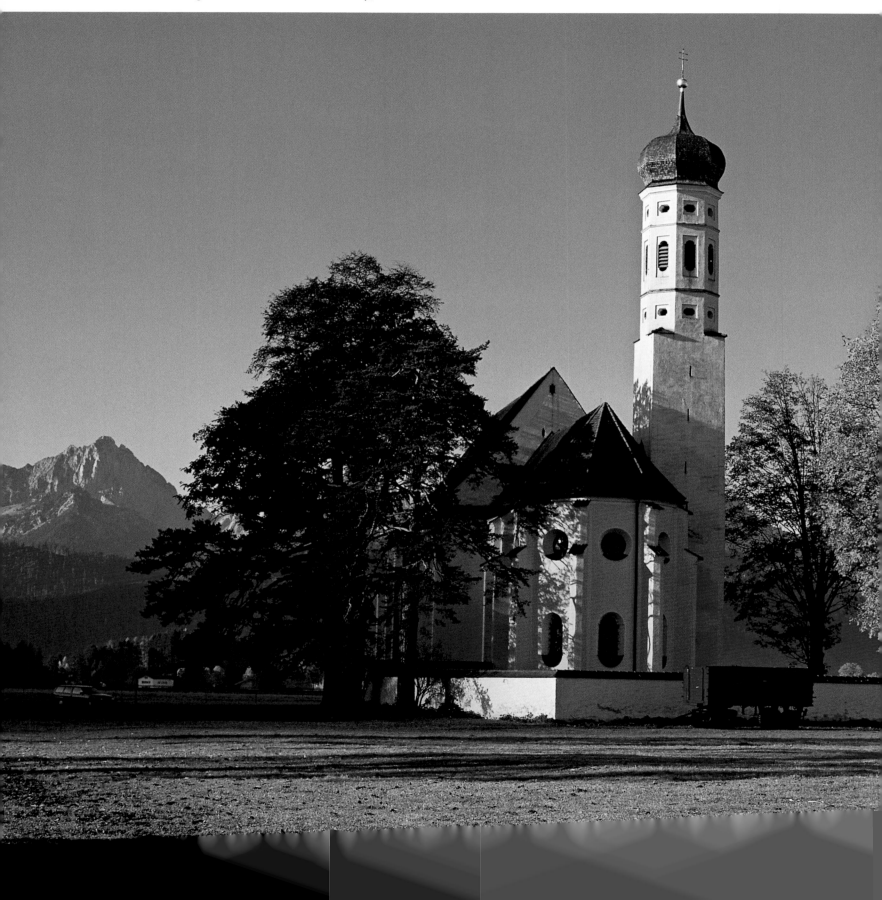

Below:
In c. 1000 the Irish pilgrim Colman or Columba stayed briefly in the Schwangau region on his way to Jerusalem. Following his murder shortly afterwards legend has it that a number of miracles occurred in the area. Centuries later, between 1673 and 1678, the pilgrimage church of St Coloman was erected in his honour and decked out in magnificent baroque stucco by Johann Schmuzer.

Small photos, right:
The herding of cattle down from their Alpine pastures in September is a festive affair in the mountain villages of the Allgäu when man and beast, young and old, take to the streets and meadows for a grand celebration. Here in Buching near Halblech a young cowherd (top right) proudly leads his wreathed charge safely home to her warm winter barn.

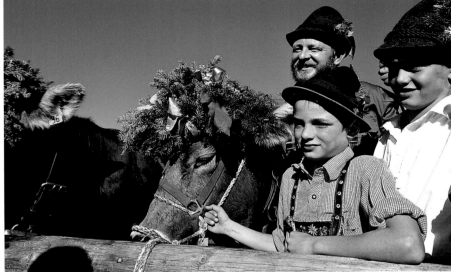

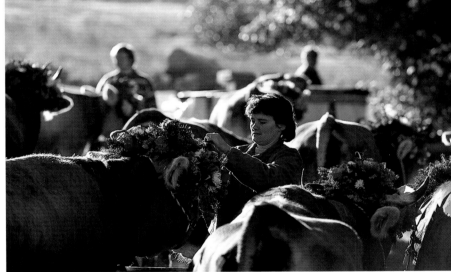

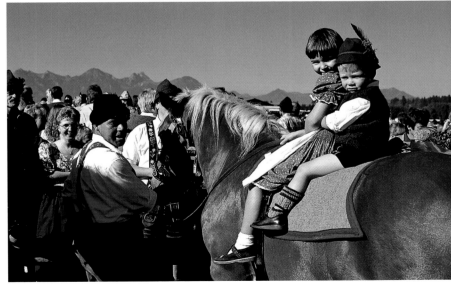

Right:
Girdled by meadows of wild flowers and rustling trees the idyllic Forggensee blends in perfectly with its Alpine surroundings as if it's always been part of the natural landscape. This is not the case; the lake is a relatively new creation from 1950 when the River Lech was dammed to create a huge reservoir.

Below:
At the time the damming of the Lech came under heavy attack from those who lost their farms and fields to the new reservoir. Today the critics are largely silent; now a popular tourist destination the Forggensee has proved a boon to the region with its many sports and leisure facilities.

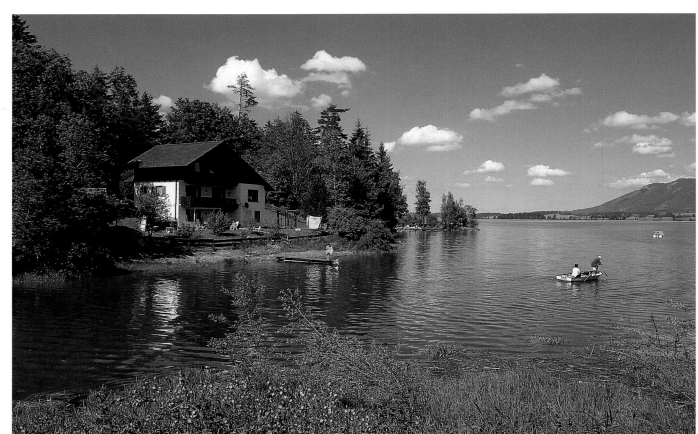

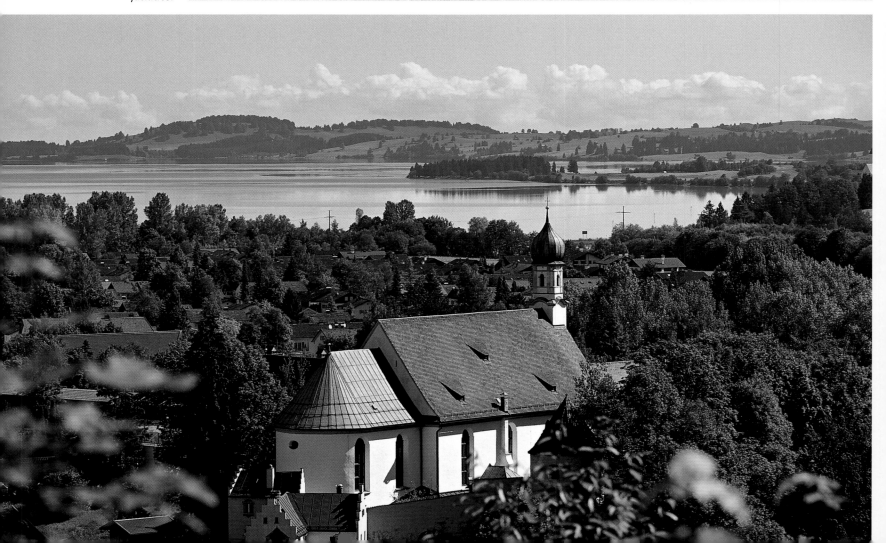

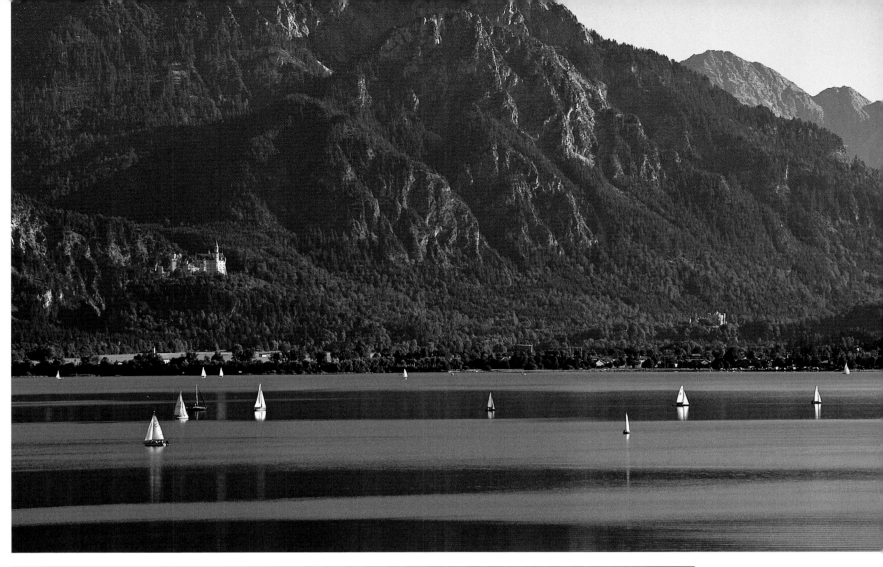

Above:
At the time the damming of the Lech came under heavy attack from those who lost their farms and fields to the new reservoir. Today the critics are largely silent; now a popular tourist destination framed by the castles of Neuschwanstein (left) and Hohenschwangau (right), the Forggensee has proved a boon to the region with its many sports and leisure facilities.

Left:
Hergatsrieder See in the East Allgäu is just one of the many lakes in the area which is famous for its numerous stretches of water, among them the Forggensee, Hopfensee, Bannwaldsee, Weißensee, Alpsee and many others.

Below:
Despite the floods of tourists from Germany and abroad stopping off at Füssen on their way to the castles of Hohenschwangau and Neuschwanstein the little town on the Forggen- see has lost none of its historical charm. Popular with Emperor Maximilian I, the town experienced a major boom during the Middle Ages as a centre of trade for merchants travelling north from Italy.

Top right:
The Hohes Schloss in Füssen towers high above the town, built on the site of a 3rd-century Roman camp erected to defend the road running between Augsburg and Italy. The edifice is one of the most significant late Gothic residences in Germany and the elaborate mock oriels painted onto its facade one of its most famous distinguishing features.

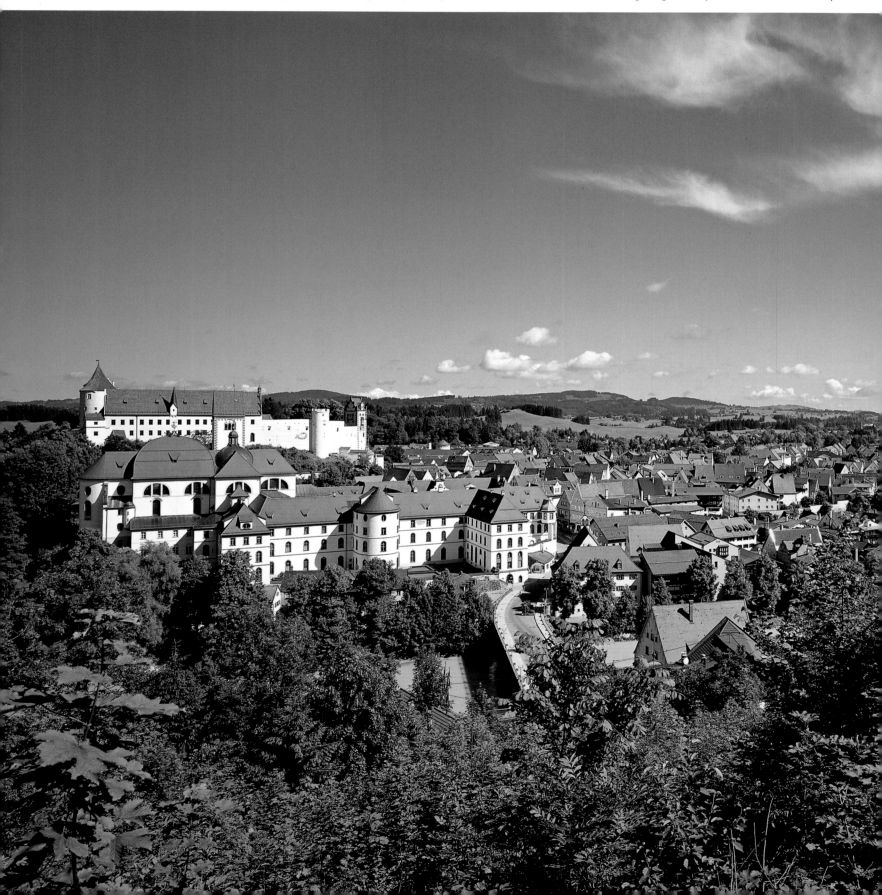

Centre right:
Even more instrumental in the development of Füssen than the Romans were the monks from St Gallen in Switzerland who founded a hermitage here during the 8th century. This grew into the Benedictine monastery of St Mang or St Magnus whose two-storey library is one of the most impressive rooms of the baroque complex.

Bottom right:
Another of St Mang's works of art is in the Annakapelle where artist Georg Hiebeler painted no less than 20 scenes depicting Death's attempted last dance with prospective victims.

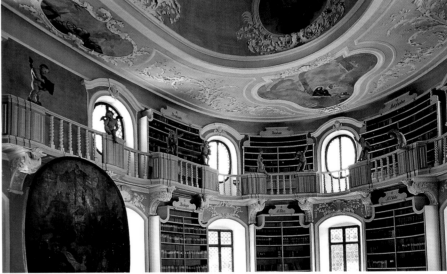

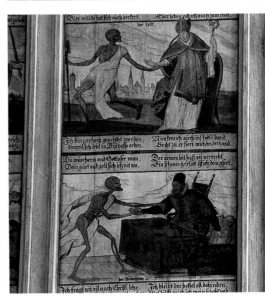
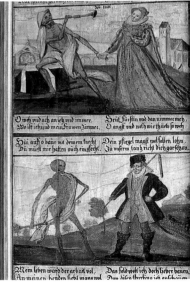

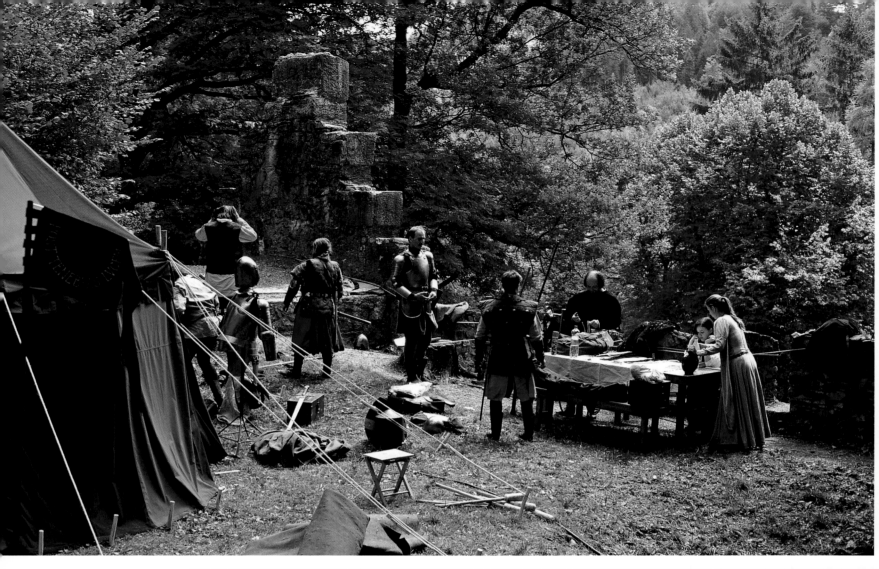

Once a year Füssen is cata-
pulted back to the Middle
Ages where it celebrates
the honeymoon of Emperor
Maximilian I and his
second bride Bianca Maria
Sforza, the duchess of
Milan. Following their
wedding the couple trav-
elled the German Empire,
spending three weeks in
the company of their many
envoys and ambassadors
on the Lech in the spring of
1494. The people of Füssen
don colourful medieval
costumes for the occasion
and happily indulge in
the musical, cultural and
culinary delights on offer
beneath the walls of the
town's castle.

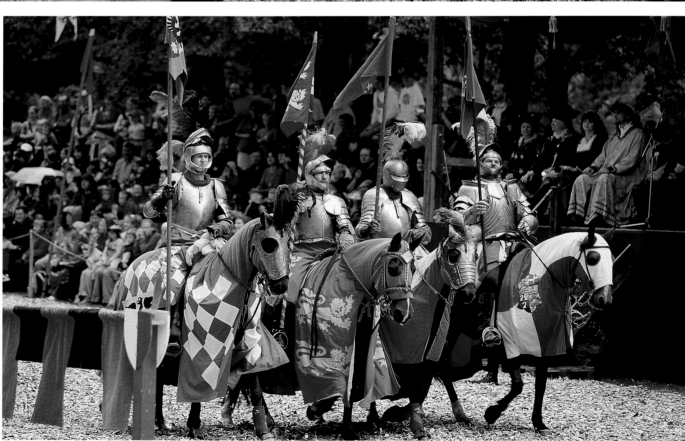

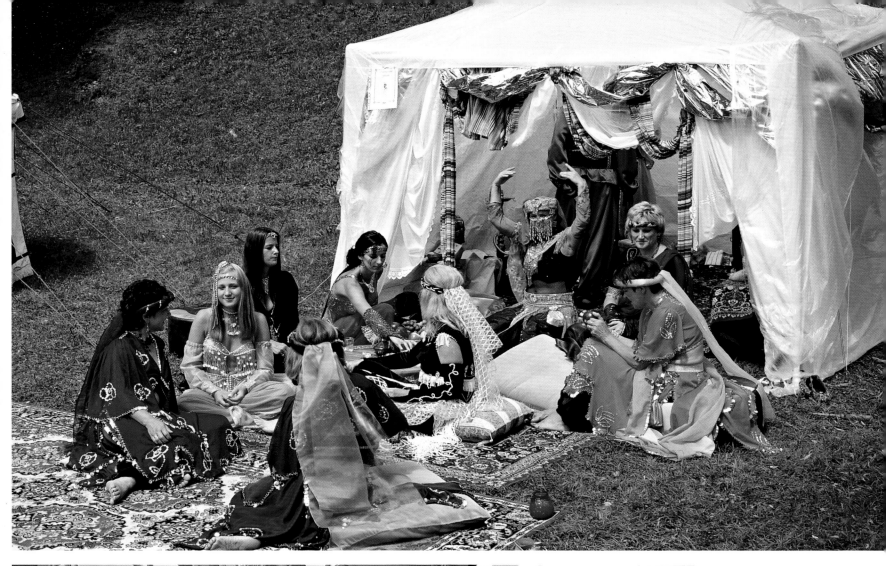

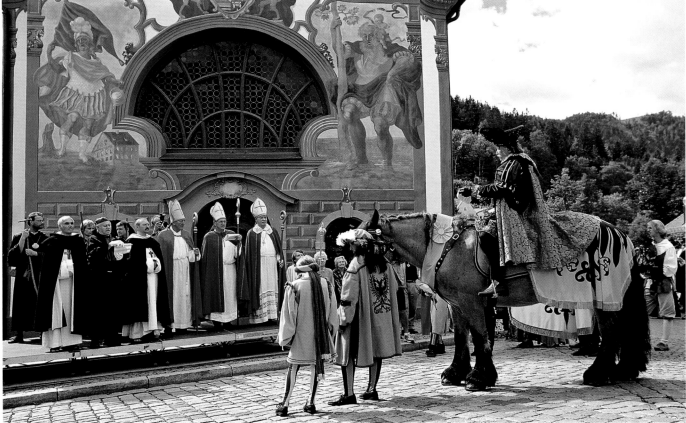

The magnificent processions of knights in shining armour and nobles in sumptuous robes through the streets of old Füssen are reminiscent of the 15th-century sojourn here of Emperor Maximilian I and his colourful entourage. He asked his hosts to provide him with three days of "dance and games, tournaments and many kinds of entertainment", an undertaking which now has tradition in the town.

Bonfire beacons and fishing nets – festivals in the Allgäu

Carnival processions, children's pageants, bonfire beacons, town parades, Alpine cattle herding and harvest festivals: with such a packed calendar of events life in the Allgäu is rarely dull! Much more than just an excuse for a good old knees-up, the religious, heathen and historic customs and feast days celebrated throughout the year have many origins and take on many forms – and all are positively steeped in tradition.

One of the oldest festivals here is the Mardi Gras carnival or "Fasnacht". Over a long weekend in February the communities of the Allgäu seize a final chance to let their hair down before the big fast for Easter begins. Dressed in artistic costumes made of rags and scraps of material and with faces painted, smeared with 'dirt' or hidden behind masks, locals disguised as devils, hags and witches parade loud and long through the streets, ringing bells, cracking whips and shaking rattles amid much screaming and shouting. The classic wooden Fasnacht masks many wear are perhaps the most fascinating aspect of their attire, with expressions ranging from the idiotic countenance of the Fasnacht fool to the ghostly grimace of the Prince of Darkness.

Unlike the punch-drunk jollities common to "Karneval" in the Rhineland, Swabian-Alemannic Fasnacht is often a sombre and almost threatening affair which is guaranteed to dampen the party spirit of any conga-dancing cousins dressed as Arab sheikhs or 'Alpine' milkmaids further north. Contrary to popular belief, the 1,000-year origins of this rather dark festival do not lie in some heathen celebration of the end of winter but in a Christian custom, one of abstinence and self-discipline. Fasnacht comes from the Middle High German "vastnacht" or "the night of fasting" and refers to the eve of the period of Lent when the church turned a blind eye to any jovial goings-on. This was the night when young bachelor apprentices were 'allowed' to lay down their tools for a few hours of mirth, poking fun at those in power without fear of retribution.

On the first Sunday in Lent the people of the Allgäu light hundreds of bonfires to drive out the evil spirits of the winter months. The collecting of fuel begins soon after Christmas when defunct Christmas trees and other inflammables are stacked up in a field on the edge of the village. Once the pyre has been built a straw guy is placed at the centre. On the big night the villagers parade to the bonfire at dusk and ceremoniously light it, forming a chain of beacons across the countryside which turn the night skies of the Allgäu a sinister orange.

The oldest children's pageant in Bavaria

One of the yearly events celebrated in many of the region's towns and villages is dedicated to the youngest members of the community: the children. The oldest of these historic jamborees in Bavaria takes place in Kaufbeuren. At the "Tänzelfest" held at the end of July the clocks are turned back to the Middle Ages, with no less than 1,600 youngsters in colourful medieval costume promenading through the centre of town, re-enacting historic events from the Carolingians to Biedermeier, performing ancient dances, waving flags and sidestepping the clowns and jugglers entertaining the waiting crowds. The annual focus of the pageant is the play commemorating the supposed initiation of the festival in 1497 when Emperor Maximilian I presented the champion of the local boys' shooting guild with a set of ceremonial chains. He also gave him what was then a very valuable present indeed: a pair of trousers. A tradition was born.

Memmingen is somewhere else which merits a special place in the festival calendar. For over 400 years now the end of July has marked the annual occurrence of the "Fischertag" or "day of the fishermen". At eight o'clock sharp in the morning hundreds of locals adorned in fancy dress and armed with a "bear" (a fishing net on a forked stick) leap into the icy waters of the town river to see who can catch the biggest trout. The man who manages to bag the fattest fish is crowned the fisher king on the very same morning and heralded a local hero. His predecessor is then named and shamed and marched through the town to prolonged hissing and booing. Memmingen's rather eccentric festival is rooted in the practice of draining the river for cleaning once a year. Before this could be done the trout had to be removed, a job which fell to the young men of a different guild each year. The custom has prevailed – and is a welcome source of great amusement and friendly competition year in, year out.

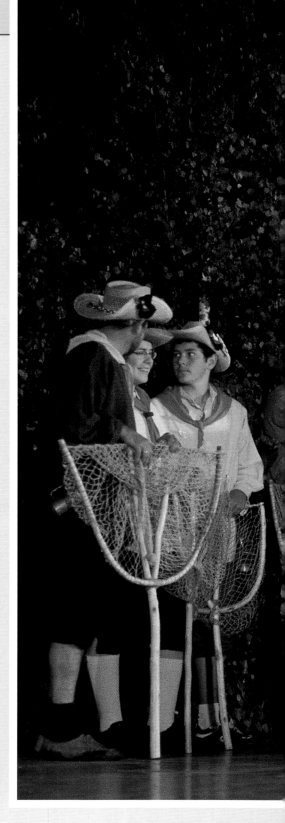

Above:
Each July Memmingen sees the annual coronation of its fisher king, the man who has managed to bag the biggest trout in the town's River Ach.

Small photos right, from top to bottom:
The yearly Tänzelfest in Kaufbeuren is a colourful occasion indeed. No less than 1,600 children in historical costume parade through the streets.

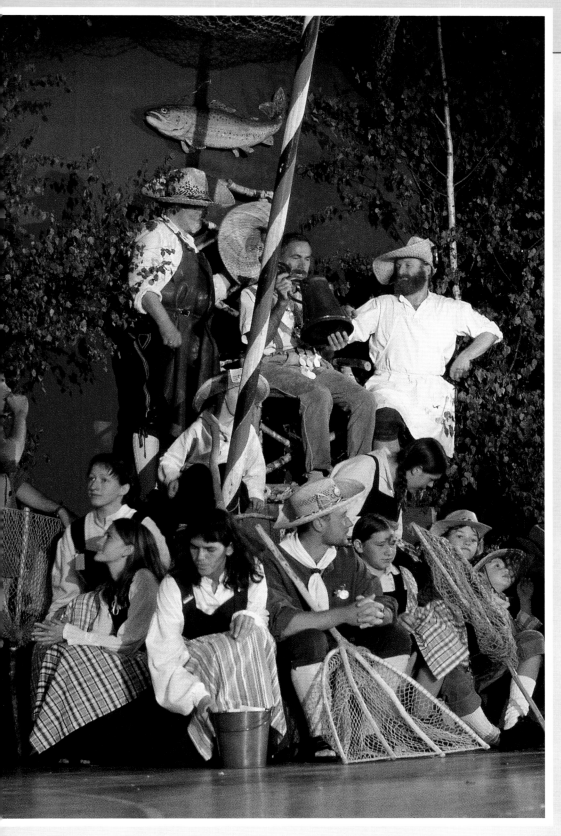

Carnival procession in Isny. Swabian-Alemannic "Fasnacht" is very different from the merry revelry of its Rhineland counterpart, a serious and almost sombre affair. One of its distinguishing features are the traditional wooden masks.

These masks on show at the local museum in Sonthofen are worn for the traditional Egga-Spiel. Every three years during the Carnival season a group of mummers sporting very realistic

carved animal heads trawl through the streets of Sonthofen, harrowing, ploughing and sowing mock fields with seed until a witch appears and destroys the farmers' hard work.

At the Kaiserfest in Füssen, where a whole range of characters from lords and ladies to beggars and thieves, from dashing knights to lowly vagabonds transport the town back to the Middle Ages.

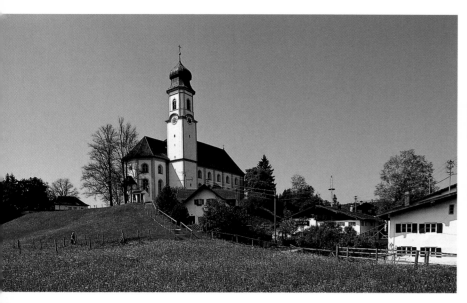

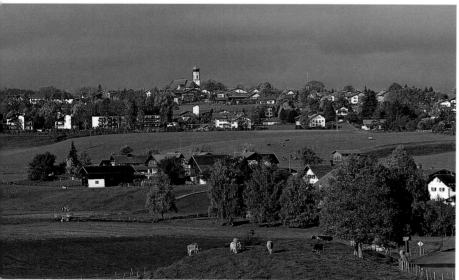

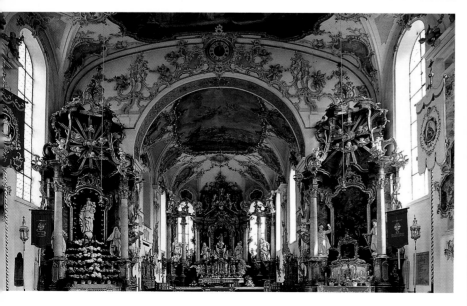

Top left:
Lechbruck's parish church dedicated to the Visitation of the Virgin Mary enjoys a scenic setting on top of a lush hillock above the River Lech. Its elegant neo-classical decor is unusual for the area; most of the churches here are baroque.

Centre left:
The little town of Seeg, popular with holiday-makers for its marvellous Alpine panoramas, perches atop an ancient moraine northwest of the Forggensee. In 1988 it was made an official climatic health resort.

Bottom left:
The parish church of St Ulrich's in Seeg is often referred to as the smaller counterpart or 'bourgeois cousin' of the famous Wieskirche in the Pfaffen-winkel. It is undoubtedly an architectural gem and

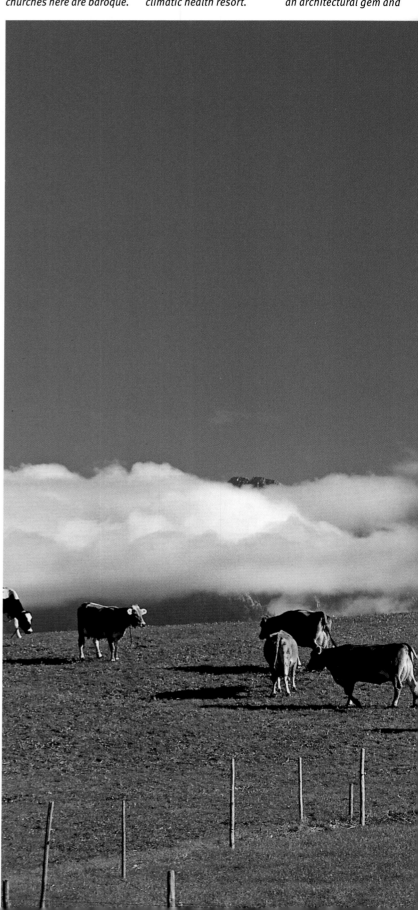

took several decades to reach perfection. Parts of the interior are the baroque creation of Johann Herkomer and consorts; the stucco and frescos are later and date back to the Rococo.

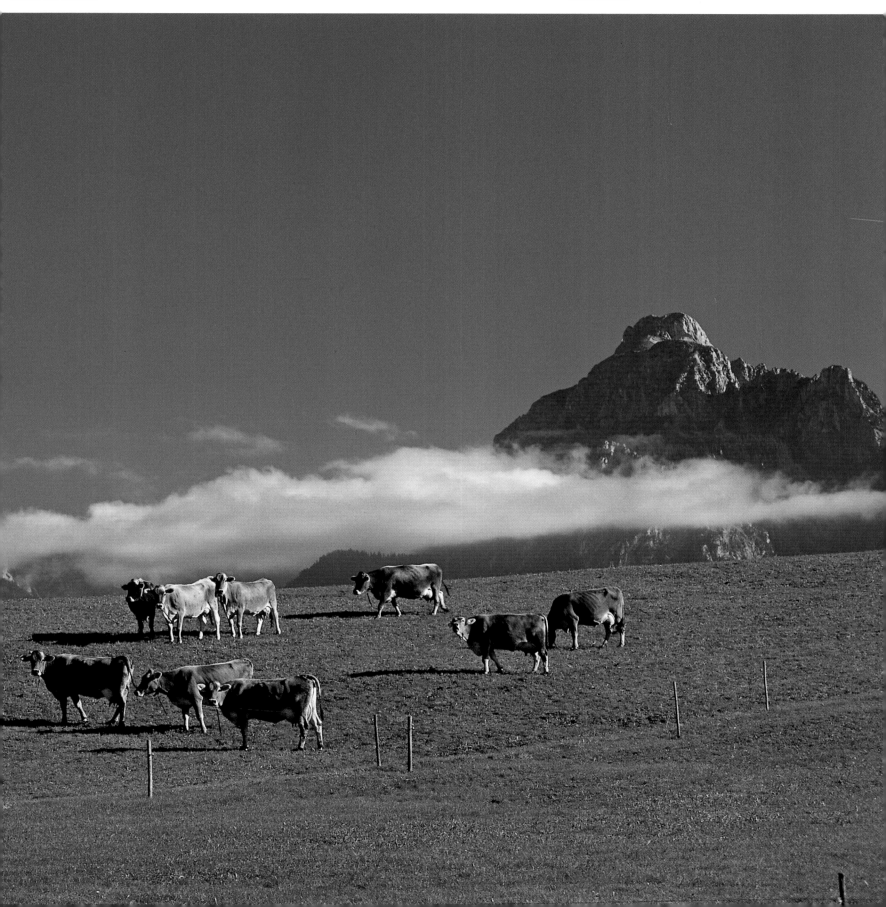

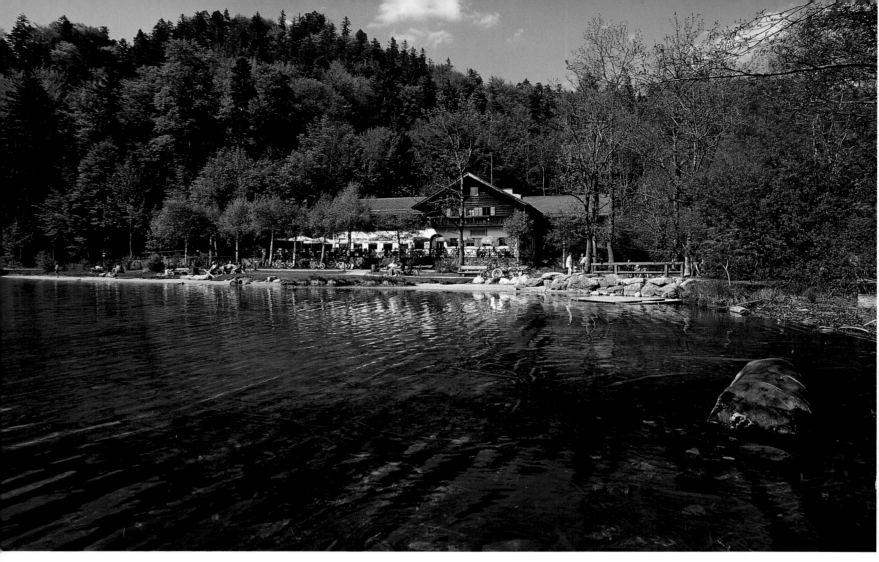

Above:
Not far from Füssen lies the Alatsee, remarkable in its extremely rare, bright red purple sulphur bacteria. It's also famous for the many myths and legends that surround it and that tell of key-rattling monks and strange little men who live on the Venediger – and more recently of sunken treasure supposedly stashed away here the Second World War.

Right:
The glittering waters of the Weißensee are bordered in the south by the mountainous slopes of the Salober and in the north by banks of reed and moorland.

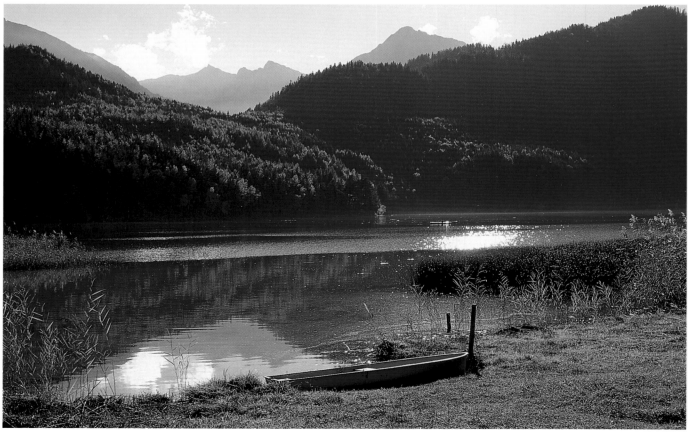

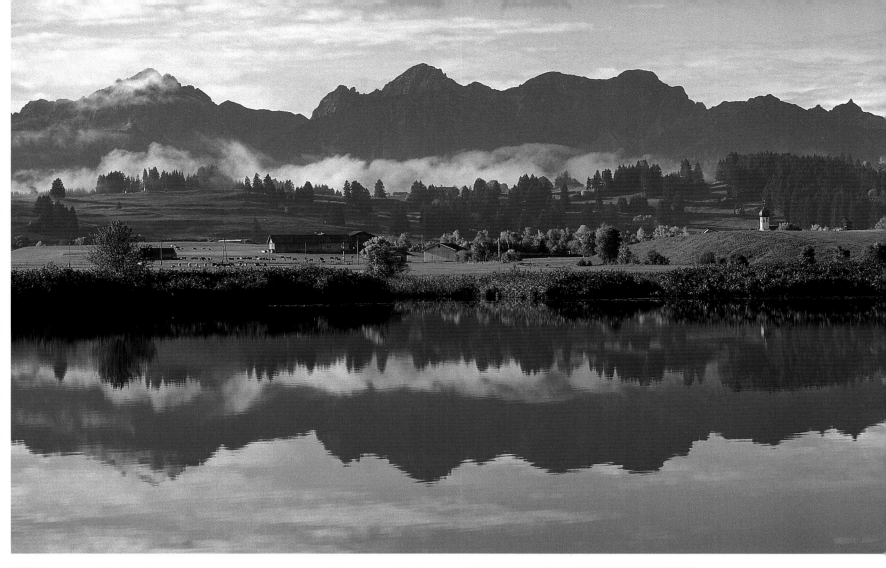

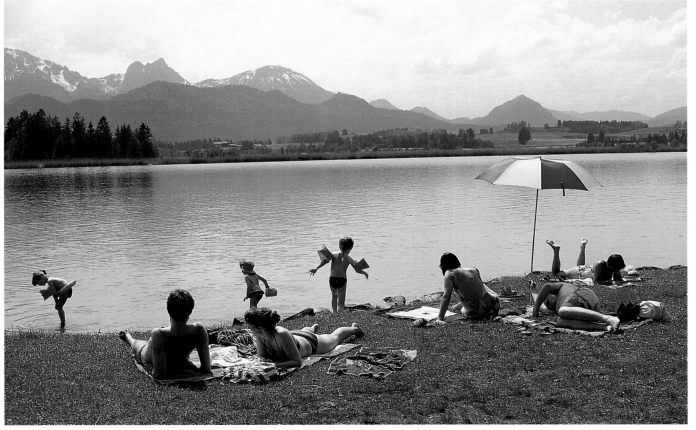

Above:
Despite its size, the tiny, almost completely circular Huttlerweiher near Roß-haupten boasts a setting just as fine as that of its larger cousins, surrounded by pastures green and lofty peaks.

Left:
Formed by the Lech Glacier thousands of years ago, the Hopfensee is perfect for swimmers and sun-bathers as its shallow waters heat up quickly in summer. The conditions are also ideal for birds, with great crested grebes and wild ducks happy to nest along its shores.

Below and bottom:
In the Allgäu tradition is
all-important. Disregard-
ing the fickle fads of
fashion and spurning
the anonymity of mass
production, rugs are still

woven by hand here in
Pfronten. Pure new wool or
scraps of leftover textiles
are used as raw materials,
the latter in homage to
the now common practice
of recycling. Customised

rugs are also produced at
the looms in Pfronten, with
classic Allgäu patterns
(shown here) proving just
as popular as the more
avant-garde designs.

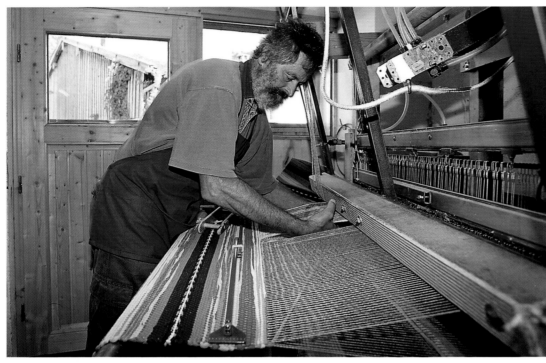

Right:
At the Kaiserfest in Füssen
many an old trade enjoys
a brief renaissance when

ropemakers, waggoners
and brushmakers show off
their skills at the yearly
festival.

Left:
The making of musical instruments enjoyed a long tradition in Füssen where many famous violin and lute makers had their roots. During the 19th century, however, the work- shops gradually closed. It was only in 1982 that this ancient craft was reintroduced to the area when master violinmaker Pierre Chaubert set up shop here.

Above:
Lutemakers in Füssen were the first in Europe to set up their own guild order in 1562 which regulated periods of apprenticeship and the number of resi- dent master lutemakers permitted. This prompted instrument makers to emigrate, with many crossing the Alps into Italy. Today lutes are again being made in Füssen, here in the attic of the old granary.

Below:
Even in the snow the slender steeple of St Nicholas's in Pfronten-Berg is visible for miles around. The indigenous population is extremely proud of the fact that the opulent interior is the work of local artists alone.

Top right:
Burghotel Falkenstein clings to its rocky precipice like an eyrie just below the castle of the same name, Germany's highest. The

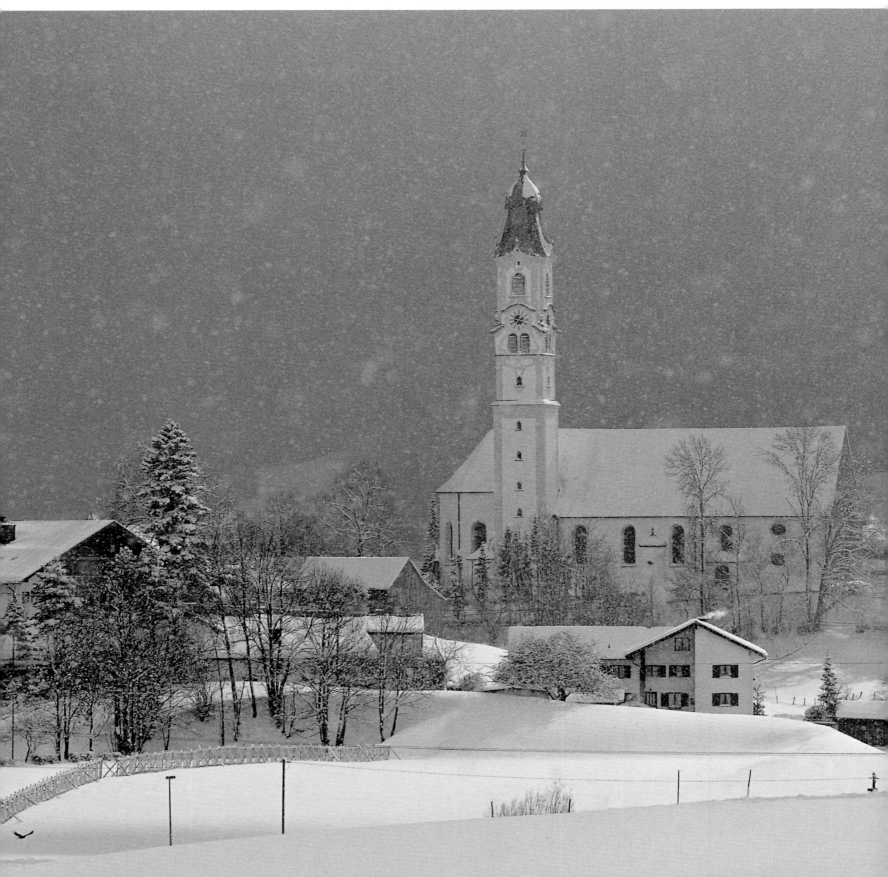

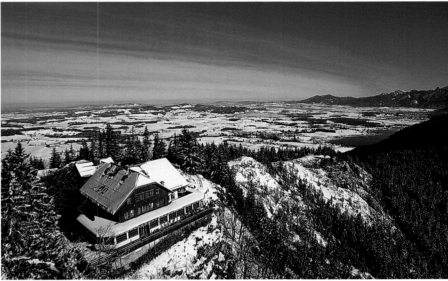

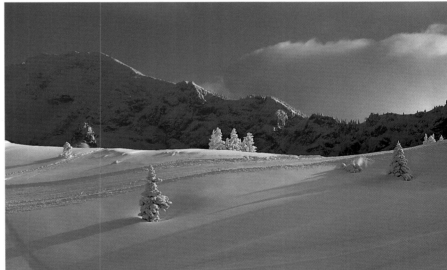

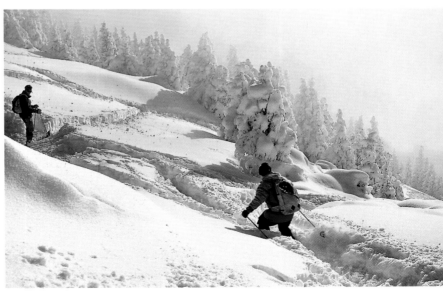

Right page:
Although it doesn't quite make the 2,000-metre mark (ca. 6,500 feet), Aggenstein Mountain on the Austrian border puts many of its neighbours in the shade, few of whom can boast such grand panoramas and such varied, distinctive scenery.

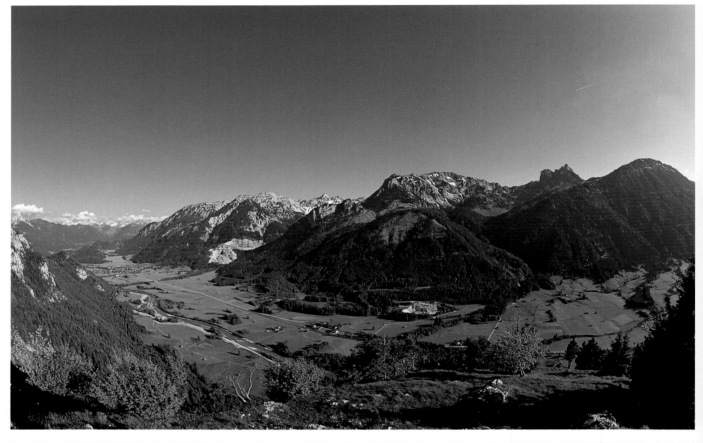

From the top of the chalk cliffs of Falkenstein Mountain east of Pfronten you can see as far as Tyrol along the valley of the Vils, lined with the majestic Tannheim Alps.

Old building traditions still thrive in the Allgäu, one of which is the cladding of farmhouses in wooden shingles, shown here in Pfronten-Steinach.

Page 126/127:
The health resort of Nesselwang has plenty of great winter sports facilities, from snowy pistes on the slopes of the Alpspitze and cross-country ski runs to an excitingly long toboggan run and hiking trails through a winter wonderland. In the village itself the neo-baroque parish church of St Andreas, a typically Allgäu local landmark, is well worth seeing.

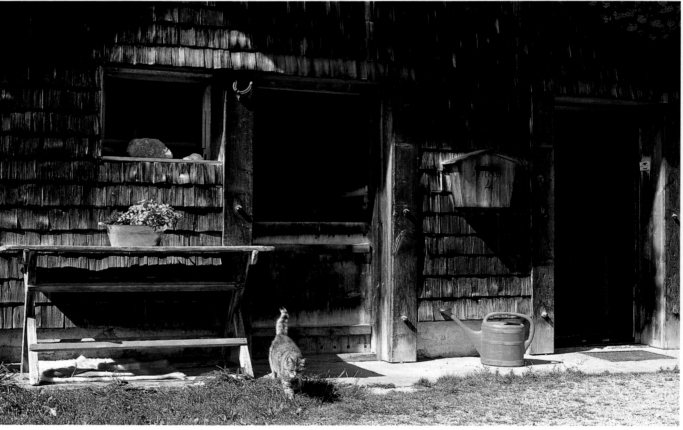

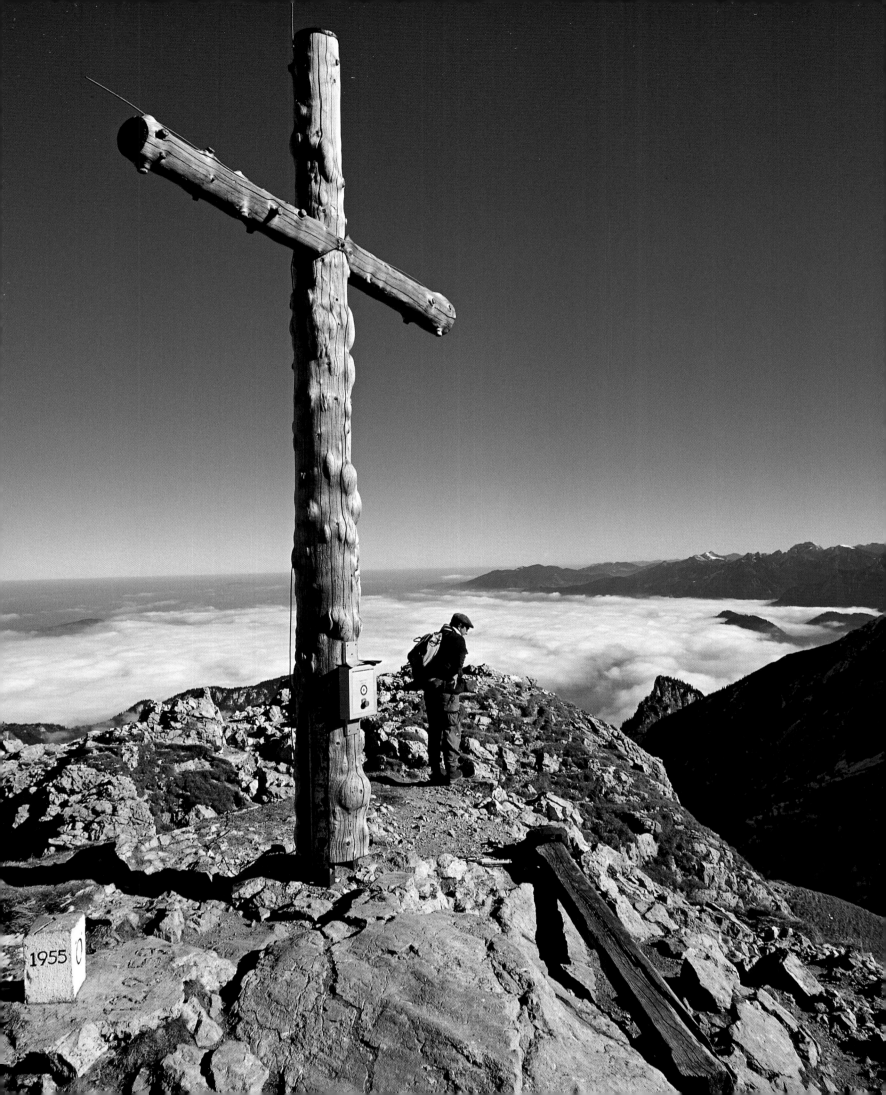

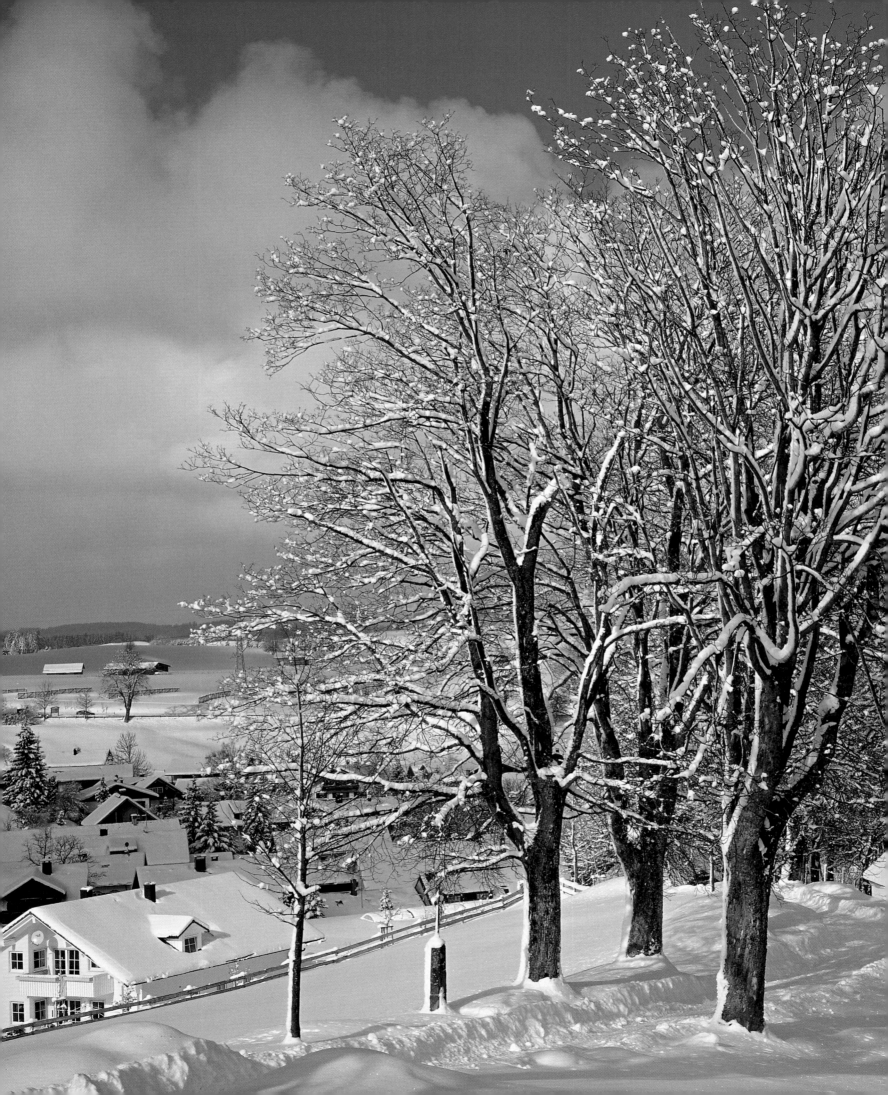

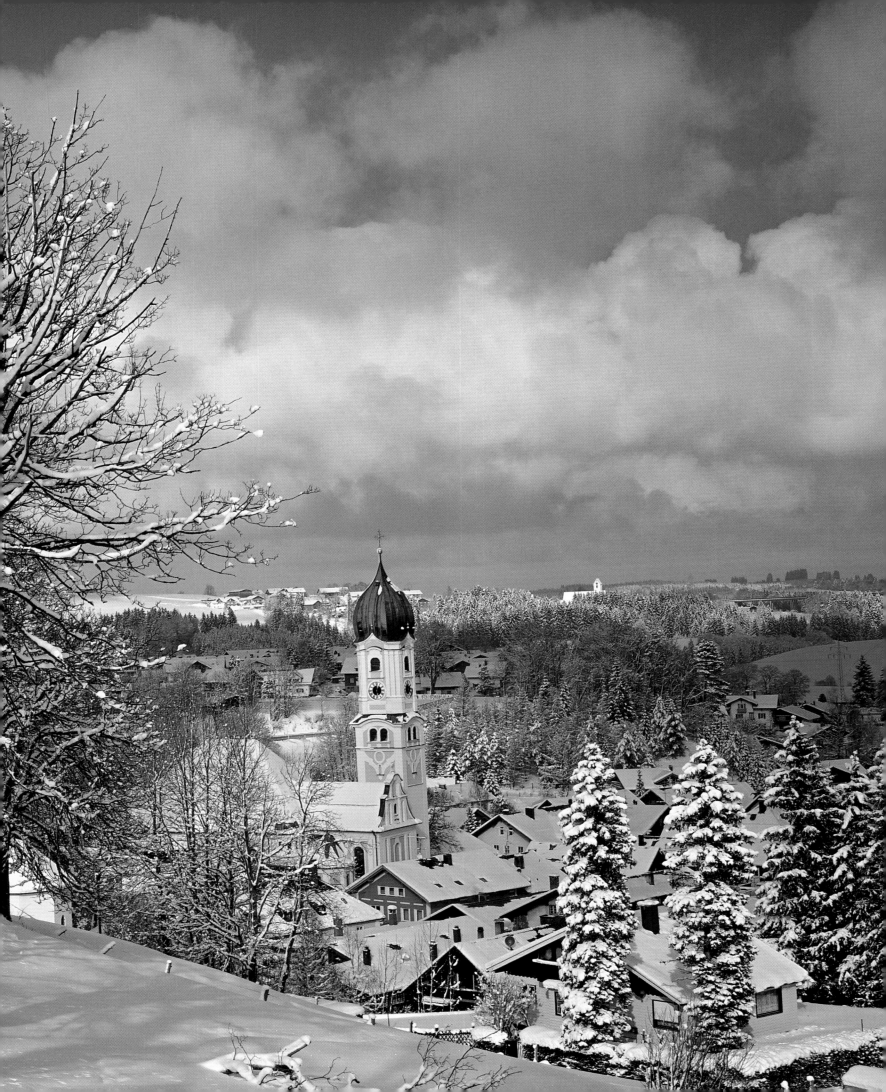

Above:
For over two decades now the people of Nesselwang have staged a yearly pilgrimage in regional dress to the church of Maria Trost. The May procession commemorates the successful restoration of the Rococo church.

Right:
The baroque monastic church dedicated to the Ascension of the Virgin Mary or Mariä Himmelfahrt in Irsee is renowned for both its Rococo pulpit in the shape of a ship's bow and its elegant stucco work by Wessobrunn artist Josef Schmuzer who has created an orgy of shells, laurel wreaths, bunches of fruit and plant tendrils in plaster.

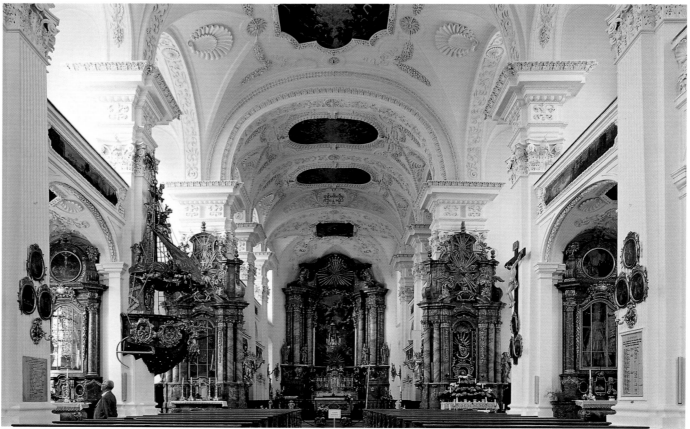

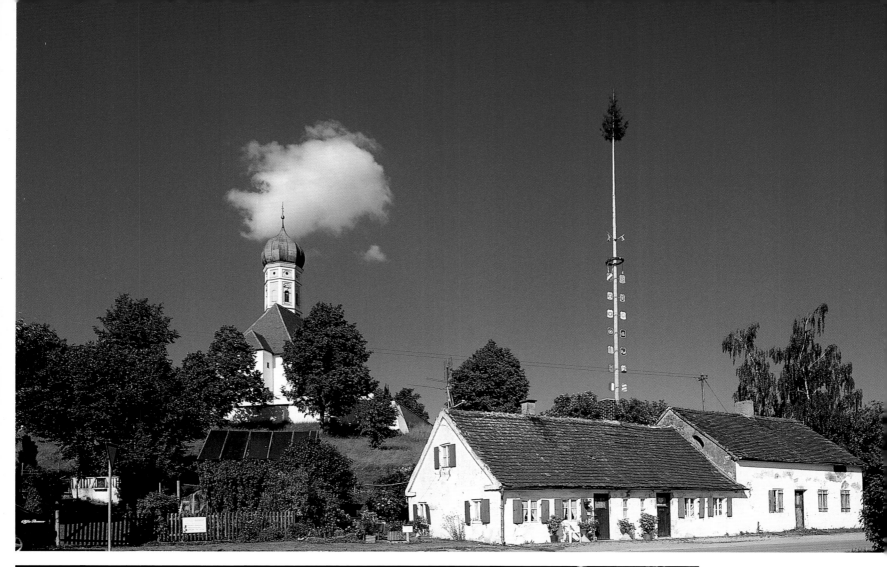

Above:
The old farming village of Lindenberg with its onion-domed church is now part of Buchloe, a self-proclaimed "hub of tourist activity", with neither the Ammersee nor the Alps, Munich nor Ludwig II's castles very far away.

Left:
Every few years Waal south of Buchloe is gripped by passion – namely the Passion of Christ, enacted by enthusiastic amateurs in similar vein to the performances in Oberammergau. The plays have been staged here since 1791.

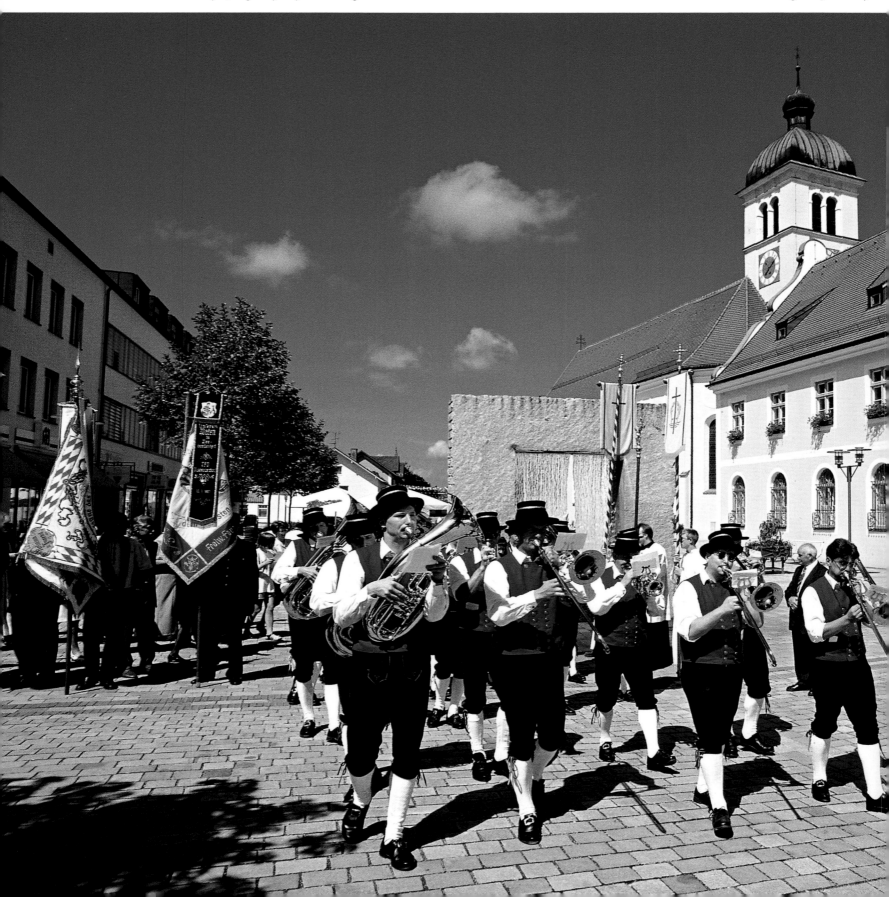

Below:
In many Allgäu communities the Catholic faith is still very much part of everyday life. Marktoberdorf, for example, stages a yearly procession in honour of the feast of Corpus Christi, proudly parading the host in a celebratory monstrance through the streets.

Top right:
Although adults have been allowed to join in the merrymaking in the recent past, the main protagonists at the Tänzel fest in Kaufbeuren are the town's children. Dressed in authentic costumes dating from the Middle Ages to the 19ᵗʰ century, they march through the town in their hundreds in celebration of the arrival of Emperor Maximilian I here during the 15ᵗʰ century.

Centre right:
The palace and Rococo church of St Martin's dominate the historical ensemble of buildings at the heart of Marktoberdorf. The interior of the early 18th-century church is dwarfed by its huge high altar and richly embellished with filigree stucco ornamentation and marvellous ceiling frescos.

Bottom right:
Festivals and feast days are when the people of Allgäu don their traditional clothes with pride, such as here at the Corpus Christi parade in Marktoberdorf.

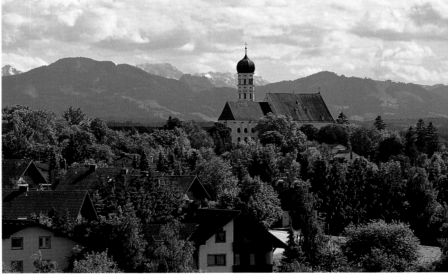

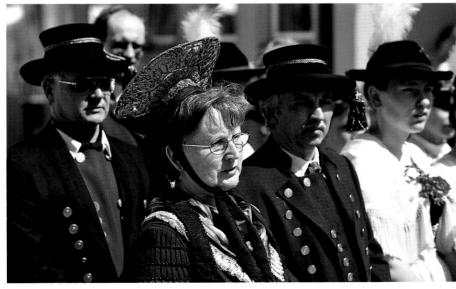

131

Above:
Once a free city of the Holy Roman Empire, Kaufbeuren can look back on over 1,000 years of history. Over the centuries a town grew up around the ancient Carolingian court, becoming prosperous during the 15th century through its smithies, linen production and paper manufacture.

Right:
The historical houses on Kaiser-Max-Straße with their richly ornamental facades provide a pleasant backdrop to the hustle and bustle along Kaufbeuren's main shopping street.

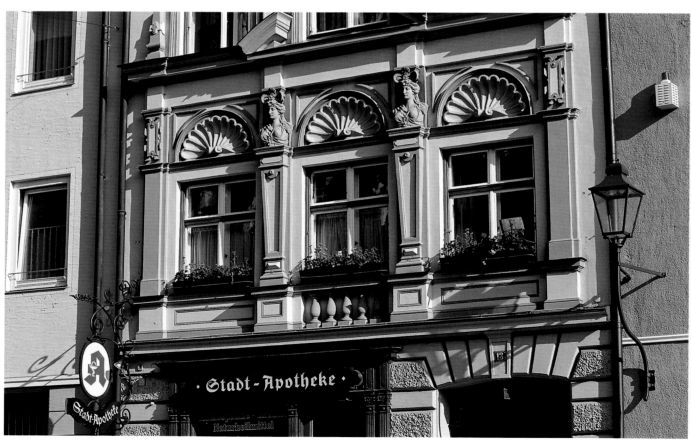

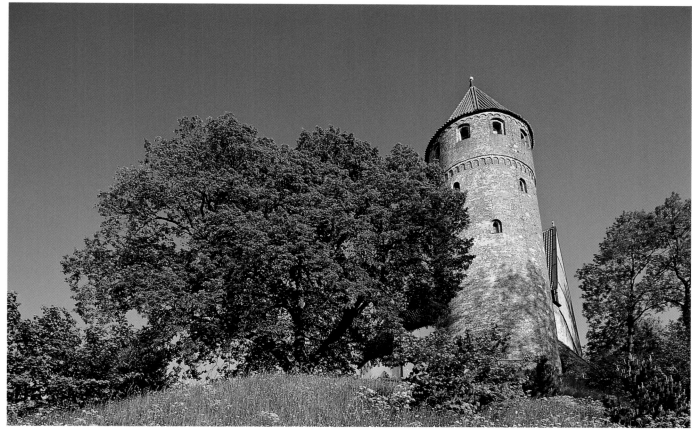

Battlements connect the Blasiusturm, the oldest of the towers along Kaufbeuren's town walls, to the adjacent church, once allowing sentries to go to prayer without having to abandon their guard posts.

The successful Kaufbeuren writer Ludwig Ganghofer (1855–1920), whose study has been incorporated into the town museum, wrote plays, stories, novellas, poems and also 18 novels, many of which have been filmed.

133

Index

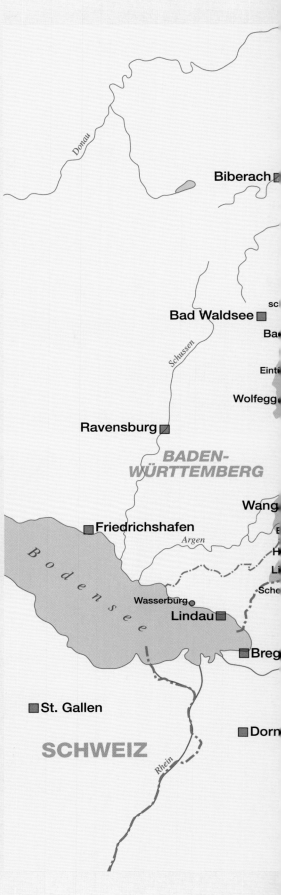

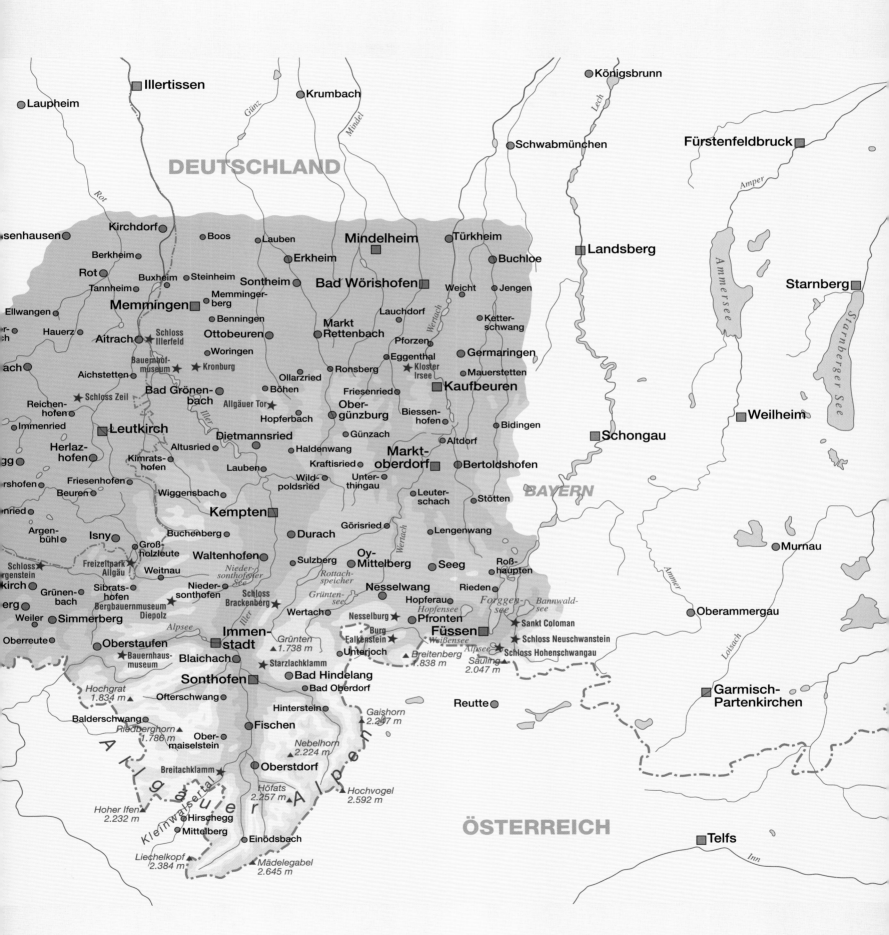

DEUTSCHLAND

BAYERN

ÖSTERREICH

Laupheim
Illertissen
Krumbach
Königsbrunn
Schwabmünchen
Fürstenfeldbruck

Günz
Mindel
Lech
Amper

Kirchdorf
Boos
Lauben
Mindelheim
Türkheim
Landsberg
Starnberg

senhausen
Berkheim
Erkheim
Buchloe
Starnberger See
Ammersee

Rot
Buxheim
Steinheim
Sontheim
Bad Wörishofen
Weicht
Jengen

Tannheim
Memmingen
Memminger- berg
Markt Rettenbach
Lauchdorf
Ketter- schwang

Ellwangen
Hauerz
Benningen
Pforzen
Germaringen

Aitrach
Schloss Illerfeld
Ottobeuren
Eggenthal
Mauerstetten

ch
Woringen
Ronsberg
Kloster Irsee

Aichstetten
Bauernhof- museum
Kronburg
Ollarzried
Böhen
Friesenried
Kaufbeuren

Reichen- hofen
Schloss Zeil
Bad Grönen- bach
Allgäuer Tor
Ober- günzburg
Biessen- hofen
Bidingen

Immenried
Hopferbach
Günzach
Altdorf

rshofen
Leutkirch
Dietmannsried
Haldenwang
Markt- oberdorf
Bertoldshofen

Herlaz- hofen
Altusried
Kraftisried
Unter- thingau

gg
Kimrats- hofen
Lauben
Wild- poldsried

Friesenhofen
Wiggensbach
Leuter- schach
Stötten

nried
Beuren
Kempten
Görisried
Lengenwang

Argen- bühl
Isny
Buchenberg
Durach

Groß- holzleute
Waltenhofen
Sulzberg
Oy- Mittelberg
Seeg
Roß- haupten

Schloss genstein
Freizeitpark Allgäu
Weitnau
Nieder- sonthofener See
Rottach- speicher
Nesselwang
Rieden

kirch
Grünen- bach
Sibrats- hofen
Nieder- sonthofen
Schloss Brackenberg
Grünten- see
Hopferau

Weiler
Bergbauernmuseum Diepolz
Wertach
Nesselburg
Pfronten
Sankt Coloman

Oberreute
Simmerberg
Alpsee
Iller
Hopfensee
Weißensee
Schloss Neuschwanstein

Oberstaufen
Bauernhaus- museum
Immen- stadt
Grünten 1.738 m
Burg Falkenstein
Füssen
Schloss Hohenschwangau

Blaichach
Starzlachklamm
Breitenberg 1.838 m
Säuling 2.047 m
Alpsee

Hochgrat 1.834 m
Sonthofen
Bad Hindelang
Unterjoch

Ofterschwang
Bad Oberdorf
Reutte

Balderschwang
Hinterstein
Gaishorn 2.247 m

Riedberghorn 1.786 m
Fischen
Ober- maiselstein

Nebelhorn 2.224 m

Breitachklamm
Oberstdorf

Hochvogel 2.592 m

Höfats 2.257 m

Hoher Ifen 2.232 m
Hirschegg
Mittelberg

Allgäuer Alpen
Kleinwalsertal

Liechelkopf 2.384 m
Einödsbach
Mädelegabel 2.645 m

Weilheim
Schongau
Murnau
Oberammergau
Garmisch- Partenkirchen
Telfs

Ammer
Loisach
Inn

The brown cow is to the Allgäu what the fluffy white sheep is to Wales; the landscape just wouldn't be complete without it! And no cow would be complete without its obligatory cowbell, here threaded onto a particularly fine harness to celebrate the animals' safe return from their high-lying summer pastures.

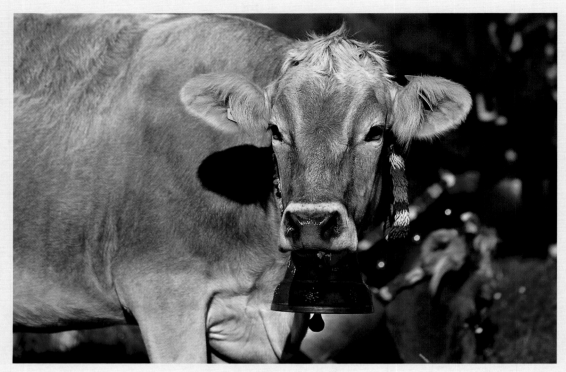

Design
hoyerdesign grafik gmbh, Freiburg
www.hoyerdesign.de

Map
Fischer Kartografie, Aichach

Translation
Ruth Chitty, Stromberg
www.rapid-com.de

Printed in Germany
Repro by Artilitho, Lavis-Trento, Italien
www.artilitho.com
Printed/Bound by Offizin Andersen Nexö, Leipzig
© 2010 Verlagshaus Würzburg GmbH & Co. KG
© Photos: Martin Siepmann
© Text: Katrin Lindner

ISBN 978-3-8003-4080-4

Details of our programme can be found at
www.verlagshaus.com